WHEN THE MOON
WAXES RED

WHEN THE MOON WAXES RED

REPRESENTATION, GENDER AND CULTURAL POLITICS

TRINH T. MINH-HA

Routledge
New York London

Published in 1991 by

Routledge
An imprint of Routledge, Chapman and Hall, Inc.
29 West 35 Street
New York, NY 10001

Published in Great Britain by

Routledge
11 New Fetter Lane
London EC4P 4EE

Library of Congress Cataloging-in-Publication Data

Trinh. T. Minh-Ha (Thi Minh-Ha), 1952–
 When the moon waxes red : representation, gender, and cultural
politics / Trinh T. Minh-ha.
 p. cm.
 Includes bibliographical references and index.
 ISBN 0-415-90430-7 (hb). ISBN 0-415-90431-5 (pb)
 1. Motion pictures—Philosophy. 2. Feminism and motion pictures.
I. Title.
PN1995.T66 1991
791.43'01—dc20 91-14059
 CIP

British Library cataloging in publication data also available.

Contents

Contents

The Third Scenario: No Light No Shade

Illustrations

Acknowledgments

The essays gathered in this book were written between 1980 and 1990. I have hardly made any changes, and the varying tones and modes of address are kept here as they were originally published. This is also reflected in the presentation of the quoted materials. The irregularities of their treatment are generally context-bound, while the differences found within the same essay are both functionally and strategically necessary to the non-univocal nature of the texts, whose meanings are not only verbal but also visual. I am grateful to all the editors who have given permission to reprint the essays. Finally, it is with much affection that I thank here my parents, my former professor Stanley Gray, my friends Suzanne Fleischman, Tom Zummer, and my sister Le-Hang Trinh, for having directly or indirectly given me their support at the times when I felt most diffident asking for it. I would also like to thank Jean-Paul Bourdier whose humor and merciless critical input have not succeeded to free him from the imposed task of being an all-year-all-time reader of my work.

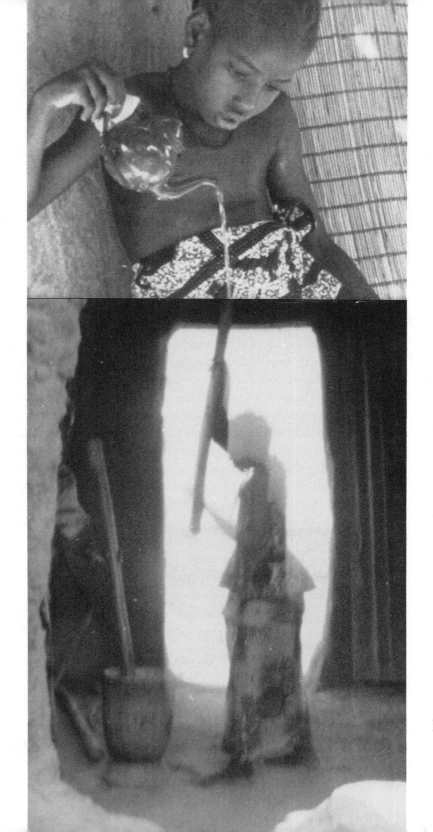

R

Yellow Sprouts

If darkness induces reverie and is the medium of a diffuse eroticism, nighttime remains for many poets and painters of Asian cultures the moment of quiescence necessary to the dawning of new awareness. Both the time when no thought arises and the time when the primal positive energy stirs into motion are called the moon. A ray shining clear through the night with the intensity of a white light burgeoning in an empty room. *Nothingness produces white snow; quiescence produces yellow sprouts* (Chang Po-tuan).[1] When stillness culminates, there is movement. The living potential returns afresh, the cycles of the moon go on regularly, again and again the light will wane. In the process of infinite beginnings, even immortality is mortal.

With each phase a shift has occurred, a new form is attained, several motions interweave within a movement. Crescent, quarter, gibbous, full: an old form continues to mutate between loss and gain, while every growth from and toward voidness invites a different entry into areas of social dissent and transformation. The new moon, as science duly demonstrates, cannot be seen at all. To speak of the thin crescent moon as being new is to forget that only when the dark half faces the earth is the moon truly new. Politics waxes and wanes, and like a lunar eclipse, it van-

1

ishes only to return rejuvenating itself as it reaches its full intensity. In the current situation of overcodification, of de-individualized individualism and of reductionist collectivism, naming critically is to dive headlong into the abyss of un-naming. The task of inquiring into all the divisions of a culture remains exacting, for the moments when things take on a proper name can only be positional, hence transitional. The function of any ideology in power is to represent the world positively unified. To challenge the regimes of representation that govern a society is to conceive of how a politics can transform reality rather than merely ideologize it. As the struggle moves onward and assumes new, different forms, it is bound to recompose subjectivity and praxis while displacing the way diverse cultural strategies relate to one another in the constitution of social and political life.

In Chinese mythology, those who first ascend to the moon—the pioneers of the Apollo flight—are the Moon-Queen Chang E who swallows the pill of immortality, the hare which throws itself into the magical fire to feed Buddha, and the Sun-King who comes to visit his wife Chang E on the fifteenth day of every moon. Now that scientists readily speak of the "Old Moon" being extinct with the advent of the "New Moon," access to the world of the moon becomes at the same time more reachable (for some) and more limited (for others). There has been a time when Western science-fiction writers cherished the possibility of using the moon as a military base for building nuclear missiles. The paradoxical idea of "colonizing the moon" with the aim of coming closer to uniting the earth has constituted an argument that some scientists have not hesitated to advance. "The *Eagle* has landed," was the statement symbolically uttered upon North American Man's arrival on the moon. Since then, Apollo has come and gone. But the fact that a dozen men have walked upon its surface does not make the moon one bit less puzzling to the scientists.

Just as new knowledge cannot nullify previous results, differ-

ent moments of a struggle constantly overlap and different relations of representation across "old" and "new" can be made possible without landing back in a dialectical destiny. Postures of exclusionism and of absolutism therefore unveil themselves to be at best no more than a form of reactive defense and at worst, an obsession with the self as holder of rights and property—or in other words, as owner of the world. In the renewed terrain of struggle and of deterritorialized subjectivities, no moon-lovers can really claim possession of the soft light that illuminates towns, villages, forests, and fields. *The same moon that rises over the ocean lands in the tea water. The wind that cools the waters scatters the moons like rabbits on a meadow.*[2] The one moon is seen in all waters; and the many-one moon is enjoyed or bawled at on a quiet night by people everywhere—possessors and dispossessed.

It used to be a custom in many parts of Asia that women, regardless of their classes, all came out in groups to stroll on the night of the Mid-Autumn Festival when the moon is at its fullest and brightest. Also parading through the streets are children from all families who moved together in wavy lines, their songs resonating from quarters to quarters, and their moon lanterns flickering in gentle undulations like so many beads of color on the dragon's body. The moonlight walk remains a memorable event, for here in September, the sky is high, the dewdrop clear, the mountains empty, the night lucent. Moon, waves, pearls, and jades: a multitude of expressions founded on these images exists in Chinese poetry to describe feminine beauty and the carnal presence of the loved woman. *Scented mist, cloud chignon damp/ Pure light, jade arm cool* ("Moonlit Night," Tu-Fu).[3] Through the eroticization of nocturnal light, she is, as tradition dictates, often all hair and skin: darkness is fragrant, soft, vaporous, moist, mist- or cloud-like, while the glow emanating from her smooth bare arm evokes the sensation of touching jade. Yet, she is not

3

simply night to his day (as in many Western philosophical and literary traditions), she is day in night.

In the realm of dualities where blinding brilliance is opposed to mysterious luminosity, or to use Taoist terminology, where the logic of conscious knowledge is set against the wisdom of real knowledge, she finds no place she can simply dwell in or transgress. Crisscrossing more than one occupied territory at a time, she remains perforce inappropriate/d—both inside *and* outside her own social positionings. What is offered then is the possibility of a break with the specular structure of hegemonic discourse and its scopic economy which, according to Western feminist critiques, circularly bases its in-sights on the sight (a voyeur's *theoria*) rather than the touch. The interstice between the visual and the tactile is perhaps the (nothing-)spiritual conveyed above in the fragrance of mist—at once within and beyond the sense of smell. Within and beyond tangible visibility. A trajectory across variable praxes of difference, her (un)location is necessarily the shifting and contextual interval between arrested boundaries.

She is the moon and she is not. All depends on how the moon partakes of language and representation. Chinese feminists have by now carefully re-read and rewritten the story of goddess Chang E. In their words, the latter was not confined to living solitarily on the moon because she *stole* the pill of immortality from her husband Hou Yi (who later became the Sun-King). Rather, she chose to live on the moon because it was nearest the earth, and she was forced by circumstances to swallow the elixir to *free* herself from the threat of having to belong to a man craving for power and possession who asserted he had killed her husband.[4] As long as the light of the moon is merely spoken of as having its birth in the sun, decreasing in proportion to its distance from the solar ray, and being accordingly light or dark as the sun comes and goes, women will reject Woman. They will agree with feminist writer Ting Lan that: "Woman is not the

4

moon. She must rely on herself to shine."[5] For having occupied such a multiply central role in Chinese arts and culture, the moon has inevitably been the object of much literary controversy. Subjected to a continuous process of re- and de-territorialization, she bears both strong positive and negative social connotations.

Not too long ago, when the fire of the revolution was at its height, some writers decided that to focus on her was to ruin China, therefore the moon had to be liquidated. A person enjoying the mid-autumn moon and eating rabbit moon cakes was either "feudalistic" or "counter-revolutionary." The moon became the property of the conservative leisure class and, again, her sight was thought to be owned by some to the detriment of others. As an ideological instrument in man's manipulative hand, she could easily constitute a means of escapism, hence to sing her praise is, indeed, to "avoid facing reality." Yet, how realistic was it to liquidate the moon? Can women simply leap *outside* the (un-)feminine without falling into the historical model of mastery? The moment was transitional. Today, as the wind keeps on changing direction, the moon can hardly be bestowed with the power to ruin the nation, and again, she proves to be "shared property" among franchised and disfranchised. The moon waxes and wanes in favor of different trends of discursive production, and the war of meaning or what Mao named the "verbal struggle" never really ends. On the social terrain, desire refuses to let itself be confined to the need of ideological legitimation. Whether the moon is scorned or exalted, she continues to be passionately the subject/the passionate subject of discussion. Even when invalidated and stripped bare of her restorative powers, she remains this empty host-center which generously invites its guests to fill it to their own likings without ever being able to arrogate to themselves the exclusive right of a landlord.

Nothing is less real than realism (Georgia O'Keeffe).[6] Insubordinate processes of resistance do not lend themselves easily to

commodification. A man convicted for seditious conspiracy, and currently serving his sixty-eight-year sentence in prison for having upheld the liberation of Puerto Rico, remarks that "the struggle is also between one fiction and another. . . . We, crazy people always strive toward the kingdom of freedom (Marx), towards our own idea and conception of Utopia." Rejecting the disabling and reductive logic that one should not engage in the so-called luxury of art when people starve every day, or when revolution is in danger, the man further asserts that without art, "revolution will lose its spirit. And the spirit of any revolution is the widening of freedom, collective and individual, and not one or the other" (Elizam Escobar).[7] To disrupt the existing systems of dominant values and to challenge the very foundation of a social and cultural order is not merely to destroy a few prejudices or to reverse power relations within the terms of an economy of the same. Rather, it is to see through the revolving door of all rationalizations and to meet head on the truth of that struggle *between fictions*. Art is a form of production. Aware that oppression can be located both in the story told and in the telling of the story, an art critical of social reality neither relies on mere consensus nor does it ask permission from ideology. Thus, the issue facing liberation movements is not that of liquidating art in its not-quite-correct, ungovernable dimension, but that of confronting the limits of centralized conscious knowledge, hence of demystifying while politicizing the artistic experience.

The moon breeds like a rabbit. She causes the seeds to germinate and the plants to grow, but she exceeds all forms of regulated fecundity through which she is expected to ensure the system's functioning. In the heterogeneity of the feminist struggle and its plurivocal projects, the impossibility of defining once and for all the condition of being sexualized as feminine and racialized as colored does not result from a lack of determination, but rather, from an inescapable awareness of the sterility of the unitary subject and its monolithic constructs. *For language is in*

6

every case not only communication of the communicable but also, at the same time, a symbol of the noncommunicable (Walter Benjamin).[8] The gift that circulates with non-closures offers no security. Here in the all-meaning circle where there is no in no out, no light no shade, she is born anew. This is the third scenario. When stillness culminates, there is movement. Non-alignment paradoxically means new alliances: those that arise from-within differences and necessarily cut across variable borderlines, for "there is no one who is automatically my ally/ because we are the same/ Alliances don't grow wild and unattended/ . . . they grow on two conditions/ that you and I/ both of us/ understand that we need each other to survive/ and that we have the courage/ to ask each other what that means" (Judit).[9]

While the full moon generally represents the conjunction of *yin* and *yang*, of stillness and action, or of beings dear to one another (the cyclic encounter of Hou Yi and Chang E), the autumn Harvest moon connotes more specifically distant presence and desire for reunion. Separated lovers burnt in longing and imbued with the thought of one another, reunite in watching the same moon. *Night follows night, bright luster wanes / Thinking of you, I am like the full moon* (Chang Chiu-Ling).[10] The potential of sharing the seed of a common journey while being apart keeps desire alive; but the lucid tranquility of lunar realizations eventually helps the desirers to find their repose. Lifted in awareness by the light in the calm fragrant night, moon-lovers remain enraptured by its gentle powers while aspiring to quietism in their creations. Such an in-between state of mind does bear the trace of a name: whoever dreams of the simple moon(life) without looking for conscious knowledge is said, in psychoanalysis, to incline toward the "feminine."

At night inhale the vitality of the moon (Sun Bu-er).[11] She is the principle of transformation and the site of possibility for diversely repressed realities. With the moon, the Imaginary She is at once centered and de-centered. Access to proper names as moments of transition (the "moon" is a name) requires that "the

imagination also [be] a political weapon" (Escobar). For, there is no space really untouched by the vicissitudes of history, and emancipatory projects never begin nor end *properly*. They are constantly hampered in their activities by the closure-effect repeatedly brought about when a group within a movement becomes invested in the exercise of power, when it takes license to legislate what it means to "be a woman," to ascertain the "truth" of the feminine, and to reject other women whose immediate agenda may differ from their own. In undoing such closure-effect one is bound again and again to recognize "that piece of the oppressor which is planted deep within each of us, and which knows only the oppressors' tactics, the oppressors' relationship" (Audre Lorde).[12]

Changes in the color of the sun or the moon used to be signs of approaching calamities. When the moon waxes red, it is said in Chinese mythology that men should be in awe of the unlucky times thus fore-omened. Today, lunar eclipses are still impressive, but scientists find them "undeniably lovely," for the dimming moon often shows strange and beautiful color effects. The old fox sees to it that everything becomes a commodity. Yet between rational and irrational enslavement there is the interval and there is the possibility for a third term in the struggle. *We are what we imagine. Our very existence consists in our imagination of ourselves. . . . The greater tragedy that can befall us is to go unimagined* (N. Scott Momaday).[13] In the existing regime of frenzied "disciplinarization," such breach in the regularity of the system constitutes the critical moment of disequilibrium and dis/illumination when Buddha may be defined as "a cactus in the moonlight."[14]

No Master Territories

SC

1

Cotton and Iron *

Conte, conté, à conter . . .
* Es-tu véridique?*
* Pour les bambins qui s'ébatent au clair de lune, mon*
* conte est une histoire*
* fantastique.*
* Pour les fileuses de coton pendant les longues nuits de la*
* saison froide, mon récit*
* est un passe-temps délectable.*
* Pour les mentons velus et les talons rugueux, c'est une*
* véritable révélation.*
* Je suis donc à la fois futile, utile et instructeur.*
* Déroule-le donc pour nous . . .*

<div align="right">(A. Hampaté Ba)[1]</div>

In these, the opening lines of a didactic narration which forms part of the traditional education of the Fulani in the Niger loop, what can be read as unwinding itself to the reader are some of the most debated issues of contemporary theory and art. *Tale, told, to be told . . . / Are you truthful?* Acknowledging the complexities inherent in any speech-act does not necessarily mean taking away or compromising the qualities of a fine story. Simple and

* First published in *Out There: Marginalization and Contemporary Culture*, eds. Russell Ferguson, Martha Gever, Trinh T. Minh-ha, and Cornel West (New York: The New Museum of Contemporary Art and M.I.T. Press, 1990).

11

direct in its indirectness, it neither wraps itself in a cloud of oratorical precautions, nor cocoons itself in realist illusions that make language the simple medium of thought. Who speaks? What speaks? The question is implied and the function named, but the individual never reigns, and the subject slips away without naturalizing its voice. S/he who speaks, speaks *to* the tale as s/he begins telling and retelling it. S/he does not speak *about* it. For, without a certain work of displacement, "speaking about" only partakes in the conservation of systems of binary opposition (subject/object; I/ It; We/ They) on which territorialized knowledge depends. It places a semantic distance between oneself and the work; oneself (the maker) and the receiver; oneself and the other. It secures for the speaker a position of mastery; I am in the midst of a knowing, acquiring, deploying world—I appropriate, own, and demarcate my sovereign territory as I advance—while the "other" remains in the sphere of acquisition. Truth is the instrument of a mastery which I exert over areas of the unknown as I gather them within the fold of the known.

"Speaking to" the tale breaks the dualistic relation between subject and object as the question "who speaks?" and the implication "it-speaks-by-itself-through-me" is also a way of foregrounding the anteriority of the tale to the teller, and thereby the merging of the two through a speech-act. Truth is both a construct and beyond it; the balance is played out as the narrator interrogates the truthfulness of the tale and provides multiple answers. *For the little people gamboling under the moonlight, my tale is a fantastic story./ For the women spinning cotton during the long nights of the cold season, my narration is a delightful diversion./ For those with hairy chins and rugged heels, it is a real revelation.* Here, truth and pleasure go hand in hand. A language reduced to the status of instrument and/or of fine style either ignores the "beauty" of language or fetishizes it (as an end point). "Fine behavior (*le bel agir*), and great knowledge are inseparable from beautiful language (*beau language*)" writes, for example,

12

the Malian scholar A. Hampaté Ba, who rejects the common concept of African aesthetics as being merely functional and utilitarian—a concept which he considers to be the product of Western rationale. Poetry, he remarks, is as delicate and as sharp as "a golden thread" weaving through the entire texture of the narration. And why was gold so esoteric before it was attributed a monetary value? Because gold, which is one of the fundamental myths of all of West Africa, is also the only metal "that becomes cotton without being any less iron." Because, "gold is the support of knowledge, but if you confuse knowledge with the support *[le savoir et le socle]*, it will fall on you and crush you" (Hampaté Ba).[2]

A form of mediation, the story and its telling are always adaptive. A narration is never a passive reflection of a reality. At the same time, it must always be truthful if it is to unwind beautifully. Truth, however, is not attained here through logocentric certainties (deriving from the tendency to identify human telos with rationality). The functions of both the tale and the mediator-storyteller are thus introduced at the outset. And, depending on who constitutes its audiences, the story can open onto the fantastic world of the imagination; it can offer a pleasant pastime; or it can engage the listener in a revelatory spiritual/philosophical journey across Fulani ethics and cosmology. *I am therefore at the same time useless, useful, and instructive.* The mediator-storyteller, through whom truth is summoned to unwind itself to the audience, is at once a creator, a delighter, and a teacher. Perhaps, when it is question of both the lie and its truth, and the truth and its lie (if "lie" is what you think a "beautiful language" and a "fantastic story" are), this doubling back which enables the tale to designate itself, leads us not necessarily to the deepest interiority (peculiar to the tradition of Western thought), but also to the "outside" (speech as speech) in which the speaking subject dis/appears. I am useless, useful. The boundaries of lie and truth are thus multiplied, reversed, and displaced without

13

rendering meaningless either the notion of lie or that of truth. Directly questioned, the story is also indirectly unquestionable in its truthfulness. *Unwind it then for us. . . .*

Re-departure: the pain and the frustration of having to live a difference that has no name and too many names already. Marginality: who names? whose fringes? An elsewhere that does not merely lie outside the center but radically striates it. Identity: the singular naming of a person, a nation, a race, has undergone a reversal of values. Effacing it used to be the only means of survival for the colonized and the exiled; naming it today often means declaring solidarity among the hyphenated people of the Diaspora. *But every place she went/ they pushed her to the other side/and that other side pushed her to the other side/ of the other side of the other side/ Kept in the shadows of other* (Gloria Anzaldúa).[3] Identity is a way of re-departing. Rather, the return to a denied heritage allows one to start again with different re-departures, different pauses, different arrivals. Since identity can very well speak its plurality without suppressing its singularity, heterologies of knowledge give all practices of the self a festively vertiginous dimension. It is hardly surprising then that when identity is doubled, tripled, multiplied across time (generations) and space (cultures), when differences keep on blooming within despite the rejections from without, she dares—by necessity. She dares to mix; she dares to cross the borders to introduce into language (verbal, visual, musical) everything monologism has repressed.*"Eres una de las otras." " . . . Don't contaminate us, get away."* *. . . Away, she went away/ but each place she went/ pushed her to the other side, al otro lado* (Anzaldúa).[4] Here again and anew, gender and sexuality: other struggles of borders. The triple oppression of the not-quite-second-sex and the kept-in-the-shadow-of-the-other. *Identity conflict. Uncertainty of the personal me, the national me, the sexual me: lament, endless lament!* (Alicia Dujovne Ortiz).[5] The necessity of re-naming so as to un-name. At times hindered by a somewhat pathetic tendency on the Brother's side

14

to ignore the link between patriarchy and hegemony, and on the Sister's side to pretend that white maternalism is either non-existent or non-discriminating. Other times, disoriented by the unconscious surfacing of the named "homophobic straight mind." *Let us not entrust ourselves to failure. That would only be to indulge nostalgia for success* (Maurice Blanchot).[6] The challenge is thus: how can one re-create without re-circulating domination?

In undoing established models and codes, plurality adds up to no total. *Oh, girl, bailing water by the road's side/ why pour off the moon's golden light?* (Vietnamese Ca Dao). This non-totalness never fails either to baffle or to awaken profound intolerance and anxieties. Every reaching out that remains non-totalizable is a "horizontal vertigo" in which the exploring explored subject can only advance through moments of blindness. Surely, the desire to proceed straightforwardly to a goal, to attain a tangible result, to affirm a concrete social transformation is always active. But a commitment to infinite progress is also a realization that the infinite is what undermines the very notion of (rational) progress. *Tale, told, to be told.* The to- and fro-movement between advancement and regression necessarily leads to a situation where every step taken is at once the first (a step back) and the last step (a step forward)—the only step, in a precise circumstance, at a precise moment of (one's) history. In this context, a work-in-progress, for example, is not a work whose step precedes other steps in a trajectory that leads to the final work. It is not a work awaiting a better, more perfect stage of realization. Inevitably, a work is always a form of tangible closure. But closures need not close off; they can be doors opening onto other closures and functioning as ongoing passages to an elsewhere(-within-here). Like a throw of the dice, each opening is also a closing, for each work generates its own laws and limits, each has its specific condition and deals with a specific context. The closure here, however, is a way of letting the work go rather than of sealing it

15

off. Thus, every work materialized can be said to be a work-in-progress. The notion of a finished work, versus that of an uncompleted work requiring finishing, loses its pertinence. What needs to be reconsidered are these widely adopted and imposed forms of closure whose main function is simply to wrap up a product and facilitate consumption. They create neither a space of serenity nor of fecundity for the mind and body to rest and grow; rather, they naturalize the zone of conformity, where freedom consists of filling in to one's taste and monetary capacity, the pre-assigned slots.

Musicians often say the meaning of music is too precise for words . . . The imperviousness in the West of the many branches of knowledge to everything that does not fall inside their predetermined scope has been repeatedly challenged by its thinkers throughout the years. They extol the concept of decolonization and continuously invite into their fold "the challenge of the Third World." Yet, they do not seem to realize the difference when they find themselves face to face with it—a difference which does not announce itself, which they do not quite anticipate and cannot fit into any single varying compartment of their catalogued world; a difference they keep on measuring with inadequate sticks designed for their own morbid purpose. When they confront the challenge "in the flesh," they naturally do not recognize it as a challenge. Do not hear, do not see. They promptly reject it as they assign it to their one-place-fits-all "other" category and either warily explain that it is "not quite what we are looking for" and that they are not the right people for it; or they kindly refer it to other "more adequate" whereabouts such as the "counter-culture," "smaller independent," "experimental" margins.

They? Yes, they. But, in the colonial periphery (as in elsewhere), we are often them as well. Colored skins, white masks; colored masks, white skins. Reversal strategies have reigned for some time. *They* accept the margins; so do *we*. For without the

margin, there is no center, no heart. *The English and the French precipitate towards us, to look at themselves in our mirror. Following the old colonizers who mixed their blood in their turn, having lost their colonies and their blondness—little by little touched by this swarthy tint spreading like an oil stain over the world—they will come to Buenos Aires in pious pilgrimmage to try to understand how one cannot be, yet always be* (Ortiz).[7] The margins, our sites of survival, become our fighting grounds and their site for pilgrimage. Thus, while we turn around and reclaim them as our exclusive territory, they happily approve, for the divisions between margin and center should be preserved, and as clearly demarcated as possible, if the two positions are to remain intact in their power relations. Without a certain work of displacement, again, the margins can easily recomfort the center in its goodwill and liberalism; strategies of reversal thereby meet with their own limits. The critical work that has led to an acceptance of negativity and to a new positivity would have to continue its course, so that even in its negativity and positivity, it baffles, displaces, rather than suppresses. By displacing, it never allows this classifying world to exert its classificatory power without returning it to its own ethnocentric classifications. All the while, it points to an elsewhere-within-here whose boundaries would continue to compel frenzied attempts at "baptizing" through logocentric naming and objectivizing to reflect on themselves as they face their own constricting apparatus of refined grids and partitioning walls.

The center itself is marginal. *By pointing attention to a feminist marginality, I have been attempting, not to win the center for ourselves, but to point at the irreducibility of the margin in all explanations* (Gayatri Chakravorty Spivak).[8] A woman narrates a displacement as she relentlessly shuttles between the center and the margin. The question is not so much that of loyalty versus betrayal, as that of practicing one's own inventive loyalty towards oneself. *Unless one lives and loves in the trenches it is*

17

difficult to remember that the war against dehumanization is cease-less (Audre Lorde).[9] Marginal by imposition, by choice, by neces-sity. The struggle is always multiple and transversal—specific but not confined to one side of any border war. At the same time as she asserts her difference, she would have to call into question everything which, in the name of the group and the community, perniciously breaks the individual's links with others, while forc-ing her back on herself and restrictively tying her down to her own reclaimed identity. She would have to work with the power effects of numerously varying forms of centralism and of margin-alization. For, how possible is it to undertake a process of decen-tralization without being made aware of the margins within the center and the centers within the margin? Without encountering marginalization from both the ruling center and the established margin? Wherever she goes she is asked to show her identity papers. What side does she speak up for? Where does she belong (politically, economically)? Where does she place her loyalty (sexually, ethnically, professionally)? Should she be met at the center, where they invite her in with much display, it is often only to be reminded that she holds the permanent status of a "foreign worker," "a migrant," or "a temporary sojourner"—a status whose definable location is necessary to the maintenance of a central power. "How about a concrete example from your own culture?" "Could you tell us what it is like in . . . (your country)?" *As a minority woman, I . . . As an Asian-American woman, I . . . As a woman-of-color filmmaker, I . . . As a feminist, a . . . , and a . . . , I . . .* Not foreigner, yet foreign. At times rejected by her own community, other times needfully retrieved, she is both useless and useful. *The irreducibility of the margin in all explanation. The ceaseless war against dehumanization.* This shut-tling in-between frontiers is a working out of and an appeal to another sensibility, another consciousness of the condition of marginality: that in which marginality is the condition of the center.

To use marginality as a starting point rather than an ending point is also to cross beyond it towards other affirmations and negations. There cannot be any grand totalizing integration without massive suppression, which is a way of recirculating the effects of domination. *Liberation opens up new relationships of power, which have to be controlled by practices of liberty* (Michel Foucault).[10] Displacement involves the invention of new forms of subjectivities, of pleasures, of intensities, of relationships, which also implies the continuous renewal of a critical work that looks carefully and intensively at the very system of values to which one refers in fabricating the tools of resistance. The risk of reproducing totalitarianism is always present and one would have to confront, in whatever capacity one has, the controversial values likely to be taken on faith as universal truths by one's own culture(s). "Why don't you show the *poverty* of these people? That's *the* reality!" "Where are the *conflicts* in your film? That's life!" *This world, they had written, was the truth* (Haunani-Kay Trask).[11] Participate or perish. "Why don't they see that it is for their own good that *we* are doing this? We are just trying to *help!*" *I don't believe that this question of "who exercises power?" can be resolved unless that other question "how does it happen?" is resolved at the same time . . . for we know perfectly well that even if we reach the point of designating exactly . . . all those "decision-makers," we will still not really know why and how the decision was made, how it came to be accepted by everybody, and how it is that it hurts a particular category of person, etc.* (Foucault).[12]

A particular category of person. *Lesbos is, in everyone's opinion, a special place. Some say that only Lesbians frequent Lesbos. Others are of the opinion that all the lesbians or companion lovers go there one day or another. The bearers of fables say that they, as a matter of fact, also go to Lesbos.* (Wittig & Zeig).[13] The struggle not only continues to be carried out on many fronts simultaneously. It is also constantly a double-edged fight. In undermining the West

as authoritative subject of knowledge by learning to see into the effects of power and its links with knowledge, competence, and qualification, she also has to fight against backlashing through the defensive revalidation of secrecy, exploitative deformation, self-gratifying mystification, and arrogant anti-intellectualism. There is no arcane place for return. Maintaining the intuitive, emotional Other under the scientistic tutelage of the rational, all-knowing Western Subject is an everlasting aim of the dominant which keeps on renewing itself through a widest range of humanistic discourses. It is difficult for her, she who partakes in theoretical production—albeit as a foreign worker—not to realize the continuing interested desire of the West to conserve itself as sovereign Subject in most of its radical criticism today. *I once overheard a conversation between two white university women: " . . . he is now in the Ethnic Studies Program. You know, they hire these people who may have an inside view of their own cultures, but who are quite unable to provide the objective, scholarly overview that is necessary for a comprehensive understanding of the culture."* She can neither settle down on a dogmatic belief in the value of scientific knowledge nor be content with a relativistic refusal of all verified truth. Decolonization often means dewesternization as taught by the White man. The latter continues to arrogate the right to tell the previously colonized how to unshackle themselves, and to pronounce whether so and so has successfully returned to his or her own kind. *Science . . . is, literally, a power that forces you to say certain things, if you are not to be disqualified not only as being wrong, but, more seriously than that, as being a charlatan* (Foucault).[14] Intimidation is part of the omni-revised strategies of power exerted in the production and legitimation of knowledge. Thus, she would have to reappropriate while resisting the movement of reappropriation that rules the Master's economy. *Right from the moment they venture to speak what they have to say, [women] will of necessity bring about a shift in metalanguage. And I think we're completely crushed, especially in places like universities, by the highly repressive operations of metalan-*

20

guage, the operation that sees to it that the moment women open their mouths—women more often than men—they are immediately asked in whose name and from what theoretical standpoint they are speaking, who is their master and where they are coming from: they have, in short, to salute . . . and show their identity papers (Hélène Cixous).[15]

The story of marginality has taken a long time to be untold. It is neither easy nor difficult, but it can't be stopped in its collective singularities and kaleidoscopic changes. *Anchorage. . . . Everyone laughed at the impossibility of it, / but also the truth. Because who would believe / the fantastic and terrible story of all of our survival / those who were never meant / to survive?* (Joy Harjo).[16] *Man in the Moon. . . . Yesterday he was poor / but tomorrow he says his house / will fill up with silver / the white flesh will fatten on his frame. / Old man, window in a sky / full of holes / I am like you / putting on a new white shirt / to drive away on the fine roads* (Linda Hogan).[17] Displacing is a way of surviving. It is an impossible, truthful story of living in-between regimens of truth. The responsibility involved in this motley in-between living is a highly creative one: the displacer proceeds by unceasingly introducing difference into repetition. By questioning over and over again what is taken for granted as self-evident, by reminding oneself and the others of the unchangeability of change itself. Disturbing thereby one's own thinking habits, dissipating what has become familiar and clichéd, and participating in the changing of received values—the transformation (with/out master) of other selves through one's self. To displace so as not to evade through shortcuts by suppressing or merely excluding. *"Nothing is that simple," [Old Betonie] said, "you don't write off all the white people, just like you don't trust all the Indians. . . . They want us to believe all evil resides with white people. Then we will look no further to see what is really happening. They want us to separate ourselves from white people, to be ignorant and helpless as we watch our own destruction . . . and I tell you, we can deal with white people, with their machines*

21

and their beliefs. We can because we invented white people; it was an Indian witchery that made white people in the first place" (Leslie Marmon Silko).[18]

The war of borders is a war waged by the West on a global scale to preserve its values. Its expression is always associated with seemingly generous motives and the pass-key ideal to provide a "richer," "more meaningful" life for all men. Whereas its by-now-familiar purpose is to spread the Master's values, comforting him in his godlike charity-giver role, protecting his lifestyle, and naturalizing it as the the only, the best way. *The United States idealist turns up in every theater of the war; the teacher, the volunteer, the missioner, the community organizer, the economic developer. Such men define their role as service. . . . They especially are the ones for whom "ingratitude" is the bitter reward* (Ivan Illich)[19] "Don't they see We are only trying to help?!" The compulsion to "help" the needy whose needs one participates in creating and legislating ultimately leads to "bombing people into the acceptance of gifts." Whether the gift is worth the price for which the receiver has to pay, is a long-term question which not every gift giver asks. But it is a non-gratuitous gesture whose perverse participation in systems of dependence gift planners are often well aware of. Thus they the receivers continue to be "ungrateful," for they suspect this is done on the individual level to bolster someone's guilty ego, and on the societal level to allow the Master to have the upper hand on all matters that concern them. The "needy" cannot always afford to refuse, so they persist in accepting ungratefully. And in persisting, they are led to displace themselves. The role of the donor becoming the grateful ones, in need of giving and of acceptance, is not only reversed. For the vitality of the ungrateful receiver lies not in destroying the giver, but in understanding that giving is mutual, and thereby in baffling expectations and unsettling the identification process of giver, given, and gift. Or of sender, receiver, and message. Social change implies a change in formalized values, and

to persist is to maintain despite and against all the strength of a drift and a calm perseverance (in challenging accepted solutions).

Strategies of displacement defy the world of compartmentalization and the systems of dependence it engenders, while filling the shifting space of creation with a passion named wonder. *Who or what the other is, I never know* (Luce Irigaray).[20] Wonder never seizes, never possesses the other as its object. It is in the ability to see, hear, and touch, to go toward things as though always for the first time. The encounter is one that surprises in its unexpected, if not entirely unknown character. It does not provoke conflict, rejection, or acceptance, for it constitutes an empty, "no-baggage" moment in which passion traverses the non-knowing (not ignorant) subject. A passion also dangerously named gift. Gift as no-gift. It "gives a send-off"; it gives the signal to depart. *I think it's more than giving the departure signal, it's really giving, making a gift of, departure, allowing breaks, "parts," partings, separations . . . from this we break with the return-to-self, with the specular relations ruling the coherence, the identification, of the individual* (Cixous).[21] We hardly know how to give. To un-give in giving, that is, to give without obligation or debt involved and, without expecting any form of return. Here, nothing is owed, for there is no donor who is not an acceptor. Who is giving whom? What is exactly given? Maybe something does become no-thing or something else when creation consists of voiding what one has secured, dicing with emptiness, and making with nothing. But what, how, and who are largely context-bound and will always defer from one giver and one receiver to another. Each itinerary taken, each reading constructed is at the same time active in its uniqueness and reflective in its collectivity. Where does the creation begin, where does it end? What if the work materialized is more residue than residence? The gift once circulated is always already a reciprocal gift. It is given as a link of a chain of transmission, as a setting into motion of a dormant

force within us, the very force which allows threads to keep on unwinding, even in periods when dreams are said to dry up, adventures are scorned upon, and novelty has so declined as to lose its magic power.

And she came to the bank of a dark river; and the bank was steep and high. And on it an old man met her, who had a long white beard; and a stick that curled was in his hand, and on it was written Reason. And he asked her what she wanted; and she said "I am woman; and I am seeking for the land of Freedom." And he said, "It is before you". . . . *She said, "How am I to get there?" He said, "There is one way, and one only. Down the banks of Labour, through the water of Suffering. There is no other." She said, "Is there no bridge?" He answered, "None." She said, "Is the water deep?" He said "Deep." She said "Is the floor worn?" He said "It is. Your foot may slip at any time, and you may be lost." She said, "Have any crossed already?" He said, "Some have tried!" She said, "Is there a track to show where the best fording is?" He said "It has to be made." She shaded her eyes with her hand; and she said, "I will go." And he said, "You must take off the clothes you wore in the desert: they are dragged down by them who go into the water so clothed." And she threw from her gladly the mantle of Ancient-received-opinions she wore, for it was worn full of holes. And she took the girdle from her waist that she had treasured so long, and the moths flew out of it in a cloud. And he said, "Take the shoes of dependence off your feet." And she stood there naked, but for one garment that clung close to her. And he said, "That you may keep. So they wear clothes in the Land of Freedom. In the water it buoys; it always swims." (Olive Shreiner)*[22]

She takes delight in detours. Her wandering makes things such that even when Reason is given a (biblical) role, it will have to outplay its own logic. For a permanent sojourner walking bare-footed on multiply de/re-territorialized land, thinking is not always knowing, and while an itinerary engaged in may first appear linearly inflexible—as Reason dictates—it is also capable of taking an abrupt turn, of making unanticipated intricate detours, playing thereby with its own straightness and likewise, outwitting the strategies of its own play.

The myth of pure creativity and expressivity encodes the "natural" to the extent that it equates individualization with commodification. Vision as knowledge is the ideology operating around a notion of interiority which postulates the existence of a central, unshakable certitude. The inner confirmation (with its inner ear, inner eye, inner revelation, inner pursuit, and external materialization, external action, external result) validates itself through concepts of originality, substantiality, essentiality, as well as through its opposites: common sense, mass communication's clarity, visibly measurable outcome, immediate gratification. Things appear to mean something by themselves: it's a Vision of the Artist. It's a Political work. They assume the clarity of statements of fact within the slipping realm of artistic invention and/or information; "Vision" goes without deliberation, and "Political's" authority is taken on faith. The myth does away with all dialectics; it depoliticizes the tools of creation ("Forget ideology; let the work come out from the vision you have; otherwise, it is impure" or, "Forget aesthetics; only bourgeois indulge in the luxury of aesthetic experience"). What is left aside in the perpetuation of such a myth are not questions like: Who is the artist? What is the work? (Where does it fit within the categories of the known?) What does the work mean? What are its origins? (Where does it come from?) Rather, what is passed over or reduced to the technical realm is the question: How is it made? Being as much a product of a language of true inwardness as that of pure surface, the work is both reflective and reflexive. It is the site of interrelations between giver and receiver. Its poetics assumes this double movement, where reflections on what is unique to the artistic form and sets it off from other forms are also reflections on its inability to isolate itself, to prevent itself from participating in the flow of social life, and from engaging in other forms of communication. (Re)creating is thus not a question of talent and of accessibility; but of exactness internal to the problematic of (each) creation. Does it work? How does it work? Always compelling is the desire to unlearn and to thwart

all artistic and discursive forms that attempt at laying hold of its object. A creative event does not grasp, it does not take possession, it is an excursion. More often than not, it requires that one leaves the realms of the known, and takes oneself there where one does not expect, is not expected to be. There is no prescriptive procedure to be applied mechanically (the formula-solutions professionals proudly come up with when questions are raised); no recipes to follow (a "successful" work is always a crucial test for the creating subject, for there could be no following without change and without risk); and no model to emulate (the imperative of having positive models often surges forth in questions like: "Who taught you?," "Who influenced you?," "Who are the artists you admire?").

If you see Buddha, kill the Buddha! (Zen tenet). Rooted and rootless. Each passion, each effort, each event materialized bears with it its own model. Walking on masterless and ownerless land is living always anew the exile's condition; which is here not quite an imposition nor a choice, but a necessity. *You'll learn that in this house it's hard to be a stranger. You'll also learn that it's not easy to stop being one. If you miss your country, every day you'll find more reasons to miss it. But if you manage to forget it and begin to love your new place, you'll be sent home, and then, uprooted once more, you'll begin a new exile* (Blanchot).[23] The work space and the space of creation is where she confronts and leaves off at the same time a world of named nooks and corners, of street signs and traffic regulations, of beaten paths and multiple masks, of constant intermeshing with other bodies'—that are also her own—needs, assumptions, prejudices, and limits.

> *Their names I know not,*
> *But every weed has*
> *Its tender flower.*
> (Sampu)[24]

Illustration on next page.

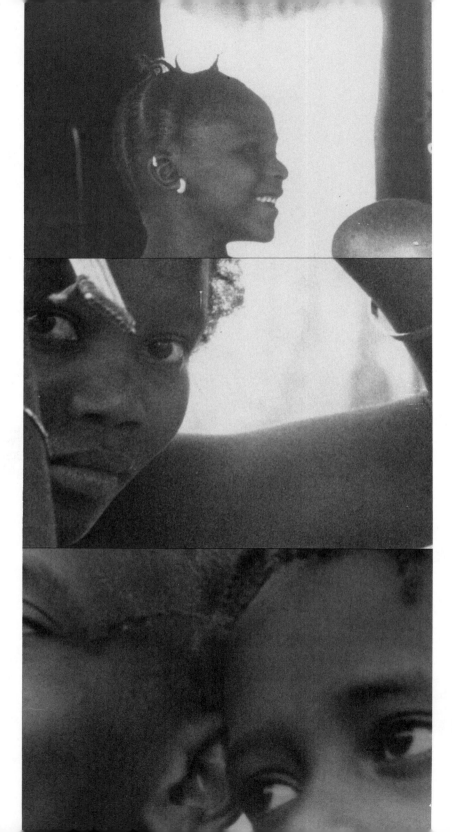

R

2

*The Totalizing Quest of Meaning**

There is no such thing as documentary—whether the term designates a category of material, a genre, an approach, or a set of techniques. This assertion—as old and as fundamental as the antagonism between names and reality—needs incessantly to be restated despite the very visible existence of a documentary tradition. In film, such a tradition, far from undergoing a crisis today, is likely to fortify itself through its very recurrence of declines and rebirths. The narratives that attempt to unify/purify its practices by positing evolution and continuity from one period to the next are numerous indeed, relying heavily on traditional historicist concepts of periodization.

Nothing is poorer than a truth expressed as it was thought.
> —Walter Benjamin[1]

In a completely catalogued world, cinema is often reified into a corpus of traditions. Its knowledge can constitute its destruction, unless the game keeps on changing its rules, never convinced of

* A shorter version of this article has been published as "Documentary Is/Not A Name," *October*, No. 52 (Summer 1990): 76–98.

its closures, and always eager to outplay itself in its own princi-
ples. On the one hand, truth is produced, induced, and extended
according to the regime in power. On the other, truth lies in
between all regimes of truth. As the fable goes, What I tell You
Three Times Is True. To question the image of a historicist ac-
count of documentary as a continuous unfolding does not neces-
sarily mean championing discontinuity; and to resist meaning
does not necessarily lead to its mere denial. Truth, even when
"caught on the run," does not yield itself either in names or in
(filmic) frames; and meaning should be prevented from coming
to closure at what is said and what is shown. Truth and meaning:
the two are likely to be equated with one another. Yet, what is
put forth as truth is often nothing more than *a* meaning. And
what persists between the meaning of something and its truth is
the interval, a break without which meaning would be fixed and
truth congealed. This is perhaps why it is so difficult to talk
about it, the interval. About the cinema. About. The words will
not ring true. Not true, for, what is one to do with films which
set out to determine truth from falsity while the visibility of this
truth lies precisely in the fact that it is false? How is one to cope
with a "film theory" that can never theorize "about" film, but
only *with* concepts that film raises in relation to concepts of other
practices?

> *A man went to a Taoist temple and asked that his fortune be told.*
> *"First," said the priest, "you must donate incense money, otherwise*
> *the divination might not be as accurate as possible. Without such a*
> *donation, in fact, none of it will come true!"*
> —"The Words Will Not Ring True,"
> *Wit and Humor from Old Cathay*[2]

Concepts are no less practical than images or sound. But the
link between the name and what is named is conventional, not
phenomenal. Producing film theory (or rather, philosophizing
with film), which is not making films, is also a practice—a related
but different practice—for theory does have to be (de)constructed

30

as it (de)construes its object of study. While concepts of cinema are not readymades and do not preexist in cinema, they are not theory *about* cinema either. The setting up of practice against theory, and vice-versa, is at best a tool for reciprocal challenge, but like all binary oppositions, it is caught in the net of positivist thinking whose impetus is to supply answers at all costs, thereby limiting both theory and practice to a process of totalization. *I'm sorry, if we're going to use words we should be accurate in our use of them, It isn't a question of technique, it is a question of the material. If the material is actual, then it is documentary. If the material is invented, then it is not documentary. . . . If you get so muddled up in your use of the term, stop using it. Just talk about films. Anyway, very often when we use these terms, they only give us an opportunity to avoid really discussing the film* (Lindsay Anderson).³

In the general effort to analyze film and to produce "theory about film," there is an unavoidable tendency to reduce film theory to an area of specialization and of expertise, one that serves to constitute a *discipline*. There is also advocacy of an Enlightenment and "bourgeois" conception of language, which holds that the means of communication is the word, its object factual, its addressee a human subject (the linear, hierarchical order of things in a world of reification)—whereas, language as the "medium" of communication in its most radical sense, "only communicates itself *in* itself."⁴ The referential function of language is thus not negated, but freed from its false identification with the phenomenal world and from its assumed authority as a means of cognition about that world. Theory can be the very place where this negative knowledge about the reliability of theory's own operative principles is made accessible, and where theoretical categories like all classificatory schemes keep on being voided, rather than appropriated, reiterated, safeguarded.

How true is the film theorist's divination? As Sor Juana Ines de la Cruz (a name among many others) would probably defend

in her devalued status as a woman in the Church, "true" knowledge has to be separated from its instrumental use.[5] The link between money and fact surfaces in the very instances where it either goes unacknowledged or is adamantly denied. The question of quality in accuracy and truth seems to depend largely on the weight or on the quantity of donation money—incense money, as the priest specifies. Indeed, some of the questions invariably burned in film public debates with the filmmaker are: What's the shooting ratio? What's the budget? How long did it take you to complete the film? The higher the bet, the better the product; the larger the amount of money involved, the more valuable the film, the more believable the truth it holds out. The longer the time spent, the more prized the experience, the more reliable the information. Filmwork is made a *de facto* "low-budget" or "big-budget" product. This is what one constantly hears and has come to say it oneself. "Low-tech," "high-tech," "High-class junk," "low-grade footage." Pressure, money, bigness does it all . . . The widespread slogan in factual and "alternative" realms may claim "the larger the grain, the better the politics," but what exclusively circulates in mass media culture is undoubtedly, the money image. Money as money and money as capital are often spoken of as one, not two. The problem of financial constraints is, however, not only a problem of money but also one of control and standardization of images and sounds. Which truth? Whose truth? How true? (Andy Warhol's renowned statement rings very true: "Buying is much more American than thinking.") In the name of public service and of mass communication, the money-making or, rather, money-subjected eye remains glued to the permanent scenario of the effect- and/or production-valued image.

Documentary is said to have come about as a need to inform the people (Dziga Vertov's *Kino-Pravda* or *Camera-Truth*), and subsequently to have affirmed itself as a reaction against the monopoly that the movie as entertainment came to have on the

uses of film. Cinema was redefined as an ideal medium for social indoctrination and comment, whose virtues lay in its capacity for "observing and selecting from life itself," for "opening up the screen on the real world," for photographing "the living scene and the living story," for giving cinema "power over a million and one images," as well as for achieving "an intimacy of knowledge and effect impossible to the shimsham mechanics of the studio and the lily-fingered interpretation of the metropolitan actor" (John Grierson).[6] Asserting its independence from the studio and the star system, documentary has its *raison d'être* in a strategic distinction. It puts the social function of film *on the market*. It takes real people and real problems from the real world and *deals with* them. It *sets a value* on intimate observation and *assesses its worth* according to how well it succeeds in capturing reality on the run, "without material interference, without intermediary." Powerful living stories, infinite authentic situations. There are no retakes. The stage is thus no more no less than life itself. *With the documentary approach the film gets back to its fundamentals. . . . By selection, elimination and coordination of natural elements, a film form evolves which is original and not bound by theatrical or literary tradition. . . . The documentary film is an original art form. It has come to grips with facts—on its own original level. It covers the rational side of our lives, from the scientific experiment to the poetic landscape-study, but never moves away from the factual* (Hans Richter).[7]

The real world: so real that the Real becomes the one basic referent—pure, concrete, fixed, visible, all-too-visible. The result is the elaboration of a whole aesthetic of objectivity and the development of comprehensive technologies of truth capable of promoting what is right and what is wrong in the world, and by extension, what is "honest" and what is "manipulative" in documentary. This involves an extensive and relentless pursuit of naturalism across all the elements of cinematic technology. Indispensable to this cinema of the authentic image and spoken

33

word are, for example, the directional microphone (localizing and restricting in its process of selecting sound for purposes of decipherability) and the Nagra portable tape-recorder (unrivaled for its maximally faithful ability to document). Lip-synchronous sound is validated as the norm; it is a "must"; not so much in replicating reality (this much has been acknowledged among the fact-makers) as in "showing real people in real locations at real tasks." (Even non-sync sounds that are recorded in-context are considered "less authentic" because the technique of sound synchronization and its institutionalized use have become "nature" within film culture.) Real time is thought to be more "truthful" than filmic time, hence the long take (that is, a take lasting the length of the 400 ft. roll of commercially available film stock) and minimal or no editing (change at the cutting stage is "trickery," as if montage did not happen at the stages of conception and shooting) are declared to be more appropriate if one is to avoid distortions in structuring the material. The camera is the switch onto life. Accordingly, the close-up is condemned for its partiality, while the wide angle is claimed to be more objective because it includes more in the frame, hence it can mirror more faithfully the event-in-context. (The more, the larger, the truer—as if wider framing is less a framing than tighter shots.) The light-weight, hand-held camera, with its independence of the tripod—the fixed observation post—is extolled for its ability "to go unnoticed," since it must be at once mobile and invisible, integrated into the milieu so as to change as little as possible, but also able to put its intrusion to use and provoke people into uttering the "truth" that they would not otherwise unveil in ordinary situations.

Thousands of bunglers have made the word [documentary] come to mean a deadly, routine form of film-making, the kind an alienated consumer society might appear to deserve—the art of talking a great deal during a film, with a commentary imposed from the outside,

in order to say nothing, and to show nothing (Louis Marcorelles).[8] The event itself. Only the event; unaffected, unregulated by the eye recording it and the eye watching it. The perfectly objective social observer may no longer stand as the cherished model among documentary-makers today, but with every broadcast the viewer, Everyman, continues to be taught that He is first and foremost a Spectator. Either one is not responsible for what one sees (because only the event presented to him counts) or the only way one can have some influence on things is to send in a monetary donation. Thus, though the filmmaker's perception may readily be admitted as being unavoidably personal, the objectiveness of the reality of what is seen and represented remains unchallenged. *[Cinéma-verité:] it would be better to call it cinema-sincerity. . . . That is, that you ask the audience to have confidence in the evidence, to say to the audience, This is what I saw. I didn't fake it, this is what happened. . . . I look at what happened with my subjective eye and this is what I believe took place. . . . It's a question of honesty* (Jean Rouch).[9]

What is presented as evidence remains evidence, whether the observing eye qualifies itself as being subjective or objective. At the core of such a rationale dwells, untouched, the Cartesian division between subject and object which perpetuates a dualistic inside-versus-outside, mind-against-matter view of the world. The emphasis is again laid on the power of film to capture reality "out there" for us "in here." The moment of appropriation and of consumption is either simply ignored or carefully rendered invisible according to the rules of good and bad documentary. The art of talking to say nothing goes hand in hand with the will to say and to say only to confine something in a meaning. Truth has to be made vivid, interesting; it has to be "dramatized" if it is to convince the audience of the evidence, whose "confidence" in it allows truth to take shape. *Documentary—the presentation of actual facts in a way that makes them credible and telling to people at the time* (William Stott).[10]

35

The real? Or the repeated artificial resurrection of the real, an operation whose overpowering success in substituting the visual and verbal signs of the real for the real itself ultimately helps to challenge the real, thereby intensifying the uncertainties engendered by any clear-cut division between the two. In the scale of what is more and what is less real, subject matter is of primary importance ("It is very difficult if not impossible," says a film festival administrator, "to ask jurors of the documentary film category panel not to identify the quality of a film with the subject it treats"). The focus is undeniably on common experience, by which the "social" is defined: an experience that features, as a famed documentary-maker (Pierre Perrault) put it (paternalistically), "man, simple man, who has never expressed himself."[11]

The socially oriented filmmaker is thus the almighty voice-giver (here, in a vocalizing context that is all-male), whose position of authority in the production of meaning continues to go unchallenged, skillfully masked as it is by its righteous mission. The relationship between mediator and medium or, the mediating activity, is either ignored—that is, assumed to be transparent, as value free and as insentient as an instrument of reproduction ought to be—or else, it is treated most conveniently: by humanizing the gathering of evidence so as to further the status quo. (Of course, like all human beings I am subjective, but nonetheless, you should have confidence in the evidence!) Good documentaries are those whose subject matter is "correct" and whose point of view the viewer agrees with. What is involved may be a question of honesty (vis-à-vis the material), but it is often also a question of (ideological) adherence, hence of legitimization.

Films made about the common people are furthermore naturally promoted as films made for the same people, and only for them. In the desire to service the needs of the un-expressed, there is, commonly enough, the urge to define them and their needs. More often than not, for example, when filmmakers find them-

selves in debates in which a film is criticized for its simplistic and reductive treatment of a subject, resulting in a maintenance of the very status quo which it sets out to challenge, their tendency is to dismiss the criticism by claiming that the film is not made for "sophisticated viewers like ourselves, but for a general audience," thereby situating themselves above and apart from the *real* audience, those "out there," the undoubtedly simpleminded folks who need everything they see explained to them. Despite the shift of emphasis—from the the world of the upwardly mobile and the very affluent that dominates the media to that of "their poor"—, what is maintained intact is the age-old opposition between the creative intelligent supplier and the mediocre unenlightened consumer. The pretext for perpetuating such a division is the belief that social relations are determinate, hence endowed with objectivity. *By "impossibility of the social" I understand . . . the assertion of the ultimate impossibility of all "objectivity" . . . society presents itself, to a great degree, not as an objective, harmonic order, but as an ensemble of divergent forces which do not seem to obey any unified or unifying logic. How can this experience of the failure of objectivity be made compatible with the affirmation of an ultimate objectivity of the real?* (Ernesto Laclau).[12]

The silent common people—those who "have never expressed themselves" unless they are given the opportunity to voice their thoughts by the one who comes to redeem them—are constantly summoned to signify the real world. They are the fundamental referent of the social, hence it suffices to point the camera at them, to show their (industrialized) poverty, or to contextualize and package their unfamiliar lifestyles for the ever-buying and donating general audience "back here," in order to enter the sanctified realm of the morally right, or the social. In other words, when the so-called "social" reigns, how these people(/we) come to visibility in the media, how meaning is given to their (/our) lives, how their(/our) truth is construed or how truth is laid down for them(/us) and despite them(/us), how representation

relates to or *is* ideology, how media hegemony continues its relentless course is simply not at issue.

> *There isn't any* cinéma-vérité. *It's necessarily a lie, from the moment the director intervenes—or it isn't cinema at all. (Georges Franju)*[13]

When the social is hypostatized and enshrined as an ideal of transparency, when it itself becomes commodified in a form of sheer administration (better service, better control), the interval between the real and the image/d or between the real and the rational shrinks to the point of unreality. Thus, to address the question of production relations as raised earlier is endlessly to reopen the question: how is the real (or the social ideal of good representation) produced? Rather than catering to it, striving to capture and discover its truth as a concealed or lost object, it is therefore important also to keep on asking: how is truth being ruled? *The penalty of realism is that it is about reality and has to bother for ever not about being "beautiful" but about being right* (John Grierson).[14] The fathers of documentary have initially insisted that documentary is not News, but Art (a "new and vital art form" as Grierson once proclaimed). That its essence is not information (as with "the hundreds of tweeddle-dum 'industrials' or worker-education films"); not reportage; not newsreels; but something close to "a creative treatment of actuality" (Grierson's renowned definition). *If Joris Ivens has made the most beautiful documentaries that anyone has ever seen, that's because the films are composed, worked out, and they have an air of truth. Sure the documentary part is true, but all around the documentary sections there's an interpretation. And then you can't talk about* cinéma-verité (Georges Franju).[15]

Documentary may be anti-aesthetic, as some still affirm in the line of the British forerunner, but it is claimed to be no less an art, albeit an art within the limits of factuality. (Interpretation, for example, is not viewed as constituting the very process of documenting and making information accessible; it is thought,

38

instead, to be the margin all around an untouched *given* center, which according to Franju is the "documentary part" or "documentary section.") When, in a world of reification, truth is widely equated with fact, any explicit use of the magic, poetic, or irrational qualities specific to the film medium itself would have to be excluded a priori as non-factual. The question is not so much one of sorting out—illusory as this may be—what is inherently factual and what is not, in a body of *pre-existing* filmic techniques, as it is one of abiding by the conventions of naturalism in film. In the reality of formula-films, only validated techniques are *right*, others are de facto wrong. The criteria are all based on their degree of invisibility in producing meaning. Thus, shooting at any speed other than the standard 24-frames-per-second (the speed necessitated for lip-sync sound) is, for example, often condemned as a form of manipulation, implying thereby that manipulativeness has to be discreet—that is, acceptable only when not easily perceptible to the "real audience." Although the whole of filmmaking *is* a question of manipulation—whether "creative" or not—, again, those endorsing the law unhesitantly decree which technique is manipulative and which, supposedly is not; and this judgement is certainly made according to the degree of visibility of each. *A documentary film is shot with three cameras: 1) the camera in the technical sense; 2) the filmmaker's mind; and 3) the generic patterns of the documentary film, which are founded on the expectations of the audience that patronizes it. For this reason one cannot simply say that the documentary film portrays facts. It photographs isolated facts and assembles from them a coherent set of facts according to three divergent schemata. All remaining possible facts and factual contexts are excluded. The naive treatment of documentation therefore provides a unique opportunity to concoct fables. In and of itself, the documentary is no more realistic than the feature film* (Alexander Kluge).[16]

Reality is more fabulous, more maddening, more strangely manipulative than fiction. To understand this, is to recognize the

naivety of a development of cinematic technology that promotes increasing unmediated "access" to reality. It is to see through the poverty of what Benjamin deplored as "a truth expressed as it was thought" and to understand why progressive fiction films are attracted and constantly pay tribute to documentary techniques. These films put the "documentary effect" to advantage, playing on the viewer's expectation in order to "concoct fables." (Common examples of this effect include: the feeling of participating in a truth-like moment of reality captured despite the filmed subject; the sense of urgency, immediacy, and authenticity in the instability of the hand-held camera; the newsreel look of the grainy image; and the oral-testimony-like quality of the direct interview—to mention just a few.)

The documentary can thus easily become a "style": it no longer constitutes a mode of production or an attitude toward life, but proves to be only an element of aesthetics (or anti-aesthetics)— which at best and without acknowledging it, it tends to be in any case when, within its own factual limits, it reduces itself to a mere category, or a set of persuasive techniques. Many of these techniques have become so "natural" to the language of broadcast television today that they "go unnoticed." These are, for example: the "personal testimony" technique (a star appears on screen to advertise his/her use of a certain product); the "plain folks" technique (a politician arranges to eat hot dogs in public); the "band wagon" technique (the use of which conveys the message that "everybody is doing it, why not you?"); or the "card stacking" technique (in which prearrangements for a "survey" shows that a certain brand of product is more popular than any other to the inhabitants of a given area).[17]

You must re-create reality because reality runs away; reality denies reality. You must first interpret it, or re-create it. . . . When I make a documentary, I try to give the realism an artificial aspect. . . . I find that the aesthetic of a document comes from the artificial aspect of the document . . . it has to be more beautiful than realism,

and therefore it has to be composed . . . to give it another sense (Franju).[18] A documentary aware of its own artifice is one that remains sensitive to the flow between fact and fiction. It does not work to conceal or exclude what is normalized as "non-factual," for it understands the mutual dependence of realism and "artificiality" in the process of filmmaking. It recognizes the necessity of composing (on) life in living it or making it. Documentary reduced to a mere vehicle of facts may be used to advocate a cause, but it does not constitute one in itself; hence the perpetuation of the bipartite system of division in the content-versus-form rationale.

To compose is not always synonymous with ordering-so-as-to-persuade, and to give the filmed document another sense, another meaning, is not necessarily to distort it. If life's paradoxes and complexities are not to be suppressed, the question of degrees and nuances is incessantly crucial. Meaning can therefore be political only when it does not let itself be easily stabilized, and, when it does not rely on any single source of authority, but rather, empties it, or decentralizes it. Thus, even when this source is referred to, it stands as one among many others, at once plural and utterly singular. In its demand to *mean* at any rate, the "documentary" often forgets how it comes about and how aesthetics and politics remain inseparable in its constitution. For, when not equated with mere techniques of beautifying, aesthetics allows one to experience life differently or, as some would say, to give it "another sense," remaining in tune with its drifts and shifts.

> *It must be possible to represent reality as the historical fiction it is. Reality is a paper-tiger. The individual does encounter it, as fate. It is not fate, however, but a creation of the labor of generations of human beings, who all the time wanted and still want something entirely different. In more than one respect, reality is simultaneously real and unreal.* (Alexander Kluge)[19]

From its descriptions to its arrangements and rearrangements, reality on the move may be heightened or impoverished but it is

41

never neutral (that is, objectivist). *Documentary at its purest and most poetic is a form in which the elements that you use are the actual elements* (Lindsay Anderson).[20] Why, for example, use the qualifying term "artificial" at all? In the process of producing a "document," is there such a thing as an artificial aspect that can be securely separated from the true aspect (except for analytical purpose—that is, for another "artifice" of language)? In other words, is a closer framing of reality more artificial than a wider one? The notion of "making strange" and of reflexivity remains but a mere distancing device so long as the division between "textual artifice" and "social attitude" exerts its power.[21] The "social" continues to go unchallenged, history keeps on being salvaged, while the sovereignty of the socio-historicizing subject is safely maintained. With the status quo of the making/consuming subject preserved, the aim is to correct "errors" (the false) and to construct an alternative view (offered as a this-is-the-true- or mine-is-truer version of reality). It is, in other words, to replace one source of unacknowledged authority by another, but not to challenge the very constitution of authority. The new socio-historical text thus rules despotically as another master-centered text, since it unwittingly helps to perpetuate the Master's ideological stance.

When the textual and the political neither separate themselves from one another nor simply collapse into a single qualifier, the practice of representation can, similarly, neither be taken for granted, nor merely dismissed as being ideologically reactionary. By putting representation under scrutiny, textual theory-practice has more likely helped to upset rooted ideologies by bringing the mechanics of their workings to the fore. It makes possible the vital differentiation between authoritative criticism and uncompromising analyses and inquiries (including those of the analyzing/inquiring activity). Moreover, it contributes to the questioning of reformist "alternative" approaches that never quite depart from the lineage of white- and male-centered humanism. Despite their explicit socio-political commitment,

42

these approaches remain unthreatening—that is, "framed," and thus neither social nor political enough.

Reality runs away, reality denies reality. Filmmaking is after all a question of "framing" reality in its course. However, it can also be the very place where the referential function of the film image/sound is not simply negated, but reflected upon in its own operative principles and questioned in its authoritative identification with the phenomenal world. In attempts at suppressing the mediation of the cinematic apparatus and the fact that language "communicates itself in itself," there always lurks what Benjamin qualified as a "bourgeois" conception of language. *Any revolutionary strategy must challenge the depiction of reality . . . so that a break between ideology and text is effected* (Claire Johnston).[22]

To deny the *reality* of film in claiming (to capture) *reality* is to stay "in ideology"—that is, to indulge in the (deliberate or not) confusion of filmic with phenomenal reality. By condemning self-reflexivity as pure formalism instead of challenging its diverse realizations, this ideology can "go on unnoticed," keeping its operations invisible and serving the goal of universal expansionism. Such aversion for self-reflexivity goes hand in hand with its widespread appropriation as a progressive formalistic device in cinema, since both work to reduce its function to a harmlessly decorative one. (For example, it has become commonplace to hear such remarks as "A film is a film" or, "This is a film about a film." Film-on-film statements are increasingly challenging to work with as they can easily fall prey to their own formulas and techniques.) Furthermore, reflexivity at times equated with personal view, is at other times endorsed as scientific rigor.

Two men were discussing the joint production of wine. One said to the other: "You shall supply the rice and I the water." The second asked: "If all the rice comes from me, how shall we apportion the finished product?" The first man replied: "I shall be absolutely fair about the whole thing. When the wine is finished, each gets back

exactly what he puts in—I'll siphon off the liquid and you can keep the rest."
 —"Joint Production," *Wit and Humor from Old Cathay*[23]

One of the areas of documentary that remains most resistant to the reality of film as film is that known as anthropological filmmaking. Filmed ethnographic material, which was thought to "replicate natural perception," has now renounced its authority to replicate only to purport to provide adequate "data" for the "sampling" of culture. The claim to objectivity may no longer stand in many anthropological circles, but its authority is likely to be replaced by the sacrosanct notion of the "scientific." Thus the recording and gathering of data and of people's testimonies are considered to be the limited aim of "ethnographic film." What makes a film anthropological and what makes it scientific is, tautologically enough, its "scholarly endeavour [to] respectively document and interpret according to anthropological standards."[24] Not merely ethnographic nor documentary, the definition positively specifies, but scholarly and anthropologically. The fundamental scientific obsession is present in every attempt to demarcate anthropology's territories. In order to be scientifically valid, a film needs the scientific intervention of the anthropologist, for it is only by adhering to the body of conventions set up by the community of anthropologists accredited by their "discipline" that the film can hope to qualify for the classification and be passed as a "scholarly endeavour."

The myth of science impresses us. But do not confuse science with its scholasticism. Science finds no truths, either mathematized or formalized; it discovers unknown facts that can be interpreted in a thousand ways (Paul Veyne).[25] One of the familiar arguments given by anthropologists to validate their prescriptively instrumental use of film and of people is to dismiss all works by filmmakers who are "not professional anthropologists" or "amateur ethnographers" under the pretext that they are not "anthropologically informed," hence they have "no theoretical significance

from an anthropological point of view." To advance such a bla-
tantly self-promoting rationale to institute *a deadly routine form
of filmmaking* (to quote a sentence of Marcorelles once more) is
also—through anthropology's primary task of "collecting data"
for knowledge of mankind—to try to skirt what is known as the
salvage paradigm and the issues implicated in the "scientific"
deployment of Western world ownership.[26] The stronger anthro-
pology's insecurity about its own project, the greater its eager-
ness to hold up a normative model, and the more seemingly
serene its disposition to dwell in its own blind spots.

In the sanctified terrain of anthropology, all of filmmaking is
reduced to a question of methodology. It is demonstrated that
the reason anthropological films go further than ethnographic
films is because they do not, for example, just show activities
being performed, but they also *explain* the "anthropological sig-
nificance" of these activities (significance that, despite the disci-
plinary qualifier "anthropological," is de facto identified with
the meaning the natives give them themselves). Now, obviously,
in the process of fixing meaning, not every explanation is valid.
This is where the role of the expert anthropologist comes in
and where methodologies need to be devised, legitimated, and
enforced. For, if a non-professional explanation is dismissed
here, it is not so much because it lacks insight or theoretical
grounding, as because it escapes anthropological control; it lacks
the seal of approval from the anthropological order. In the name
of science, a distinction is made between reliable and non-reli-
able information. Anthropological and non-anthropological ex-
planations may share the same subject matter, but they differ in
the way they produce meaning. The unreliable constructs are
the ones that do not obey the rules of anthropological authority,
which a concerned expert like Evans-Pritchard skillfully speci-
fies as being nothing else but "a scientific habit of mind."[27] Sci-
ence defined as the most appropriate approach to the object of
investigation serves as a banner for every scientistic attempt to

45

promote the West's paternalistic role as subject of knowledge and its historicity of the Same. *The West agrees with us today that the way to Truth passes by numerous paths, other than Aristotelian Thomistic logic or Hegelian dialectic. But social and human sciences themselves must be decolonized* (E. Mveng).[28]

In its scientistic "quest to make meaning," anthropology constantly reactivates the power relations embedded in the Master's confident discourses on Himself and His Other, thereby aiding both the *centri* petal and *centri* fugal movement of their global spread. With the diverse challenges issued today to the very process of producing "scientific" interpretation of culture as well as to that of making anthropological knowledge possible, visually oriented members of its community have come up with an epistemological position in which the notion of reflexivity is typically reduced to a question of technique and method. Equated with a form of self-exposure common in field work, it is discussed at times as *self-reflectivity* and at other times condemned as individualistic idealism sorely in need of being controlled if the individual maker is not to loom larger than the scientific community or the people observed. Thus, "being reflexive is virtually synonymous with being scientific."[29]

The reasons justifying such a statement are many, but one that can be read through it and despite it is: as long as the maker abides by a series of "reflexive" techniques in filmmaking that are devised for the purpose of exposing the "context" of production and as long as the required techniques are method(olog)-ically carried out, the maker can be assured that "reflexivity" is elevated to that status of scientific rigor. These reflexive techniques would include the insertion of a verbal or visual narrative about the anthropologist, the methodology adopted, and the condition of production—in other words, all the conventional means of validating an anthropological text through the disciplinary practice of head- and footnoting and the totalistic concept of pre-production presentation. Those who reject such a rationale do so out of a preoccupation with the "community of scientists,"

whose collective judgment they feel should be the only true form of reflection. For an individual validation of a work can only be suspicious because it "ignores the historical development of science." In these constant attempts at enforcing anthropology as (a) discipline and at recentering the dominant representation of culture (despite all the changes in methodologies), what seems to be oddly suppressed in the notion of reflexivity in filmmaking is its practice as processes to prevent meaning from ending with what is said and what is shown—as inquiries into production relations—thereby to challenge representation itself while emphasizing the reality of the experience of film as well as the important role that reality plays in the lives of the spectators.

Unless an image displaces itself from its natural state, it acquires no significance. Displacement causes resonance. (Shanta Gokhale).[30]

After his voluntary surrender, Zheng Guang, a pirate operating off the coast of Fujian, was to be given an official post (in return for surrendering). When a superior instructed him to write a poem, Zheng replied with a doggerel: "No matter whether they are civil or military officials they are all the same. The officials assumed their posts before becoming thieves, but I, Zheng Guang, was a thief before becoming an official."

—"The Significance of Officialdom,"
Wit and Humor from Old Cathay[31]

As an aesthetic closure or an old relativizing gambit in the process nonetheless of absolutizing meaning, reflexivity proves critically in/significant when it merely serves to refine and to further the accumulation of knowledge. No going beyond, no elsewhere-within-here seems possible if the reflection on oneself is not at one and the same time the analysis of established forms of the social that define one's limits. Thus to drive the self into an abyss is neither a moralistic stricture against oneself (for future improvement), nor a task of critique that humanizes the decoding self but never challenges the very notion of self and decoder. Left intact in its positionality and its fundamental urge

47

to decree meaning, the self conceived both as key and as transparent mediator, is more often than not likely to turn responsibility into license. The license to *name,* as though meaning presented itself to be deciphered without any ideological mediation. As though specifying a context can only result in the finalizing of what is shown and said. As though naming can stop the process of naming—that very abyss of the relation of self to self.

The bringing of the self into play necessarily exceeds the concern for human errors, for it cannot but involve as well the problem inherent in representation and communication. Radically plural in its scope, reflexivity is thus not a mere question of *rect*ifying and *just*ifying. (*Subject*ivizing.) What is set in motion in its praxis are the self-generating links between different forms of reflexivity. Thus, a subject who points to him/her/itself as subject-in-process, a work that displays its own formal properties or its own constitution as work, is bound to upset one's sense of identity—the familiar distinction between the Same and the Other since the latter is no longer kept in a recognizable relation of dependence, derivation, or appropriation. The process of self-constitution is also that in which the self vacillates and loses its assurance. The paradox of such a process lies in its fundamental instability; an instability that brings forth the disorder inherent to every order. The "core" of representation is the reflexive interval. It is the place in which the play within the textual frame is a play on this very frame, hence on the borderlines of the textual and extra-textual, where a positioning within constantly incurs the risk of de-positioning, and where the work, never freed from historical and socio-political contexts nor entirely subjected to them, can only be itself by constantly risking being no-thing.

A work that reflects back on itself offers itself infinitely as nothing else but work . . . *and* void. Its gaze is at once an impulse that causes the work to fall apart (to return to the initial no-work-ness) and an ultimate gift to its constitution. A gift, by which the work is freed from the tyranny of meaning as well as

from the omnipresence of a subject of meaning. To let go of the hold at the very moment when it is at its most effective is to allow the work to live, and to live on independently of the intended links, communicating itself in itself like Benjamin's "the self is a text"—no more no less "a project to be built."[32] *Orpheus' gaze . . . is the impulse of desire which shatters the song's destiny and concern, and in that inspired and unconcerned decision reaches the origin, consecrates the song* (Maurice Blanchot).[33]

Meaning can neither be imposed nor denied. Although every film is in itself a form of ordering and closing, each closure can defy its own closure, opening onto other closures, thereby emphasizing the interval between apertures and creating a space in which meaning remains fascinated by what escapes and exceeds it. The necessity to let go of the notion of intentionality that dominates the question of the "social" as well as that of creativity cannot therefore be confused with the ideal of nonintervention, an ideal in relation to which the filmmaker, trying to become as invisible as possible in the process of producing meaning, promotes empathic subjectivity at the expense of critical inquiry even when the intention is to show and to condemn oppression. *It is idealist mystification to believe that "truth" can be captured by the camera or that the conditions of a film's production (e.g. a film made collectively by women) can* of itself *reflect the conditions of its production. This is mere utopianism: new meaning has to* be manufactured *within the text of the film. . . . What the camera in fact grasps is the "natural" world of the dominant ideology* (Claire Johnston).[34]

In the quest for totalized meaning and for knowledge-for-knowledge's sake, the worst meaning is meaninglessness. A Caucasian missionary nun based in a remote village of Africa qualifies her task in these simple, confident terms: "We are here to help people give meaning to their lives." Ownership is monotonously circular in its give-and-take demands. It is a monolithic view of the world whose irrationality expresses itself in the imperative of both giving and meaning, and whose irreality manifests itself

in the need to require that visual and verbal constructs yield meaning down to their last detail. *The West moistens everything with meaning, like an authoritarian religion which imposes baptism on entire peoples* (Roland Barthes).[35] Yet such illusion is real; it has its own reality, one in which the subject of Knowledge, the subject of Vision, or the subject of Meaning continues to deploy established power relations, assuming Himself to be the basic reserve of reference in the totalistic quest for the referent, the true referent that lies out there in nature, in the dark, waiting patiently to be unveiled and deciphered correctly. To be redeemed. Perhaps then, an imagination that goes toward the texture of reality is one capable of playing upon the illusion in question and the power it exerts. The production of one irreality upon the other and the play of non-sense (which is not mere meaninglessness) upon meaning may therefore help to relieve the basic referent of its occupation, for the present situation of critical inquiry seems much less one of attacking the illusion of reality as one of displacing and emptying out the establishment of totality.

Illustration on next page.

SV

3

Mechanical Eye, Electronic Ear, and the Lure of Authenticity*

Some call it Documentary. i call it No Art, No Experiment, No Fiction, No Documentary. To say some thing, no thing, and allow reality to enter. Capture me. This, i feel, is no surrender. Contraries meet and mate and i work best at the limits of all categories.

In the quest for a scientific use of film, there is, typically, a tendency to validate certain technical strategies, in order to ensure the defense of the ideological neutrality of the image. The purposeful, object-oriented camera eye does not allow any filmed event to be simply fortuitous. Everything must be bathed with meaning.

* Paper delivered at "The Documentary Today: A Symposium," Film in the Cities (Minneapolis), 10–12 November, 1983. First published in *Wide Angle*, Vol. 6, No. 2 (1984).

Translated or scientifically interpreted. Contrary to what many writers on documentary films have said, the striving for verisimilitude and for that "authentic" contact with "lived" reality is precisely that which links "factual" ("direct" and "concrete" according to another classification) films to studio-made films and blurs their line of distinction. Both types perpetuate the myth of cinematic "naturalness," even though one tries its best to *imitate* life while the other claims to *duplicate it*. THIS IS HOW IT IS. Or was. The unfolding scene is captured, not only by an individual, but also by a mechanical device. The mechanical bears testimony to its true existence and is a guarantee of objectivity. "Seeing is believing." The formula, dear to both fictional and factual films, assumes that cinema's role remains that of hypnotizing and propagandizing. The more sophisticated the recording technology, the closer to the real the film practice is said to be. (Documentary) films that appeal to the objective, scientific mind are those eager to "tie cinematic language to scientific rigor." With the development of an increasing,

Reassemblage. From silences to silences, the fragile essence of each fragment sparks across the screen, subsides and takes flight. Almost there, half named.

There is no hidden unity to be grasped. Yours. Perhaps a plural moment of meeting or a single significant note, on the run. To seize it as substance is to mistake the footprints made by the

unobtrusive technology, the human eye is expected to identify with the camera eye and its mechanical neutrality. The film-maker/camera-operator should either remain as absent as possible from the work, masking thereby the constructed meaning under the appearance of the naturally given meaning, or appear in person in the film so as to guarantee the authenticity of the observation. Such a boldness or a concession (depending on how you interpret it) denotes less a need to acknowledge the subjectivity of an individual's point of view (if it does, it is bound to be a very simplistic solution to the problem of subject and power), than a desire to marry impersonal observation and personal participation. This happy synthesis of the "universal scientific" and the "personal humanist" is thought to result in a greater humanity and at the same time a greater objectivity. In the progression toward Truth, it seems clear that one can only gain, never lose. First, conform to scientific demands, then show scientists are also human beings. The order is irreversible. And the ideology adopted is no other than that of *capturing*

shoes for the shoes themselves. To fix it as pure moment pure note is to restore it to the void.

The nature of many questions asked leads inescapably to intention-oriented answers. On the frontline, every single intervention on my side has its reason of being. True. But the truth of reason is not necessarily the reality of the lived. Filming supposes as much premeditation as experimentation. Intentionally unintentional then?

The fools are interesting people, a film says. And i look outside. Can't do without rest. Can't the fools be fools too?

We all see differently. How can it be otherwise when

55

movement (objects) of *life* or restituting it (them) in a raw manner, and revealing the authentic reality by a neutral camera as well as a neutral cineaste, whose role is to interfere/participate as little as possible, therefore to hide technologically as much as feasible. Human interventions in the filming and editing process are carried out "scientifically" and reduced to a minimum. The cineaste still selects the framing, lighting (be it natural or artificial), focus, speed, but s/he should follow validated technical strategies and avoid all montage—regarded as an artifice likely to compromise the authenticity of the work. The question at issue is that of greater or lesser falsification. Although the selection and treatment of the material being filmed already indicate the side s/he chooses (with its ideological bias and constraints), *lesser* falsification—such as editing in the camera (sic) or exposing cuts as black spaces in the structure of the film—often implies *no* falsification. At least, this is what one senses through many documentary filmmakers' discourse and what their works connote. For despite their denial of conventional notions of objectivity

images no longer illustrate words and words no longer explain images? Which progression? Which folding?

What self expression? i mis-express myself more than it mis-expresses me. Impresses itself on me. Until it enters. Penetrates. Ensnares. Now i see and hear myself decensoring.

Jump-cuts; jerky, unfinished, insignificant pans; split faces, bodies, actions, events, rhythms, rhythmized images, slightly off the beat, discord; irregular colors, vibrant, saturated, or too bright; framing and re-

56

and contempt for romantic naturalism, they continue to ask: how can we be more objective?, better *capture the essence?*, "see them as they see each other?" and "*let them* speak for themselves?" Among the validated strategies that reflect such a yearning and state of mind are: the long take, hand-held camera, sync-sound (authentic sound) overlaid with omniscient commentary (the *human science* rationale), wide-angle lens, and anti-aestheticism (the natural versus the beautiful, or the real/native versus the fictional/foreign). To value the long take as an attempt at eliminating distortions is, in a way, to say that life is a continuous process with no ruptures, no blanks, no blackouts. The longer, the truer. Hollywoodian montage also aims at the same: building up the illusion of continuity and immortality. For death strolls between images and what advanced technology holds out to us are the prospects of longer and longer life. The fusing of real time and film time may denote an intent to challenge the codes of cinematic tricks as well as a rigor in working with limitations. But the long take is rarely used as a principle of construc-

framing, hesita. tences on sentences, looped phrases, snatches of conversations, cuts, broken lines, words; repetitions; silences; chasing camera; squatting position; a look for a look; questions, returned questions; silences.

For many of us, the best way to be neutral and objective is to copy reality meticulously. Repeated.

Discontinuity begins with non-cleavages. Inside/outside, personal/impersonal, subjectivity/objectivity.

57

tion in itself, involving not only the length but also the quality and structure of shot. In most cases, it is defended on the grounds of its temporal *realism*, and the goal pursued remains chiefly that of preventing reality from being falsely interpreted or deformed through the removal of expressive editing techniques. The same may be said of the hand-held camera. Emphasis, here again, is laid on coherence of cinematic space, not on discontinuity (the hand-held camera can be used precisely to deny and shatter that coherence). The traveling shot gives the image a touch of authenticity: the movements of the person filming and those of the camera are said to intermingle, even though nothing in the result yielded seems to suggest a radical departure from the conventional realist account of an action. Walking about with the camera does provide the camera-operator with greater freedom of movement, hence greater ability to catch people either unaware or acting naturally, that is to say while they are still "alive." The camera changes situations, especially when it remains static on a tripod, and when the operator has

They can't do without cleavages. i always blink when i look. Yet they pretend to gaze at it for you ten minutes, half an hour without blinking. And i often take back what i've just shown, for i wish i had made a better choice. How do you go about framing life? We linger on, believing everything we show is worth showing. "Worth?"

That's not imposing, that's sharing. i frequently accept similar formulas . . .

58

to move from one "observation post" to another. But what so often goes unchallenged here—in the tripod as well as hand-held camera—is the assumed need to offer several views of the same subject/object from different angles, to follow or circle him/her/it; and the exigency for an identification between the camera's eye and the spectator's eye, as well as for a "perfect balance" between the movements of the camera/operator and those of the subjects being filmed. Omniscience. The synchronous recording of image and sound further reinforces the authentic contact with the lived and living reality. Given the present state of technology, the use of sync-sound has become almost mandatory in all factual films. So has the practice of translating and subtitling the words of the informants. There is a certain veneration for the real sound of the film (an electronic sound that is often spoken of as if it is "real life" sound) and for the oral testimony of the people filmed. There is also a tendency to apprehend language exclusively as Meaning. IT HAS TO MAKE SENSE. WE WANT TO KNOW WHAT THEY THINK

"Breaking rules" still refers to rules.

On the lookout for "messages" that may be wrested from the objects of observation.

Music is the opium of cinema.

Why not put in some natural sounds instead of silences? someone asks.

Images. Not only images, but images and words that defy words and com-

AND HOW THEY FEEL. Making a film on/about the "others" consists of allowing them paternalistically "to speak for themselves" and, since this proves insufficient in most cases, of completing their speech with the insertion of a commentary that will objectively describe/interpret the images according to a scientific-humanistic rationale. Language as voice and music—grain, tone, inflections, pauses, silences, repetitions—goes underground. Instead, people from remote parts of the world are made accessible through dubbing/subtitling, transformed into English-speaking elements and brought into conformity with a definite mentality. This is astutely called "giving voice"—literally meaning that those who are/need to *be given* an opportunity to speak up never had a voice before. Without their benefactors, they are bound to remain non-admitted, non-incorporated, therefore, unheard. One of the strategies that has been gaining ground in ethnographic cinema is the extensive if not exclusive use of the wide angle. Here again, the wide angle is favored for its ability to reduce false interpretations and is par-

mentary.

A sliding relation between ear and eye. Repetitions are never identical.

To say nothing, no thing, and shut that spinning verbal top.
Or shatter that outer, inner speech, which fills in every time space, allowing me to exist as a crystallized I.

Hear with that mechanical eye and see with that electronic ear. The text is not meant to duplicate or strengthen the verisimilitude of the images. It can,

60

ticularly valued by filmmakers concerned with, for example, indigenous peoples' complex kinship structures and their notions of the community, the group, or the family. This time, the creed is: the wider, the truer. Close-ups are too partial; the camera that focuses on an individual or a group proves to be heavily biased, for it fails to relate that person's or that group's activities to those of their kin. So goes the reasoning, as if a larger frame (one that contains more) is less of a frame, as if the wide angle does not, like the close-up, cut off life. Moreover, the wide angle is known to distort images. Thus, when it is used exclusively and unquestionably throughout a film, even in instances where there is only one person in front of the camera, it voluntarily deforms the figures of the subjects, giving the spectator the impression of looking constantly through an aquarium. Some filmmakers will not hesitate to answer to this that the aesthetic quality of the visuals is of secondary importance. No Art here. A beautiful shot is apt to lie, while a bad shot "is a guarantee of authenticity," one that loses in attractiveness but gains in truth.

at best, strip them of their usual chatter.

The tyranny of the camera goes unchallenged. Instead of alleviating it and acknowledging it, many declare it arrogant and walk on unpressured.

Surely, "there is more to Art than the straightness of lines and the perfection of images." Similarly, there must be more to Life than analogy and accumulation of the real.

A fiction of security. When i spoke about relationships i was immediately asked: "between what?" i have always thought "within what?"

61

Which truth, finally? And which reality, when "life" and "art" are perceived dualistically as two mutually exclusive poles? When *dead*, shallow, un-imag-inative images are validated on pre-text of their "capturing *life* directly?" It is, perhaps, precisely the claim to catch life in its motion and show it "as it is" that has led a great number of "documentarians" not only to present "bad shots," but also to make us believe that life is as dull as the images they project on the screen. Beauty for beauty's sake sounds hopelessly sterile in today's context of filmmaking. However, between a film that is not slick (that is to say not concerned with aestheticism per se), one that wallows in natural romanticism, and one that mechanically or lifelessly records the seen, there are differences. And differences, I believe, never offer two absolute oppositions.

For "between" can be endless, starting from you and me, camera/filmmaker/ spectator/events/persons filmed/images/sound/ silence/music/language/ color/texture/links/cuts/ sequences/ . . .

The very effort will kill it.

They only speak their own language and when they hear foreign sounds—no language to their ear—they walk off warily, saying: "It's not deep enough, we haven't learned anything."

Illustration on next page.

NS

4

*Outside In Inside Out**

An objective constantly claimed by those who "seek to reveal one society to another" is "to grasp the native's point of view" and "to realize *his* vision of *his* world." Fomenting much discord, in terms of methodology and approach, among specialists in the directly concerned fields of anthropology and ethnographic filmmaking in the last decade, such a goal is also diversely taken to heart by many of us who consider it our mission to represent others, and to be their loyal interpretors. The injunction to see things from the native's point of view speaks for a definite ideology of truth and authenticity; it lies at the center of every polemical discussion on "reality" in its relation to "beauty" and "truth." To raise the question of representing the Other is, therefore, to reopen endlessly the fundamental issue of science and art; documentary and fiction; universal and personal; objectivity and subjectivity; masculine and feminine; outsider and insider.

Knowledge about often gives the illusion of knowledge.

* Paper delivered at the Conference "Third Cinema: Theories and Practices," Edinburgh International Film Festival, August 1986. First published in *Questions of Third Cinema*, ed. J. Pines and P. Willemen (London: British Film Institute, 1988).

Zora Neale Hurston wrote years ago how amazed she was by the Anglo-Saxon's lack of curiosity about the internal lives and emotions of blacks, and more generally speaking, of any non-Anglo-Saxon peoples. Although this still largely holds true today, one is more inclined to restate this differently by saying that one is presently more amazed by the general claim of Western "experts" to be interested just in that aspect of the Other's life and in not much else. The final aim now is "to uncover the Javanese, Balinese, or Moroccan sense of self," supposedly through the definitions they have of themselves. Things often look as though they have radically changed; whereas they may have just taken on opposite appearances, as they so often do, to shuffle the cards and set people on a side track. The move from obnoxious exteriority to obtrusive interiority, the race for the so-called *hidden* values of a person or a culture, has given rise to a form of legitimized (but unacknowledged as such) voyeurism and subtle arrogance—namely, the pretense to see into or to *own* the others' *minds*, whose *knowledge* these others cannot, supposedly, have themselves; and the need to define, hence confine, providing them thereby with a standard of self-evaluation on which they necessarily depend. Psychological *conflicts*, among other idiosyncratic elements, are thus equated with *depth* (a keyword of Occidental metaphysics), while *inner* experience is reduced to subjectivity as *personal* feelings and views.

"How it Feels to Be Colored Me"[1]
How Does it Feel to Be White You?

A good, serious film about the Other must show some kind of conflict, for this is how the West often defines identities and differences. To many scientifically oriented filmmakers, seeing ironically continues to be believing. Showing is not showing how I can see you, how you can see me, and how we are both being perceived—the encounter—but how you see yourself and represent your own kind (at best, through conflicts)—the Fact by itself. Factual authenticity relies heavily on the Other's words and

testimony. To authenticate a work, it becomes therefore most important to prove or make evident how this Other has participated in the making of his/her own image; hence, for example, the prominence of the string-of-interviews style and the talking-heads, oral-witnessing strategy in documentary film practices. This is often called "giving voice," even though these "given" voices never truly form the Voice of the film, being mostly used as devices of legitimation whose random, conveniently given-as and taken-for-granted authority often serves as compensation for a filmic Lack (the lack of imag-ination or of believability, for example). Power creates its very constraints, for the Powerful is also necessarily defined by the Powerless. Power therefore has to be shared ("shared anthropology" is a notion that has been tossed around for a try), so that its effect may continue to circulate; but it will be shared only partly, with much caution, and on the condition that the share is *given*, not taken. A famed anthropologist thus voiced the crisis existing in his field when he wrote: "where are we when we can no longer claim some unique form of psychological closeness, a sort of transcultural identification with our subjects?"[2] Surely, the man has to keep his role alive. And, after all, there is always some truth in every error.

> "The matter is one of degree, not polar opposition . . . Confinement to experience-near concepts leaves an ethnographer awash in immediacies, as well as entangled in vernacular. Confinement to experience-distant ones leaves him stranded in abstractions and smothered in jargon. The real question, and the one . . . in the case of 'natives,' you don't have to be one to know one, is what roles the two sorts of concepts play in anthropological analysis."[3]

However, "to put oneself into someone else's skin" is not without difficulty. The risk the man fears for himself as well as for his fellowmen is that of "going over the hill." For this, he takes on the task of advising and training his followers for detachment in the field so that they may all remain on the winning side. Giving, in such context, should always be determined "with reference to what, by the light of Western knowledge and experience tempered

67

by local considerations," *We think is best for them.*[4] Thus, make sure to take in Their secrets, but don't ever give up Ours.

> *"The trick is not to get yourself into some inner correspondence of spirit with your informants. Preferring, like the rest of us, to call their souls their own, they are not going to be altogether keen about such effort anyhow. The trick is to figure out what the devil they think they are up to."*[5]

The natural outcome of such a rationale is the arranged marriage between "experience-distant" and "experience-near," between the scientist's objectivity and the native's subjectivity, between outsider's input and insider's output. To get at the most intimate, hidden notions of the Other's self, the man has to rely on a form of (neo-)colonial interdependency. And since sharing in this framework always means giving little and taking more than little, the need for informants grows into a need for disciples. We have to train Insiders so that they may busy themselves with Our preoccupations, and make themselves useful by asking the right kind of Question and providing the right kind of Answer. Thus, the ideal Insider is the psychologically conflict-detecting and problem-solving subject who faithfully represents the Other for the Master, or comforts, more specifically, the Master's self-other relationship in its enactment of power relations, gathering serviceable data, minding his/her own business-territory, and yet offering the difference expected.

THE "PET" NEGRO SYSTEM
(by Zora Neale Hurston)

And every white man shall be allowed to pet himself a Negro. Yea, he shall take a black man unto himself to pet and to cherish, and this same Negro shall be perfect in his sight. Nor shall hatred among the races of men, nor conditions of strife in the walled cities, cause his pride and pleasure in his own Negro to wane. . . . when everything is discounted, it still remains true that white people North and South have promoted Negroes—usually in the capacity of "representing the Negro"—with little thought of the ability of the person promoted but in line with the "pet" system.[6]

Apartheid precludes any contact with people of different races which might undermine the assumption of essential difference.[7]

An Insider's view: the magic word that bears within itself a seal of approval. What can be more authentically "other" than an otherness by the Other him/herself? Yet, every piece of the cake given by the Master comes with a double-edged blade. The Afrikaners are prompt in saying "You can take a black man from the bush, but you can't take the bush from the black man."

The place of the native is always well-delimitated. "Correct" cultural filmmaking usually implies that Africans show Africa; Asians, Asia; and Euro-Americans, . . . the World. Otherness has its laws and interdictions. Since "you can't take the bush from the black man," it is the bush that is consistently given back to him, and as things often turn out, it is also this very bush that the black man makes his exclusive territory. And he may do so with the full awareness that barren land is hardly a gift, for, in the unfolding of power inequalities, changes frequently require that rules be re-appropriated so that the Master be beaten at his own game. The conceited giver likes to give with the understanding that he is in a position to take back what he gives whenever he feels like it and whenever the acceptor dares or happens to trespass on his preserves. The latter, however, sees no gift (can you imagine such a thing as a gift that takes?) but only debts that once given back should remain his property, although (land) owning is a concept that has long been foreign to him and that he has refused to assimilate.

Through audiences' responses to and expectations of their works, non-white filmmakers are thus often informed and reminded of the territorial boundaries in which they are to remain. An insider can speak with authority about his/her own culture, and s/he is referred to as a source of authority in this matter— not as a filmmaker necessarily, but as an insider, merely. This automatic and arbitrary endowment of an insider with legiti-

mized knowledge about his/her cultural heritage and environment only exerts its power when it is a question of validating power. It is a paradoxical twist of the colonial mind: what the Outsider expects from the Insider is, in fact, a projection of an all-knowing subject that this Outsider usually attributes to himself and to his own kind. In this unacknowledged self-other relation, however, the other would always remain the shadow of the self, hence *not-really-not-quite* "all-knowing." That a white person makes a film on the Goba of the Zambezi or on the Tasaday in the Philippine rain forest seems hardly surprising to anyone, but that a Third World member makes a film on other Third World peoples never fails to appear questionable to many. The question concerning the choice of subject matter immediately arises, sometimes out of curiosity, most often out of hostility. The marriage is not consumable, for the pair is no longer "outside-inside" (objective versus subjective), but something between "inside-inside" (subjective in what is already designated as subjective) and "outside-outside" (objective in what is already claimed as objective). No real conflict.

Difference, yes, but difference
Within the borders of your homelands, they say
White rule and the policy of ethnic divisions.

Any attempts at blurring the dividing line between outsider and insider would justifiably provoke anxiety, if not anger. Territorial rights are not being respected here. Violations of boundaries have always led to displacement, for the in-between zones are the shifting grounds on which the (doubly) exiled walk. Not You/like You. The Insider's subjectivity (understood as limited affective horizon—the personal) is that very area for which the objective (understood as unbiased limitless horizon—the universal) Outsider cannot claim full authority, but thanks to which he can continue to validate his indispensable role, claiming now his due through "interpretive," but still totalizing scientific knowledge.

70

Outside In Inside Out

"Anthropology is the science of culture as seen from the outside."
(Claude Lévi-Strauss)[8]

Thus, if the natives were to study themselves, they were said to produce history or philology, not anthropology.[9]

"It is only a representative of our civilization who can, in adequate detail, document the difference, and help create an idea of the primitive which would not ordinarily be constructed by primitives themselves."[10]

Interdependency cannot be reduced to a mere question of mutual enslavement. It also consists in creating a ground that belongs to no one, not even to the "creator." Otherness becomes empowering critical difference when it is not given, but re-created. Defined with the Other's newly formed criteria. Imperfect cinema is subversive—not because science is contributing to the "purification" of art as it "allows us to free ourselves from so many fraudulent films, concealed behind what has been called the world of poetry"[11]; not because "the larger the grain, the better the politics"; or because a shaky blurry, badly framed shot is truer, more sincere, and authentic than a "beautiful," technically masterful shot (shaking the camera can also be a technique)—but more, I would say, because there is no such thing as an (abso-lute) imperfection when perfection can only construct itself through the existence of its imperfect Other. In other words, perfection is produced, not merely given. The values that keep the dominant set of criteria in power are simply ineffective in a framework where one no longer abides by them.

Non-Westerners may or may not want to make films on their own societies. Whatever the choice, the question is certainly not that of setting an opposition to dominant practices, since "opposing" in the one-dimensional context of modern societies usually means playing into the Master's hand. For years, They have been saying with much patronizing care: "Africa to Africans"; "We should encourage those from the Third World to make films on their own people"; "We would like to see Asians as told

71

by Asians"; or We want "to *teach* people with a culture different from ours to make motion pictures depicting their culture and themselves as *they* saw fit" (so that We can collect data on the indigenous ethnographic filmmaking process, and show Navajos through Navajo eyes to our folks in the field).[12] Again, this is akin to saying that a non-white view is desirable because it would help to fill in a hole that whites are now *willing* to leave more or less empty so as to lessen the critical pressure and to give the illusion of a certain incompleteness that needs the native's input to be more complete, but is ultimately dependent on white authority to attain any form of "real" completion. Such a "charity" mission is still held up with much righteousness by many, and despite the many changing appearances it has taken through the years, the image of the white colonial Savior seems more pernicious than ever since it operates now via consent. Indigenous anthropology allows white anthropology to futher anthropologize Man.

> *Anthropology is today the foundation of every single discourse pronounced above the native's head.*

> *The "portraits" of a group produced by the observer as outsider and by the observer as insider will differ, as they will be relevant in different contexts. This awareness underlies the current cry "You have to be one to understand one."*[13]

The question is also not that of merely "correcting" the images whites have of non-whites, nor of reacting to the colonial territorial mind by simply reversing the situation and setting up an opposition that at best, will hold up a mirror to the Master's activities and preoccupations. (It has been, for example, the talk of some French anthropologists, not long ago, to train and bring in a few African anthropologists-disciples to study the cultural aspects of remote villages in France. Again, let Them—whom We taught—study Us, for this is also information, and this is how the anthropologizing wheel is kept rotating.) The question, rather, is

that of tracking down and exposing the Voice of Power and Censorship whenever and in whichever side it appears. Essential difference allows those who rely on it to rest reassuringly on its gamut of fixed notions. Any mutation in identity, in essence, in regularity, and even in physical place poses a problem, if not a threat, in terms of classification and control. If you can't locate the other, how are you to locate your-self?

> *One's sense of self is always mediated by the image one has of the other. (I have asked myself at times whether a superficial knowledge of the other, in terms of some stereotype, is not a way of preserving a superficial image of oneself.)*[14]

Furthermore, where should the dividing line between outsider and insider stop? How should it be defined? By skin color (no blacks should make films on yellows)? By language (only Fulani can talk about Fulani, a Bassari is a foreigner here)? By nation (only Vietnamese can produce works on Vietnam)? By geography (in the North-South setting, East is East and East can't meet West)? Or by political affinity (Third World on Third World counter First and Second Worlds)? What about those with hyphenated identities and hybrid realities? (It is worth noting here a journalist's report in a recent *Time* issue, which is entitled "A Crazy Game of Musical Chairs." In this brief but concise report, attention is drawn on the fact that South Africans, who are classified by race and placed into one of the nine racial categories that determine where they can live and work, can have their classification changed if they can prove they were put in the wrong group. Thus, in an announcement of racial reclassifications by the Home Affairs Minister, one learns that: *"nine whites became colored, 506 coloreds became white, two whites became Malay, 14 Malay became white, . . . 40 coloreds became black, 666 blacks became colored, 87 coloreds became Indian, 67 Indians became colored, 26 coloreds became Malay, 50 Malays became Indian, 61 Indians became Malay . . . "* and the list goes on. However, says the Minister, *no blacks applied to become white, and no whites became black.)*[15]

The moment the insider steps out from the inside, she is no longer a mere insider (and vice versa). She necessarily looks in from the outside while also looking out from the inside. Like the outsider, she steps back and records what never occurs to her the insider as being worth or in need of recording. But unlike the outsider, she also resorts to non-explicative, non-totalizing strategies that suspend meaning and resist closure. (This is often viewed by the outsiders as strategies of partial concealment and disclosure aimed at preserving secrets that should only be imparted to initiates.) She refuses to reduce herself to an Other, and her reflections to a mere outsider's objective reasoning or insider's subjective feeling. She knows, probably like Zora Neale Hurston the insider-anthropologist knew, that she is not an outsider like the foreign outsider. She knows she is different while at the same time being Him. Not quite the Same, not quite the Other, she stands in that undetermined threshold place where she constantly drifts in and out. Undercutting the inside/outside opposition, her intervention is necessarily that of both a deceptive insider and a deceptive outsider. She is this Inappropriate Other/Same who moves about with always at least two/four gestures: that of affirming "I am like you" while persisting in her difference; and that of reminding "I am different" while unsettling every definition of otherness arrived at.

> *It is thrilling to think—to know that for any act of mine, I shall get twice as much praise or twice as much blame. It is quite exciting to hold the center of the national stage, with the spectators not knowing whether to laugh or to weep.* (Zora Neale Hurston)[16]

> *"The coloured are a very emotional people, and you can't trust the Bantus. A farmer here asked his Bantu foreman once, 'Tell me, Johnny, would you shoot me?' 'No,* baas, *I wouldn't shoot you,' Johnny said. 'I'd go to the neighbor's place and shoot the* baas *there. And his man would shoot you.'"* (An Afrikaner)[17]

> *The theory behind our tactics: "The white man is always trying to know into somebody else' business. All right, I'll set something outside*

74

the door of my mind for him to play with and handle. He can read my writing but he sho' can't read my mind. I'll put this play toy in his hand, and he will seize it and go away. Then I'll say my say and sing my song." (Zora Neale Hurston)[18]

The only possible ethnology is the one that studies the anthropophagous behaviour of the White man. (Stanislas S. Adotevi)[19]

Whether she turns the inside out or the outside in, she is, like the two sides of a coin, the same impure, both-in-one insider/outsider. For there can hardly be such a thing as an essential inside that can be homogeneously represented by all insiders; an authentic insider in there, an absolute reality out there, or an incorrupted representative who cannot be questioned by another incorrupted representative.

The most powerful reason why Negroes do not do more about false 'representation' by pets is that they know from experience that the thing is too deep-rooted to be budged. The appointer has his reasons, personal or political. He can always point to the beneficiary and say, "Look, Negroes, you have been taken care of. Didn't I give a member of your group a big job?" White officials assume that the Negro element is satisfied and they do not know what to make of it when later they find that so large a body of Negroes charge indifference and double-dealing. The white friend of the Negroes mumbles about ingratitude and decides that you simply can't understand Negroes . . . just like children.[20]

In the context of this Inappropriate Other, questions like "How loyal a representative of his/her people is s/he?" (the filmmaker as insider), or "How authentic is his/her representation of the culture observed?" (the filmmaker as outsider) are of little relevance. When the magic of essences ceases to impress and intimidate, there no longer is a position of authority from which one can definitely judge the verisimilitude value of the representation. In the first question, the questioning subject, even if s/he is an insider, is no more authentic and has no more authority on the subject matter than the subject whom the questions concern.

75

This is not to say that the historical "I" can be obscured or ignored, and that differentiation cannot be made; but that "I" is not unitary, culture has never been monolithic, and more or less is always more or less in relation to a judging subject. Differences do not only exist between outsider and insider—two entities—, they are also at work within the outsider or the insider—a single entity. This leads us to the second question in which the film-maker is an outsider. As long as the filmmaker takes up a positiv-istic attitude and chooses to bypass the inter-subjectivities and realities involved, factual truth remains the dominant criterion for evaluation and the question as to whether his/her work suc-cessfully represents the reality it claims would continue to exert its power. The more the representation leans on verisimilitude, the more it is subject to normative verification.

For the Inappropriate Other, however, the questions men-tioned above seems inadequate; the criterion of authenticity no longer proves pertinent. It is like saying to an atheist: "How faithful to the words of God are yours?" (with the understanding that the atheist is not opposed, but *in-different* to the believer). She who knows she cannot speak of them without speaking of herself, of history without involving her story, also knows that she cannot make a gesture without activating the to-and-fro movement of life. The subjectivity at work in the context of this Inappropriate Other can hardly be submitted to the old subjectivity/objectivity paradigm. Acute political subject-aware-ness cannot be reduced to a question of self-criticism toward self-improvement nor of self-praise toward greater self-confidence. Such differentiation is useful, for a grasp of subjectivity as a "science of the subject" makes the fear of ethnographic self-ab-sorption look absurd. Awareness of the limits in which one works need not lead to any form of indulgence in personal partiality, nor to the narrow conclusion that it is impossible to understand anything about other peoples since the difference is one of "es-sence."

By refusing to naturalize the "I," subjectivity uncovers the

myth of essential core, of spontaneity, and of depth as inner vision. Subjectivity therefore does not merely consist of talking about oneself, be this talking indulgent or critical. Many who agree to the necessity of self-reflectivity and reflexivity in film-making think that it suffices to show oneself at work on the screen, or to point to one's role once in a while in the film, and to suggest some future improvement in order to convince the audience of one's "honesty" and pay one's due to liberal thinking. Thus, there is now a growing body of films in which the spectators see the narrator narrating, the filmmaker filming or directing, and quite expectably, the natives—to whom a little camera (usually a Super-8) or tape-recorder is temporarily handed out—supposedly contributing to the production process. What is put forth as self-reflexivity here is no more than a small faction—the most conveniently visible one—of the many possibilities of uncovering the work of ideology that this "science of the subject" can open unto. In short, what is at stake is a practice of subjectivity that is still unaware of its own constituted nature (hence the difficulty to exceed that simplistic pair, subjectivity and objectivity); unaware of its continuous role in the production of meaning (as if things can "make sense" by themselves, so that the interpreter's function consists only of *choosing* among the many existing readings); unaware of representation as representation (the cultural, sexual, political inter-realities involved in the making: that of the filmmaker as subject; that of the subject filmed; and that of the cinematic apparatus); and, finally, unaware of the Inappropriate Other within every "I."

> *My certainty of being excluded by the Blacks one day is not strong enough to prevent me from fighting on their sides.* (A South African writer)[21]

> *What does present a challenge is an organization that consists either in close association or in alliance of black, white, Indian, Coloured. Such a body constitutes a negation of the Afrikaans' theory of separateness, their medieval clannishness.* (Ezekiel Mphahlele)[22]

77

The stereotyped quiet, obedient, conforming modes of Japanese behavior clashed with white expectations of being a motivated, independent, ambitious thinker. When I was with whites, I worried about talking loud enough; when I was with the Japanese, I worried about talking too loud. (Joanne Harumi Sechi)[23]

Walking erect and speaking in an inaudible voice, I have tried to turn myself American-feminine. Chinese communication was loud, public. Only sick people had to whisper. (Maxine Hong Kingston)[24]

When I hear my students say "We're not against the Iranians here who are minding their own business. We're just against those ungrateful ones who overstep our hospitality by demonstrating and badmouthing our government," I know they speak about me. (Mitsuye Yamada)[25]

She, of the Interval

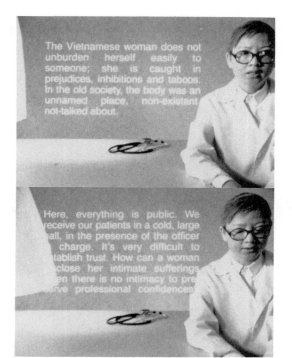

The Vietnamese woman does not unburden herself easily to someone; she is caught in prejudices, inhibitions and taboos. In the old society, the body was an unnamed place, non-existant not-talked about.

Here, everything is public. We receive our patients in a cold, large hall, in the presence of the officer in charge. It's very difficult to establish trust. How can a woman disclose her intimate sufferings when there is no intimacy to preserve professional confidences?

It is impossible to feel for someone's pains and sufferings when there is no complicity between a doctor and her patient. When a woman understands nothing about her body, hygiene or contraception, she came to see me and shyly whispered these to me.

5

*All-Owning Spectatorship**

. . . Of late, a friend's mother died. One day the family chanced to eat steamed sorghum, which was of a reddish color. A local pedant felt that while in mourning it was inappropriate to have a meal with the main course in so gay a color, so he took up this point with them, pointing out that red was always indicative of happy events, such as weddings. The friend replied : "Well, I suppose all those people eating white rice every day are doing so because they are in mourning!"[1] In classical Chinese humor a position of indirection is assumed; a reaction to social conditions is woven in the fabric of an anecdote; a laughter momentarily releases demonstration from its demonstrative attribute. In the world of Western film production, some would call such an opening a "directorial trick," highly valued among feature-story makers. Others would mumble "clumsy dramatic devices," "poor exposition," "muddy connectives," "lack of clear thought." Public opinion usually prefers immediate communication, for quantified exchange dominates in a world of reification. To have knowledge, more and more knowledge, often takes precedence over knowing. The creed constantly reads: if one has nothing, one is nothing.

 * Published in *Quarterly Review of Film & Video*, Vol 13, Nos. 1 and 2 (January 1991). Part of this essay has also appeared as "Black Bamboo," in *CineAction!* (Canada), a special issue on Imperialism and Film, No. 18 (Fall 1989).

She, of the Interval

A mother died. What holds the reader? What motivates the story and generates the action? A reddish color; a family's attempt; a local pedant; a "steamed" meal; people's white rice . . . in mourning. Red is the color of life. Its hue is that of blood, of the ruby, of the rose. And when the world sees red, white could become the international color of mourning. Conventionally a bridal color in many Western societies, white is indeed the funeral color in numerous African and Asian cultures. Passionate reds and pinks also populate the joyful decor of weddings, but they cut across the borderlines of both Western and Eastern cultural traditions. Even the bride is clad in red in the latter parts of the world. Whoever has taken a stroll in Chinatown on Chinese New Year's days, cannot have missed the sight of doorways vividly adorned with red scrolls and of streets thickly coated with the red refuse of firecrackers. Children are accordingly greeted with red envelopes with lucky bank-notes inside and words of Luck, Prosperity, and Happiness on the outside. The return of spring is celebrated as a renewal of life, growth, and emancipation. After days of intense preparation, women are allowed to enjoy five days of idleness when, in order to preserve good luck, they are spared the drudgery of cooking, washing, and sweeping (since during this period, all such drudgery means throwing away a the happy fortune). At once an unlimited and profoundly subjective color, red can physio- or psycho-logically close in as well as open up. It points to both a person's boundless inner voyage, and the indeterminate outer burning of the worlds of war. Through centuries, it remains the badge of revolution.

Here is where the earth becomes blue like an orange.[2] To say red, to show red, is already to open up vistas of disagreement. Not only because red conveys different meanings in different contexts, but also because red comes in many hues, saturations, and brightnesses, and no two reds are alike. In addition to the varying symbols implied, there is the unavoidable plurality of language. And since no history can exhaust the meaning of red,

such plurality is not a mere matter of relativist approach to the evershifting mores of the individual moment and of cultural diversification; it is inherent to the process of producing meaning; it is a way of life. The symbol of red lies not simply in the image, but in the radical plurality of meanings. Taking literalness for naturalness seems, indeed, to be as normal as claiming the sun is white and not red. Thus, should the need for banal concrete examples arise, it could be said that society cannot be experienced as objective and fully constituted in its order; rather, only as incessantly recomposed of diverging forces wherein the war of interpretations reigns.

Seeing red is a matter of reading. And reading is properly symbolic. In a guide listing the elements of screenwriting, a voice of authority dutifully calls attention to cultural differences and the many ensuing contradictory behaviors of characters in relation to an event; but it further warns: "If ten viewers can walk away from a film with ten different interpretations, maybe the film was about nothing specific. Perhaps, they were looking at the proverbial emperor's new clothes. The marks of the artsy-craftsy film are withholding basic exposition and leaving the viewer confused. The illusion of profundity is not the same as being profound."[3] True, in a world where the will to say prevails (a "good" work is invariably believed to be a work "that *has* something to say"), the skill at excluding gaps and cracks which reveal language in its nakedness—its very void—can always be measured, and the criteria for good and bad will always exert its power. The emperor's new clothes are only invoked because the emperor is an emperor. But what if profundity neither makes sense nor constitutes a non-sense? Where, for example, does profundity stand in: "A, black; E, white; I, red"?[4]

More likely to persist in bordering on both profundity and absurdity, the work of saying in unsaying, or of unsaying in saying again what is already said and unsaid, seems always

uneasily and provocatively fragile. Playing between "absurdi-ties," anecdotes, and decisive analysis, or between non-sense and critical languages, it often runs the risk of being mistaken immediately for the-sky-is-blue-the-grass-is-green type of work, and can be both condemned and praised within that very read-ing. It is easy to commit an outrage on those (men) who fulminate against what they call "those school *boyish* evidences" (referring here to statements in a film uttered by women's voices), when the work succeeds to lure them into a spectacle that shows neither spectacular beings nor sensational actions; offers neither a per-sonal nor a professional point of view; provides no encased knowledge to the acquisitive mind; and has no single story to tell nor any central message to spread, except the unconcealed one(s) about the spectators themselves as related to each specific context.

The inability to think symbolically or to apprehend language in its very symbolic nature is commonly validated as an attribute of "realistic," clear, and accomplished thinking. The cards are readily shifted so as to turn a limit, if not an impoverishment of dominant thinking into a virtue, a legitimate stance in mass communication, therefore a tool for political demagogy to appeal to widely naturalized prejudices. Since clarity is always ideologi-cal and reality always adaptive, such a demand for clear commu-nication often proves to be nothing else but an intolerance for any language other than the one approved by the dominant ideology. At times obscured and other times blatant, this inabil-ity and unwillingness to deal with the unfamiliar, or with a language different from one's own, is, in fact, a trait that inti-mately belongs to the man of coercive power. It is a reputable form of colonial discrimination, one in which difference can only be admitted once it is appropriated, that is, when it operates within the Master's sphere of having. Activities that aim at pro-ducing a different hearing and a renewed viewing are undiffer-entiatingly confused with obscurantism and hastily dismissed

84

as sheer incompetency or deficiency. They are often accused of being incoherent, inarticulate, amateurish ("it looks like my *mother* 's first film," says a young to-be-professional male), or when the initiating source of these activities happens to be both female and "articulate," of "intellectualism"—the unvarying target of attack of those for whom thinking (which involves reflection and reexamination) and moreover thinking differently within differences, remains a male ability and justifiably, an unwarranted threat. As the proverbial line goes, He only hears (sees) what He wants to hear (see), and certainly, there are none so deaf (blind) as those who don't want to hear (see).

"All the prejudice against intellectuals originates from the narrow-mindedness of small producers," wrote the *Beijing Review* not long ago to rectify the "Left" mistakes perpetuated from the time of the Cultural Revolution.[5] The moment she opens her mouth, she is immediately asked to show her identification number and to tell the (reluctant) listener in whose name she is speaking. ("Is this a semiological approach?" "Who taught you?" "Whose work do you like?" "What I find badly missing in your talk are the models! Where do we go without models?" "If it is a deliberate attempt at breaking *the rules,* then I certainly applaud you, but I doubt it is consciously done, and if it is *just a subjective approach*, then I don't see where it leads us . . . ") If she relies on names, she finds herself walking in line both with "the penis-envy" women and "the colored-skin-white-mask" oppressed who blindly praise their oppressor's deeds. If she distrusts names and names no master, she will, whether she likes it or not, be given one or several, depending on the donor's whims ("The film reminds me of Kubelka's *Unsere Afrikareise* and of Chris Marker's *Sans Soleil*"; "How different are these films from Godard's?") ; otherwise, she is bound to face fiery charges of circulating "schoolboyish evidences." This type of charge repeats itself endlessly in varying faces. Knowledge is no knowledge until it bears the seal of the Master's approval ("She doesn't really know what

85

she does"). Without the Name, the product is valueless in a society of acquisition. (Thus, after having, for example, taken over the floor during the entire length of a film debate session, where angry reactions were continuously thrown out at a woman filmmaker, a number of men approached her individually afterwards to intimate: "All that is very *cute* . . . and I *commend* you for your effort, but . . . ," "You can't *have* an answer for every question!")

She is both inarticulate and too articulate. *Although one can speak of intellectuals, one cannot speak of non-intellectuals, because [they] do not exist. . . . There is no human activity from which every form of intellectual participation can be excluded* (Antonio Gramsci).[6] Standardization and sameness in variations is the unacknowledged agenda of media suppliers and consumers who, under the banner of "accessibility," work at leveling out differences to defend their property, whether this property takes the form of mercantile monopoly, or of political tenure. While the craving for *accession* to power seems to underlie every intolerance for alternatives that may expose the totalizing character of their discourses (whether rightist or leftist), the goal is to render power sufficiently invisible so as to control more efficaciously the widest number down to the smallest details of existence. ("Self-help" and "Do-it-yourself" systems are an example.) The literal mind has to dominate if accessibility were to be equated with efficacity. Literal and linear readings are thus not simply favored; they are championed and validated as the only ones "accessible" to the wide number, in all media work, whether documentary or narrative. (Even Francis Coppola who is "the best of what *We have* in America" is blamed for emphasizing the visuals at the cost of a good story line.) Mass production, as Gandhi defined it, is production by the fewest possible number. The needs (for orderly literal thinking) created by the few and voiced back in chorus by the many are normalized to the extent that not only consumers come to internalize the suppliers' ex-

ploitative rationale, but the latter more often than not become the victims of their own practices. "The greatest error I've committed in my career is to have once made a film for people who think," says a respected Hollywood director (not to name any names); "it featured in all the festivals, but never made it at the box office. . . . Don't forget that people in the media are all very smart and creative, but the audience is invariably simple-minded."

With such a rationale, the hackneyed question of elitism arises again, albeit reversed and slightly displaced: who appears more elitist here? The institutional producer who caters to the needs of the "masses" while down- and de-grading their mentality in the interest of mercantilism (the Master's sphere of having)? Or the "independent" producer who disturbs while soliciting the audience's participation in rethinking the conditions of this "society of the spectacle," and therefore neither pleases the large number nor expects to make it at the box office? My admittedly biased question should probably remain without an answer after all, for in a situation where the suppliers are victims of their own supplies, no clear-cut division operates between makers and consumers. Only the *humanism of the commodity* reigns, and the vicious circle continously reactivated provides no response to inquiries such as: "Is it the media which induces fascination in the masses, or is it the masses which divert the media into spectacle?"[7] The media's message may condemn war, violence, and bloodshed, for example, but its language fundamentally operates as a form of fascination with war; and war scenes persist in dominating the spectacle. (The only way to represent war or to speak about it in the language of commodified humanism, is to show war scenes; any form of indirection and of non-literalness in approaching the subject of war is immediately viewed as a form of absence of war.) Thus, under the regime of commodities, even the distinction between institutionalized and independent (or mainstream and alternative) producers becomes prob-

87

lematic; and within the realm of independent filmmaking there are nuances to bring out, there are varied ramifications, and there are crucial differences.

If Hollywood films are consistently condemned for their capitalist enterprise and "apolitical" commitment to film as an industry, "political" films (or "issue films" as Hollywood members call them) are looked down upon by mainstream feature producers as representative of the unimaginative mediocres' domain: "Don't apply the criteria of today's politics in feature films, otherwise they will all look like PBS products, which are boring as hell!" Whether political, educational, or cultural (if one can momentarily accept these conventional categories), rational linear-literal communication has been the vehicle of quantified exchange. The imperative to produce meaning according to established rationales presents itself repeatedly in the form of moralizing information: every film made should inform the masses, raise their cultural level, and give an objective, scientific foundation to all explanations of society. *The revolutionary view point of a movement which thinks it can dominate current history by means of scientific knowledge remains bourgeois* (Guy Debord).[8] Here, there is almost never any question of challenging rational communication with its normalized filmic codes and prevailing objectivist, deterministic-scientific discourse; only a relentless unfolding of pros and cons, and of "facts" delivered with a *sense of urgency*, which present themselves as liberal but imperative; neutral and value-free; objective or universal.

> *Yesterday's anti-colonialists are trying to humanize today's generalized colonialism. They become its watchdogs in the cleverest way: by barking at all the after-effects of past inhumanity* (Raoul Vaneigem).[9]

Red is the color of life. Nearly all cultures attribute a greater potency to red, but red can never be assigned a unitary character. Giving the physiological impression of "advancing" toward the viewer rather than receding, it is analyzed as having "a great

wealth of modulations because it can be widely varied between cold and warm, dull and clear, light and dark, without destroying its character of redness. From demonic, sinister red-orange on black to sweet angelic pink, red can express all intermediate degrees between the infernal and the sublime."[10] Thus, whether red radiates luminous warmth or not depends on its contextual placement in relation to other colors. On white it looks dark, while on black it glows; with yellow, it can be intensified to fiery strength. In the costuming and make-up of Vietnamese opera, red symbolizes anger; black, boldness; and white, treachery. In classical Chinese symbolics, red characterizes Summer and the south; black, Winter and the north; green, the color of virtue and goodness, represents Spring and the east; and white, the color of war and penalty, stands for Fall and the west. The color of life and of revolution may thus remain a transnational sign of warmth and anger, but whether or not it is associated with war, violence, and bloodshed—as it is unfailingly so in the modern concept of revolution—depends largely on one's praxis of revolution. To think that red is red, no matter whether the red is that of blood or that of a rose, is to forget that there is no red without non-red elements, and no single essential red among reds.

If, in the opening Chinese anecdote, red humoristically incurs the risk of being fixed as a sign "always indicative of happy events" by "a local pedant," in Dogon (Mali) cosmology, red is one of the three fundamental colors (with black and white) whose complex symbolism exceeds all linear interpretations and remains inexhaustible. A sign opening constantly onto other signs, it is read in practice with all its signifying subtlety and density. The Dogon myth of the red sorghum tells us, for example, that its grains grew at the time when the pond had become impure, its water having served to wash the corpse of the ancestor Dyongou Serou—the first human dead, also called the "great mask." The impurity of death had tainted the pond, and the color red of the sorghum is a manifestation of this contamination. Red, is also

89

the glare of the sun. The latter is associated with putrefaction and death (it rots Dyongou Serou's corpse), although it remains absolutely necessary to agriculture and plants; in other words, to the growth of life.[11] The sun is essentially feminine in Dogon mythology, and its ambivalent character reflects back upon the ambivalent character of the notion of femininity in the culture's symbolics.

Red as the Sun is both beneficial and maleficial. Women who are the bearers and givers of life, are also the cyclical producers of "impurity." Dogon societies abound with rituals in which the "bad blood"—menstruation, the blood shed at childbirth, the dark blood that clots—is distinguished from the bright healthy blood that flows in the body. The latter which is evoked when a wife is pregnant ("your body's blood is good"), is also identified with men's semen; it is said to represent the successful, fecund sexual act, while the former results from a failure of the couple to reproduce. Yet the bright red flowers of the Kapok tree are associated with menstruation and death, and it is with its wood that masks are carved. Women are raised to fear "the mask with a red eye," for the masks are the men's domain and he who is angry is said to have "the red eye," while he whose anger gets violent has "the red heart." However, men are also referred to as "having their periods" when their blood runs during circumcision time or when they carve the masks and tint the fibers red. Their words are then "impure" and women are strictly forbidden to come near them while they carry out these tasks. Paradoxically, to decorate the masks and to tint the fibers amount to nursing the sick; for the white wood and fibers do not look healthy—just like sick people—and to paint and tint them with vivid colors is to "heal" them.[12]

The reading of red as impurity and death proves appropriate to the eating of red sorghum during mourning time in the Chinese anecdote. Should the friend of the dead mother remember this,

90

he or she would have more than one witty answer to reply to the pedant. And depending on the context, this friend could also decide whether or not it is at all necessary to resort to another color for comparison. ("Remember" is here adequate, for even without knowledge of Dogon cosmology, the relation commonly drawn between red and blood evokes meanings that cut across cultural borderlines.) Rich in significations and symbols, red defies any literal elucidation. Not only do its values vary between one culture and another, but they also proliferate within each culture itself. The complexities are further multiplied when reading takes into consideration the question of gender. "Impurity" is the interval in which the impure subject is feared and alienated for her or his potential to pollute other clean(sed) and clear(ed) subjects. It is also the state in which gender division exerts its power. (Just as women are excluded from the tinting process of the masks, no Dogon man can witness a woman giving birth, nor can he come near her when she has her period. For, like many women from other parts of the world, Dogon women temporarily separate themselves from the community during menstruation, living in confinement—or rather, in differentness—in a dwelling built for that very purpose.)

Many of us working at bringing about change in our lives and in others' in contexts of oppression have looked upon red as a passionate sign of life and have relied on its decisive healing attributes. But as history goes, every time the sign of life is brandished, the sign of death also appears, the latter at times more compelling than the former. This does not mean that red can no longer stand for life, but that everywhere red is affirmed, it im-purifies itself, it necessarily renounces its idealized unitary character, and the war of meanings never ceases between reds and non-reds and among reds themselves. The reading of "bad blood" and "good blood" continues to engender savage controversies, for what is at stake in every battle of ideologies are territories and possessions. While in conservative milieux, the heat and

anger surrounding the debates generate from the emblem of red itself ("What can you expect but hostilities? You are waving a red flag in front of the bull!"), in (pseudo-)progressist milieux they have more likely to do with sanctified territories and reified power. The dogmatic mind proceeds with ready-made formulas which it pounds hard into whoever's ear it can catch. It validates itself through its own network of law-makers and recruited followers, and constantly seeks to institute itself as an ideological authority. Always ready to oppose obvious forms of power but fundamentally uncritical towards its own, it also works at eliminating all differences other than those pre-formulated; and when it speaks, it prescribes. It preaches revolution in the form of commands, in the steeped-in-convention language of linear rationality and clarity. At length, it never fails to speak *for* the masses, *on behalf of* the working class, or *in the name of* "the American people."

Nazism and facism were only possible insofar as there could exist within the masses a relatively large section which took on the responsibility for a number of state functions of repression, control, policing, etc. This, I believe, is a crucial characteristic of Nazism; that is, its deep penetration inside the masses and the fact that a part of the power was actually delegated to a specific fringe of the masses . . . You have to bear in mind the way power was delegated, distributed within the very heart of the population. . . . It wasn't simply the intensified central power of the military" (Michel Foucault)[13] Power is at once repulsive *and* intoxicating. Oppositional practices which thrive on binary thinking have always worked at preserving the old dichotomy of oppressor and oppressed, even though it has become more and more difficult today to establish a safe line between the government and the people, or the institution and the individual. When it is question of desire and power, there are no possible short-cuts in dealing with the system of rationality that imprisons both the body politic and the people, and regulates their relationship. There are, in other

words, no "innocent people," no subjects untouched in the play of power. Although repression cannot simply be denied, its always-duplicative-never-original sources cannot be merely pointed at from a safe articulatory position either. As has been noted, in the society of the spectacle (where the idea of opposition and the representation of oppression are themselves commodified) "the commodity contemplates itself in a world it has created."[14]

A woman viewer:—By having the women re-enact the interviews, you have defeated your own purpose in the film!
The woman filmmaker:—What is my purpose? What do you think it is?
The viewer irritated:—To show women's power, of course!

Every spectator mediates a text to his or her own reality. To repeat such a banality in this context is to remember that although everyone *knows* this, everytime an interpretation of a work implicitly presents itself as a mere (obvious or objective) decoding of the producer's message, there is an explicit reiteration of the fetishistic language of the spectacle; in other words, a blind denial of the mediating subjectivity of the spectator as reading subject and meaning maker-contributor. The same applies to producers who consider their works to be transparent descriptions or immediate experiences of Reality "as it is" ("This is *the* reality of the poor people"; "the reality of the nine-to-five working class is that they have no time to think about 'issues' in their lives"). Literal translations are particularly fond of "evident truths," and the more they take themselves for granted, the more readily they mouth truisms and view themselves as *the* ones and the only *right* ones. The self-permitting voice of authority is common in interpretation, yet every decoding implies choice and is interpellated by ideology, whether spoken or not. Reading as a creative responsibility is crucial to every attempt at thwarting "the humanism of commodity." Although important in any enterprise, it is pivotal in works that break off the habit of the Spectacle by asking questions aloud; by addressing the reality

of representations and entering explicitly into dialogue with the viewer/reader. Each work has its own sets of constraints, its own limits and its own rules, and although "anything could be said" in relation to it, this "anything" should be rooted in the specific reality of the work itself. The interpreters' conventional role is disrupted since their function is not to tell "what the work is all about," but to complete and "co-produce" it by addressing their own language and representational subject-ivity.

The Text is a little like a score of this new kind: it solicits from the reader a practical collaboration. . . . The reduction of reading to consumption is obviously responsible for the "boredom" many feel in the presence of the modern ("unreadable") text, the avant-garde film or painting: to be bored means one cannot produce the text, play it, release it, make it go (Roland Barthes).[15] Ironically enough, both the all-too-familiar (PBS conventions according to Holly-wood standards) and the un-familiar have been qualified as bor-ing. In one case, the question is that of instituting representa-tional habits and of providing alibis of ownership, while in the other, that of disturbing and dispossessing them of their evident attributes. Yet what links these two "boring" modes of produc-tion is precisely this lack: that of the Spectacular, the very power to appeal. In the first instance such a lack usually derives from a normalized deficiency: the (involuntary, hence lesser) spectacle never admits to itself, that it is a spectacle; in the second in-stance, it results from an ambiguous rupture: the spectacle(-on-trial) fractures its own unicity by holding a mirror to itself as spectacle. Being the site where all the fragments are diversely collected, the viewer/reader remains, in this situation of rupture, intimately involved in a dialogue with the work. The latter's legibility and unity lie therefore as much in its origin as in its destination—which in this case cannot be righteously predeter-mined, otherwise Commodity and its vicious circle would trium-phantly reappear on the scene. With such emphasis laid on the spectator's creative role and critical resistance to consumption,

it is amazing (although not in the least surprising) to hear the unfamiliar or different/autonomous work morally condemned in the name of a humanism which hypocritically demands respect for the viewers/readers, claiming, sure enough, to speak on their behalf and advocate their rights.

Among the many realms of occupied territories, one of particular relevance to the problems of reading here is the concept of the "political." Although much has already been said and done concerning the "apolitical" character of the narrow "political," it is still interesting to observe the endlessly varying ways the boundaries of "the political" are being obsessively guarded and reassigned to the exclusive realm of politics-by-politicians. Thus, despite the effectiveness and persistence of the women's movement in deconstructing the opposition between nature (female) and culture (male) or between the private (personal) and the public (political); despite the growing visibility of numerous Third Worldist activities in de-commodifying ethnicity, displacing thereby all divisions of Self and Other or of margin and center based on geographical arbitrations and racial essences; despite all these attacks on pre-defined territories, a "political" work continues unvaryingly for many to be one which opposes (hence remains particularly dependent upon) institutions and personalities from the body politic, and mechanically "barks at all the after-effects of past inhumanity"—in other words, which safely counteracts within the limits of pre-formulated, codified forms of resistance.

Particularly intriguing here are the kinds of questions and expectations repeatedly voiced whenever films made on and by members of the Third World are concerned. Generally speaking, there is an excessive tendency to focus on economic matters in "underdeveloped" or "developing" contexts among members of overdeveloping nations. It is as if, by some tacit consent, "Third World" can/must only be defined in terms of hierarchical eco-

nomic development in relation to "First World" achievements in this domain. And, it is as if the presence and the sight of imported Western products being "misused" in non-Western contexts remain highly compelling and recomforting to the Western viewer on imag-inary foreign land. The incorporation (if not emphasis) of recognizable signs of Westernization even in the most remote parts of Third World countrysides is binding; for exoticism can only be consumed when it is salvaged, that is, reappropriated and translated into the Master's language of authenticity and otherness. A difference that *defies while not defying* is not exotic, it is not even recognized as difference, it is simply no language to the dominant's ear (only sheer charlatanism—a "mother's first [attempt]"; a something that infuriated the men asking: "What is it!?" "What can you *do* with such a film?"). Any film that fails to display these signs of "planned poverty" in its images and to adopt the *diagnostic* language of economic-deterministic rationale, is often immediately classified as "apolitical." The devices set up by the Master's liberals to correct his own mistakes thus become naturalized rules, which exercise their power irrespective of the differences of context.

The political is hereby *not* this "permanent task inherent in all social existence" which, as Michel Foucault suggests, "cannot be reduced to the study of a series of institutions, not even to the study of all those institutions which would merit the name 'political,' " but pertains to "the analysis, elaboration, and bringing into question of power relations and the 'agonism' between power relations and the intransitivity of freedom."[16] *The political becomes compulsively instead "the legislative, institutional, executive mirror of the social."*[17] In this exclusive realm of politics by politicians, the political is systematically de-politicized. The more "self-evident" the location of politics, the easier it is to claim knowledge, to gain control, and to acquire territory. The

progressive "First World" thus takes as much pride in its "Third World" underdeveloped as the church used to take pride in its poor. (As it has been astutely pointed out, the humanitarianism advocated through all the "feed the poor" images of Africa and the "do good" messages of the television missionaries may ease the consciences of the rich, but what they hide are precisely the ties between world hunger and imperialism.[18]) Not only all films related to the Third World must show the people's poverty, but whatever they put forth in their critical stance vis-à-vis oppression should not depart from the Master's image of progress, for it is only in terms of progress—more particularly acquisitive, quantified progress—that he conceives of "revolution" and transformation.

A woman viewer:—In dealing with socialist Vietnam, why don't you show what has been acquired through the Revolution?
The woman filmmaker:—The women in the film wouldn't have spoken as they did without the Revolution.
The viewer:—. . . True, but I mean real acquisitions, real attainments . . . something tangible! Do you understand me?

Poverty and class. Even the notion of class is commodified. Again, it is almost exclusively in the context of films on and by people of color that middle-class viewers become suddenly over(t)ly concerned with the question of class—more as a classifying term however, than as a way of rethinking production relations. Class, which is reduced to a fixed and categorized meaning in its common use among the viewers mentioned, has apparently never been their preoccupation in contexts other than the one that concerns "their" poor. (For they do not seem to have any qualms going to the movies whose dominating attractions are the love stories of the Western petty bourgeoisie; nor are they disturbed every time they switch their television set on, whose visual symbols and chatter are governed by the myths of the upwardly mobile and the tastes of the very affluent.) *[The] attach-*

ment to the new insures that television will be a vaguely leftist medium, no matter who its personnel might be. Insofar as it debunks traditions and institutions . . . television serves the purposes of that larger movement within which left and right (in America, at least) are rather like the two legs of locomotion: the movement of modernization. . . . Television is a parade of experts instructing the unenlightened about the weather, aspirins, toothpastes, the latest books or proposals for social reform, and the correct attitudes to have with respect to race, poverty, social conflict, and new moralities (Michael Novak).[19]

The mandatory concern for class in the exclusive context of films on and by Third World members *is in itself a class issue.* The complexity of the problem often goes unnoticed, as the class bias many of us project onto others is often masked by the apparent righteousness of these "correct attitudes" popularized in relation to race and poverty. The tendency to identify Third World with mere economic poverty is always lurking below questions such as: "The film is beautiful. But some people look as if they have starched their clothes [sic] for the camera. Why do they dress so well?" (concerning a documentary shot in villages of Senegal); or else: "I am surprised to see how beautiful the women are. Here [in the US], they would have been fashion models. You have obviously selected them!" Such a tendency is further recognizable in the way the difference in dress codes is often ignored. While among many progressist middle-class women today it is important to signal publicly, through the very casual way one often dresses, that one is sufficiently secure to enact the downwardly mobile, the situation is rather the reverse in the working class. "Most black women don't dress like this [in slacks and shirt]," observes Julia Lesage, "nor do most trade union women, if they are gathering in public for a meeting. Many, if not most, women in the U.S. cherish a notion of dressing up in

public or dressing up out of respect for other people. . . . [Blacks] do not have a legacy of pride in dressing down."[20] Nor do most Asians in the US or elsewhere (including post-Mao China)—especially when it is question of appearing on camera for the thousands of (respected) others, and of "saving face" for one's own family and community. Thus, in a film where both Asian middle-class and working-class women are featured, a woman viewer remarks for example: "All the women in the film are middle class. Can you talk about this?" The woman filmmaker: "Oh! . . . How do you see them all as middle class?" The viewer: "Aren't they?! . . . the way they dress! . . ." Whose middle class is it finally? In refusing to situate its own legacy in dress codes, hence to acknowledge the problem of class in dealing with class, middle-class spectatorship believes it can simply evacuate class content from its safe observer's post by reiterating the objectifying Look—the Spectacle 's totalitarian monologue.

So gay a color . . . in mourning. Not too long ago (1986), in an issue of the weekly *Figaro-Magazine,* one reads in large bold letters, the following title of a feature article by a famed French reporter who is said to have spent twenty years covering the war in Vietnam: *"Mon" Viet-nam d'aujourd'hui, c'est la désolation* ("My" Vietnam Today Is a Desolation). Vietnam: a sacred territory and an ideal subject for generalized colonialism. A widely unknown people, but an exceptionally famed name; all the more unforgettable as every attempt at appropriating it through the re-justification of motives and goals of the war only succeeds in setting into relief the political vacuum of a system, whose desperate desire to re-deploy its power and to correct its world image in a situation of bitter "defeat," unfolds itself through the supremacy of war as mass spectacle. Every spectator owns a Vietnam of his or her own. If France only remembers its ex-colony to expatiate forever on it being the model of a successful revolutionary struggle against the largest world power, America

is particularly eager to recall its predecessor's defeat at Dien Bien Phu and Vietnam's ensuing independence from French colonialism, whose desperate effort to cling to their Asian possession had led to the American involvement in the war. It is by denouncing past colonialism that today's generalized colonialism presents itself as more humane. North and South Vietnam are alternately attributed the role of the Good and the Bad according to the time, to suit the ideological whims of the two foreign powers. And the latter carefully take turns in siding with the "winner," for it is always historically more uplifting to endorse the "enemy" who wins than the "friend" who loses.

Yes, we defeated the United States. But now we are plagued by problems. We do not have enough to eat. We are a poor, underdeveloped nation. . . . Waging a war is simple, but running a country is very difficult (Pham Van Dong).[21] For general Western spectatorship, Vietnam does not exist outside of the war. And she no longer exists since the war has ended, except as a name, an exemplary model of revolution, or a nostalgic cult object for those who, while admiring unconditionally the revolution, do not seem to take any genuine, sustained interest in the troubled reality of Vietnam in her social and cultural autonomy. The more Vietnam is mystified, the more invisible she becomes. The longer Vietnam is extolled as the unequal model of the struggle against Imperialism, the more convenient it is for the rest of the world to close their eyes on the harrowing difficulties the nation, governed by a large post-revolutionary bureaucracy, continues to face in trying to cope with the challenge of recovery. (Even when the possessive pronoun "my" is liberalistically bracketed), whose Vietnam is the Vietnam depicted in Hollywood films, as well as in the daily news and television series that offer "fresh action from Vietnam into our living rooms each evening" (Time-Life Books brochure on *Vietnam: A Television History*) and claim to deliver "the entire story of what really happened in Vietnam" in a few hours for VCR owners? Whose Vietnam is the one presented

100

in *The Vietnam Experience* book series, "the definitive work on the Vietnam conflict . . . the whole explosive story . . . the whole astonishing truth. . . . More colorful than any novel, more comprehensive than any encyclopedia"? Whose conflict triumphantly features in "The TV war"? Whose experience finally does Time-Life Books posters herald in its large, bold title-letters as being exclusively that of: "The Men, The Weapons, The Battles"?

Contrary to what has been affirmed by certain Vietnam experts, America's concept of its own "exceptionalism," which is said to have nurtured the roots of American intervention in the war, did not die on the shores of Vietnam. It is still well and alive even in its most negative aspects. Vietnam as spectacle remains passionately an owned territory. Presented through the mediation of the dominant world forces, she only exists within the latter's binarism; hence the inability to conceive of her outside (or rather, in the gaps and fissures, in the to-and fro movement across the boundaries of) the pro-communist/anti-communist opposition. Every effort at challenging such reductive paternal bilaterism and at producing a different viewing of Vietnam is immediately recuperated within the limit of the totalized discourse of red is red and white is white. Not every Vietnam anti-war demonstration effort was based on an advocacy of socialism, or on an elaborate questioning (instead of a mere moral condemning) of imperialism. Nor was every demonstration based on an extensive interrogation of the territorial and numerical principle of the war machine whereby the earth becomes an object. It is interesting to note the extent to which common reactions presented as oppositions to the government's stance often involuntarily met the latter's ultimate objective in its foreign interventions, which was that of defending and promoting a specific lifestyle—the world of reification. Thus, despite the anti-war denotation of such a comment as: "It seems like we're always getting pulled in by other people's problems. We've got enough problems of our own to deal with," what is also connoted

101

is a certain myopic view of America's "goodwill," which reduces the rest of the world to "beggars" whose misery does not concern us, because *We have our own* beggars here at home.

While in Vietnam, Party officials readily acknowledge the severity of their economic crisis and even feel the urge recently to publicly declare that "only when we no longer refuse, out of fear, to admit our own failures and oversights, only when we can squarely face the truth, even if it is sad, only then can we learn how to win" (Secretary General Nguyen Van Linh, October 1988); while in Vietnam, women reject the heroic-fighter image the world retains of them, and vocally condemn the notion of heroism as being monstrously inhuman,[22] numerous foreign sympathizers continue to hold fast to the image of an exemplary model of revolutionary society and to deny the multifacet problems the regime has been facing. Thus, all reflections on socialist Vietnam which do not abide by a certain socialist orthodoxy, positively embrace the system, and postulate the validity of its social organization, are crudely distorted as they are forced into the mold of hegemonic worldview and its lifelong infatuation with binary classifications: pro-communist/ anti-communist, left/right, good/bad, victory/failure. *"I am not a Marxist!" exclaimed Marx in despair of his disciples.*[23] In fact, it is imperative that socialist Vietnam remains "pure" and that it continues to be unconditionally praised, for, through past denunciations of "America's most controversial war," America can still prove that it is not entirely wrong, that "the Vietnam failure" should be attributed to a guilty government but not to "the American people." The West's friendliness and benevolence toward its Others often consists of granting itself the omnipotent rights to counteract its government and to choose, as circumstances dictate, when to endorse or when to detach itself from its institutions, while members from the Third World are required to stand by their kinsmen—government and people alike—and urged to show the

102

official seal of approval "back home" wherever they go, in what-
ever enterprise they undertake . . .

The Commodity contemplates itself in a world it has created.
And this world it has created is *boldly* that of "The Men, the
Weapons, the Battles." To say that the spectacle is always mas-
terly owned and that it aspires to genderlessness is to indulge
again and again in redundancy. But repetition is at times neces-
sary, for it has a function to fulfill, especially when it does not
present itself as the mechanical recurrence of sameness, but
rather, as the persistence of sameness in difference. If in Dogon
rituals men also "have their periods" and their days of "impu-
rity," no such reversal seems to be tolerated in a male-centered
context where the concept of gender is irremediably reduced to
a question of sexual difference or of universal sex opposition.
And since in such opposition, priority is always given to literal
reading and to the validation of "evidences" (essences), rather
than to the interrogation of representation, the tools of (gender)
production are bound to remain the Master's (invisible) tools.
(Thus, reacting to a film in which women's sufferings have been
commented upon by numerous women viewers as being "very
intense and depressive," a male viewer blurted out, after having
uneasily tried to put forth a lengthy weasel-worded question he
has embarked upon: " . . . The subject of the film is so partial . . .
Don't you think it overshadows the rest of the issues? . . . I mean,
how can one make a film on Vietnam, where there is so much
sufferings [sic] and focus on women?" A number of women in
the audience express their approval, others hiss.) While the male-
is-norm world continues to be taken for granted as the objective,
comprehensive societal world, the world of women subjects(ivi-
ties) can only be viewed in terms of partiality, individuality, and
incompleteness. The tendency is to *obscure* the issue of women's
oppression or of women's autonomy in a relation of mutual ex-
clusiveness rather than of interdependency. The impetus of the
positivist project is first and foremost to supply answers, hence

the need to level out all forms of oppression into one. *Not only has the question of women's liberation traditionally been bypassed by revolutionary organizations in the Third World (as it has in the West), but (again this applies to groups in the West) it has also become a target for hostility from the Left. . . .* (Miranda Davies).[24]

In the society of the male-centered spectacle, gender will always be denied, even and especially when the spectacle exalts feminism (heroic workers who are also good mothers and good wives). For, what the humanism of commodity markets is not two, three, but one, only One feminism. One package at a time in a policy of mutual exclusion. *To deny gender, first of all, is to deny the social relations of gender that constitute and validate the sexual oppression of women; and second, to deny gender is to remain "in ideology," an ideology which . . . is manifestly self-serving to the male-gendered subject* (Teresa de Lauretis).[25] The dogmatic, hence genderless mind has never been eager to ask why, for example, the bright red flowers of the Kapok tree are associated with menstruation and death in a context where "bad blood" is identified with dark, coagulated blood. As mentioned earlier, "impurity" is the interval in which the impure subject is feared and alienated. It is the state in which the issue of gender prevails, for if red defies all literal, male-centered elucidation, it is because it intimately belongs to women's domain, in other words, to women's struggles. To say this is simply to recognize that the impure subject cannot but challenge hegemonic divisions and boundaries. Bound to other marginalized groups, women are often "impure" because their red necessarily exceeds totalized discourses. In a society where they remain constantly at odds on occupied territories, women can only situate their social spaces precariously in the interstices of diverse systems of ownership. Their elsewhere is never a pure elsewhere, but only a no-escape-elsewhere, an elsewhere-within-here that enters in at the same time as it breaks with the circle of omnispectatorship, in which women always incur the risk of remaining endlessly a spectator,

whether to an object, an event, an attribute, a duty, an adherence, a classification, or a social process. The challenge of modifying frontiers is also that of producing a situated, shifting, and contingent difference in which the only constant is the emphasis on the irresistible to-and-fro movement across (sexual and political) boundaries: margins and centers, red and white. It has often been noted that in China ink painting there is a "lack of interest in natural color." One day, someone asked a painter why he painted his bamboos in red. When the painter replied "What color should they be?," the answer came: "Black, of course."

NS

6
*A Minute Too Long**

Whether we choose to concentrate on another culture, or on our own culture, our work will always be cross-cultural. It is bound to be so, and in my case, not only because of my personal background and historical actualities, but also and above all because of the heterogeneous reality we all live today, in postmodern times—a reality, therefore, that is not a mere crossing from one borderline to the other or that is not merely double, but a reality that involves the crossing of an indeterminate number of borderlines, one that remains multiple in its hyphenation.

Multiculturalism does not lead us very far if it remains a question of difference only between one culture and another. Differences should also be understood within the same culture, just as multiculturalism as an explicit condition of our times exists within every self. Intercultural, intersubjective, interdisciplinary. These are some of the keywords that keep on circulating in artistic and educational as well as political milieux. To cut across boundaries and borderlines is to live aloud the malaise of categories and labels; it is to

* Paper delivered as keynote address at The Orcas Conference on "Creative Support for the Creative Artist," at Orcas Islands, Washington, sponsored by the New York Foundation for the Arts, November 12–15, 1988.

resist simplistic attempts at classifying, to resist the comfort of belonging to a classification, and of producing classifiable *works. Interdisciplinary is, for example, not just a question of putting several fields together, so that individuals can share their specialized knowledge and converse with one another within their expertise. It is to create in sharing a field that belongs to no one, not even to those who create it. What is at stake, therefore, in this inter-creation is the very notion of* specialization *and of* expertise, *of* discipline *and* professionalism. *To identify oneself with a position of specialized knowledge, to see oneself as an expert or as an authority on certain matters, even and especially on artistic matters is to give up all attempts at understanding relations in the game of power. To survive, to live with heterogeneity , artists are necessarily polyvalent in their skills, their function, their role—so polyvalent, I would say, as to make the very label of "artist" appear simplistic and reductive. The idea of being an artist vs. being an art administrator, an academic, or a scholar, for example, is as untenable as the idea of defining oneself according to labels and formulas.*

Working creatively always entails change. To create is not so much to make something new as to shift. Not to shift from a lesser place to a higher or better one, but to shift, intransitively. Each creation I come up with is, at the personal level, a historical experience. It is a working out of an old problem and a formulation of a new question. A well-known theorist and an admirer of Bertolt Brecht (Fredric Jameson, 1988) recently reinstates that the function of art is "to teach, to move, to delight."[1] To accept such a definition is first of all to refuse to take for granted the meanings of teaching, moving, and delighting. These functions need to be re-contextualized accordingly, just like Brecht needs to be re-read in our times. I am not interested, for example, in making films to teach someone a lesson. Nor am I interested in making films that induce people to cry, that solicit identification with the image seen, and facilitate consumption through a well-formulated story-spectacle or well-packaged information.

108

I am, however, interested in making films that further engage filmmaking, *and contribute to the body of existing works that inspire and generate other works. In this process of mutual learning, of constant modification in consciousness, the relation between filmmaker, filmed subject, and film viewer becomes so tightly interdependent that the reading of the film can never be reduced to the filmmaker's intentions. With this comes today's much debated questioning of art as a vehicle for* self-expression *and of* originality *as an attribute of the artist's individuality. Instead of re-opening these questions, I will just move on here to further state that "raising consciousness" in this context does not consist of telling people what they don't know, but of* awakening their reflective and critical ability. *For I know I do not learn anything when I am told what to learn; I learn when the learning comes as much from myself as a viewer as from the film I see. Reading a film is a creative act and I will continue to make films whose reading I may provoke and initiate but do not control. A film is like a page of paper which I offer the viewers. I am responsible for what is within the boundary of the paper but I do not control and do not wish to control its folding. The viewers can fold it horizontally, obliquely, vertically; they can weave the elements to their liking and background. This interfolding and interviewing situation is what I consider to be most exciting in making films.*

The question whether Film is Art or not, and whether it deserves the attention of art funding sources, is one that, to my great surprise—but also pleasure—is still very much alive and continues to be raised or reactivated among grantmakers. I am surprised because film-as-art was a battle fought years ago by such pioneering women filmmakers in the West as Germaine Dulac and Maya Deren, both of whose films and writings on film have greatly contributed to the making of the history of avant-garde cinema. In their work, both Dulac and Deren repeatedly compared film with the other arts in order to carve for it a space of its own. Today, over 60 years since Dulac's Coquille et le Clergyman *and 45 since Deren's* At Land,

109

such a need for a justification seems quite obsolete and redundant. Yet the question still circulates, and, as I said, I am also pleased that it does, because hopefully, it does not lead us back to the old battles that Dulac and Deren fought, but is necessarily the result of an ongoing attempt at questioning and modifying the limits of filmmaking as practiced by a number of producers and as widely circulated in the media networks. Nothing should be taken for granted, especially not "art." And rare are the art works that deal precisely with the boundaries of art—instead of being merely instrumental to "self-expression."

Cinema can be defined as a composite art based on the involvement of a number of arts. This does not mean that it is simply an amalgam of the principles of other contiguous art forms. As Andrei Tarkovsky noted: "a meld of literary thought and painterly form will not be a cinematic image: it can only produce a more or less empty or pretentious hybrid." To reduce cinema to such a mishmash is, at best, to achieve "a mere semblance of harmony in which the heart of cinema is not to be found."[2] The differentiation made by Tarkovsky here between the creative and the cumulative processes leads us back to the question of "interdisciplinary" raised earlier, more particularly to the challenge of creating a field/an art that defies the notion of discipline/art. Of importance, then, is how the malaise of categories is materialized as well as how the exercise of coercive power implied in the notion of "professionalism" and its hierarchical system of classification is nullified.

As the philosopher Gilles Deleuze remarks, our civilization is not one of the image, but rather, a civilization of the cliché. We often read images on the level of metaphors and perceive meaning as something there, already existing. What seems more difficult is to see an image as image, without metaphors, with its excess, its radical or unjustifiable character. To find again, to restore all that one does not see in the image is not simply to parody the cliché or to correct it. Rather it implies disturbing the comfort and security

110

of stable meaning that leads to a different conception of montage, of framing and reframing in which the notions of time and of movement are redefined, while no single reading can exhaust the dimensions of the image.

Why do people go to the cinema? What takes them into a darkened room where for two hours their attention is riveted on the play of lights and shadows on a screen? Is it the search for entertainment, as is so often claimed and repeated? All over the world there are, indeed, entertainment firms and organizations which exploit—as commodities—cinema, television, and spectacles of other kinds. But, again, as this well-known poet of cinema—Tarkovsky—affirms: "what people normally go to the cinema for is time: for time lost or spent or not yet had. They go there for living experience; for cinema, like no other art, widens, enhances, and concentrates a person's experience—and not only enhances it but makes it longer, significantly longer. That is the power of cinema: 'stars,' story-lines, and entertainment have nothing to do with it."[3] The Director's work in this context is that of sculpting in time.

To understand the importance of working with time in filmmaking is to understand that the function of the mise-en-scène cannot be reduced to expressing the meaning of what is happening, as it is usually thought of. For example: to show a quantity of skulls to convey the horror of war and to signify death is to reduce war and death to its most banal form. Blurring the image to signal the passage of reality to dream, using fade-ins and fade-outs to tell the passage of time; placing an all-knowing (preferably male) voice-over with its marked neutrally scientific tone to perpetuate the master's knowledge and to package information for the viewer—all these are formulas whose mechanical, repeated uses result in "formula films" that deserve the kind of audience they normally get and continue to engender. The spectators immediately knock their heads against the ceiling of the director's intention. A number of audiences do enjoy such immediate accessibility, mainly because it gives them the illusion that they know where they're going. That they see all and

111

can even foresee what will happen. The idea is clear and there's no need to strain the brain or the eye. The cliched image dominates the film scene.

Our experiences in life are complex, plural, and full of uncertainties. And this complexity can never be reduced and fitted into the rigid corners of ready-made solutions and filmic conventions. Mise-en-scène as the montage and recreation of the texture of life and of the inner dynamics of the subject filmed would have to incorporate the heterogeneity of living experience. The notion of the film image as a precise observation of our daily environment and activities, takes us straight back in the case of Tarkovsky, who like Sergei Eisenstein in part likened his filmmaking to the poetic principle of the haiku. "What attracts me in Haikku," wrote Tarkovsky, "is its observation of life—pure, subtle, one with its subject. . . . And although I am very chary of making comparisons with other art forms, this particular example from poetry seems to me close to the truth of cinema."[4] To me, the most inspiring works of art are those that cut across the boundaries of specific art form and specific cultures, even in their most specific aspects. ("Whenever culture is limited," says filmmaker Sarah Maldoror, "it stagnates."[5]) Some well-known examples in the arts and humanities of the West include Brecht's powerful work influenced by Chinese and Japanese theaters; Eisenstein's filmic portraits and methods of montage inspired by Sharaku's drawings and paintings; John Cage's silences and music inspirited by Zen Buddhism; Roland Barthes's écriture informed by the principles of Asian art, which he describes as "always seeking to paint the void," or better, as grasping "the representable object in that rare moment when the plenitude of its identity falls abruptly into a new space, that of the Interstice."[6]

Working with that new in-between-the-naming space, and reconceiving time in film are precisely the areas that a number of women filmmakers have been exploring for sometime now. Feminist consciousness is understood here not as a state of awareness arrived at after an accumulation of knowledge and experiences, but as the

112

term of a process. It is a dialectical understanding and practice of identity and difference; a consciousness of identity not as the end point but rather the point of re-departure of the processes by which one has come to understand how the personal—the ethnic me, the female me—is political. Subjectivity cannot therefore be reduced to a mere expression of the self. The identity question and the personal/ political relationship is a way of rewriting culture. What seems necessary today are works that address each viewer in her unique (but) social self, that speak to her personally, inviting her to perceive them according to her own experience and background while soliciting at the same time her ability to reflect on her social conditioning or on the ties that bind her to other social selves in the very process of perceiving. These works allow her to assert her difference in relation to other viewers around her, not by individualizing her perception but more precisely, by setting into relief the type of individualization that links her (whether centrally or marginally) as an individual to the systems of dominant values. It is by assuming her role as active viewer in the operation of reading and re-reading the incidences that form the filmic text, therefore, of producing meanings, that she takes up the social challenge issued with or by the work. Not every personal event is political, but all personal events certainly have the potential to be political. The personal politicized and the political personalized is the in-between ground where the questioning work materializes itself and resists its status as mere object of consumption. It is this critical stance maintained toward the self-other, personal-political relationship that informs feminist consciousness of the oppressive workings of both patriarchal and hegemonic ideology.

So when some of us insist on art as self-expression or as expression of the inner vision of the artist, the woman artist, we are bound again to inquire how such a statement "encodes the natural," how it can replace the political by the personal and how it can depoliticize the self by reducing it to the particularities of an individual. The self is always in the making. With each work, we will have

113

to face these issues of modern subjectivity, such as attraction and repulsion of facile art and facile information; such as commitment within a context of ideological lassitude disillusionment; such as self-reflexivity and constant interrogations within a context of easy prescriptions; such as continuous struggle within a context of pervasive consumption and cooptation; such as responsibility within a context of uneasy conscience where one realizes one is often the oppressor of someone else.

The place from which the woman artist works is always fragile, because empowerment of the self can only be achieved by emptying, reversing, and displacing power relations. (Upon the first screening of her film India Song, Marguerite Duras who shapes the very terms of cinema to her desire, noted that she "had been dispossessed, not only of a given area, a place, my habitat, . . . but even of my identity."⁷) She takes the plunge. She risks all or she risks nothing, because she has nothing to save. Seeing differently and hearing differently, she is bound always to challenge the "look" in the cinematic apparatus—or the system of looks that distinguishes cinema from other art forms. It is, for example, the insistence on the relationship of the look to the making and/or speaking subject that characterizes Chantal Akerman's films; a look that is alternately attentive and obsessive in its love and respect for the woman's space, gestures, and activities. "Any form of power," as Roland Barthes observes, "because of its violence, never gazes; if it were to gaze a minute too long it would lose its essence of power."⁸ To pause and look more closely than is required, to look at what one is not supposed to look at in the context of cinema action, cinema affection, cinema superproduction, upsets the established order in all its forms, to the degree that the very duration or intensity of the gaze is controlled by society. Hence, the outrageous nature of certain films when they escape this control, not because they are indecent or aggressive but simply because they foreground the "pose." Because what one can call the movement-image, which characterizes the concept of filmmaking in mainstream cinema and equates action

114

to movement, is being challenged here by the time-image in which time is no longer made the measure of movement, but rather, through movement, a perspective of time is made visible.[9] The image is subversive, not through violence and agression, but through duration and intensity. The eye that gazes with passion and acuteness is one that induces us vaguely to think—as the object it sees is an object that speaks. The image that speaks and speaks volumes for what it is not supposed to say—the pensive image—is one that does not facilitate consumption and challenges the mainstream film in its most basic assumptions. It disturbs it in its skilled manipulations of visual pleasure, in the way it has coded the other of man and the other of the West—the exotic and erotic feminine ethnic minority. It unsettles the male apparatus of the gaze, in which men own, articulate, and create the look while woman is either being looked-at (displayed for the gaze of male protagonists as well as of male spectators), or she only holds the look to signify the master's desire. In objectifying the other and subjecting her to a controlling, all-knowing male gaze (the director's), the ideology of representation of mainstream cinema works at rendering invisible the two other looks: the camera's look whose discretion is indispensable to creating a convincing world of verisimilitude and the audience's look whose denial is reflected in the skillful strategies that prevent them from questioning the believability of the image and to see through its construct.[10]

Each film is a way of experiencing and experimenting with limits; it is a journey from which there is no turning back. In reversing, displacing, and creating anew the gaze, her film will not be offering an object to look at but an articulation of images to consider. When she introduces the object, the latter immediately poses the question of look and position which, in traditional cinema, it would so carefully conceal. ("What the images have in common," says Duras with respect to her films, "is that they are always a space offered, but never occupied."[11]) Closing this paper on the relation between the work and her desire is to start it again on the relation between

money and images, which in a way, remains the focus of this conference. Jean-Luc Godard used to say "the cinema is all money but the money figures twice: first you spend all your time running to get the money to make the film but then in the film the money comes back again, in the image." In one of his film projects, one reads "Let the images flow faster than money does." Commercial cinema works at eschewing the financial determinations of its images (or to hide it only to better validate it; hence the common habit of looking at films as "low budget" and "big budget") so that they can function more effectively as phantasy. Intensifying time-in-/ timing the image, slowing it down or speeding it beyond the normalized limits of acceptance for viewing may contribute to exposing the money and displaying the very constitution of the phantasy; it may also allow the viewer to scrutinize the image in its money-power or de-power, so that there can be moments, as Godard puts it, where "speaking about money [is] a way of speaking about art."[12]

Illustration on next page.

SV

7
L'Innécriture:
Un-writing/Inmost Writing*

Masculine, feminine, or bisexual?

Three stages have occurred in the history of women's libera-
tion: "femininity experienced as a handicap—in the name of its
inferiority; femininity disabled in the world of virility—in the
name of equality; womanhood vaunted like negritude—in the
name of difference." These three still coexist today, remarks
Mariella Righini, who concludes: "I passed by the first two with-
out ever really recognizing myself in them."[1] Convenient, sim-
plistic, and linear (as are all attempts at classification), this
representation correctly reflects general opinion on the women's
movement. Three conventional images that the word feminism
incessantly evokes: the docile woman, crushed by an inferiority
complex; the frustrated woman, wanting to be more of a man
than the men; and the suspicious woman, vaunting her differ-
ence. Such a simplification naturally leads most independent
women to refuse the feminist label. Categories erase the anarchy

* Originally published in French in *French Forum*, Vol. 8 No. 1 (January 1983),
this essay has been translated into English by Elizabeth C. Wright (San Francisco
State University).

of difference; the rejection of (a) label(s) is obviously a protest against this kind of compartmentalization. Thus, to assume responsibility as a feminist, is, necessarily, to be aware of the established limits and to remove the censure of "non-categorical" thought (Foucault)—thought in which the interval is a quick flash: between a Do and a Re, exist not only a half, a quarter, an eighth of a tone, but a whole variety of shifts and fluctuations of sound. Imitating, copying, aping man: the same reproaches around which critics (men and women, feminist or non-feminist) continue to circle. Why keep trotting out the same themes when they have already been exhaustively discussed by the instigators of the struggle? No feminist writing, to my knowledge, has been able to ignore the danger of uniformity. To understand the women's movement, is first to make a distinction between equality and similarity.

The difficulty, naturally, is to live out a theory fully. How is it possible not to slip or skid when one has to walk along an abyss and at the same time measure its depth? Who among us would be pretentious enough to claim to be "liberated" from all dominant values? But one must continue along the path and not dwell over a few false steps, at the risk of losing one's way. Looking at things always from the same angle doesn't allow us to break with this circular reasoning. These three images of women, we recognize all of them in us, without however identifying solely with one of them. They appear neither in successive stages, nor as separate entities, but simultaneously, surreptitiously, as traces of ourselves.

Femaleness [féminitude] proclaimed in the name of difference: the other extreme of the struggle. Many women have difficulty in recognizing themselves here. To vaunt difference for the sake of difference has always been a double-edged sword. It's useless to go back to the old arguments which, while praising women, enclosed them and stripped them of freedom in the name of biological difference. The choice of a direction opposite to the one rejected remains a reaction within the same frame of references.

Furthermore, the association blacks/women cannot be made without reservations; the risk of falling back into imitation is always present. Negritude itself has become an outdated attitude. Analyzed in depth and thoroughly challenged by numerous writers (Fanon, Towa, Adotevi, Mphalele), it has been rejected along with the anti-colonialism by the young African writers, in particular those of the new Nigerian literature, for its abstract and illusory quality. Negritude as a soporific for the Negro causes revulsion, some have denounced the abusive exploitation of the reactionary and Senghorian myth of the black soul in this manner: "The Negro in his Negro-ness couldn't give a damn about Negritude. . . . If he sees Negro-ly when he needs to see straight, he loses himself, he loses his Negro-ness by losing his sight."[2] Weakness becomes strength when consciousness is born (Gisèle Halimi); it's not a matter of erecting a wall in order to go against one's conditioning, but of maintaining one's awareness. To accept one's difference does not necessarily mean to valorize it. Since "my femininity doesn't owe you anything" (Righini), why feel the necessity to hide it or to proclaim it? "A tiger does not proclaim his tigritude, he pounces" (Wole Soyinka).

Not "masculine," not completely "feminine" either. This last word is suitable only when corrected; it must, so to speak, extend itself beyond its alienating meaning. Refusing the label of feminist, many women who write feel even more repulsion for the qualifier "feminine" inevitably linked to words such as "work," "literature," "language," "writing." Susan Sontag, who doesn't hesitate to declare herself feminist, specifies however: "To say that my work is "feminine" . . . I don't accept it. That's a limitation. I want to go beyond these limits, while still being completely within, inside."[3] This last sentence highlights the fragile position of the woman writer who, moving forward on unstable ground, can, like Jacques Rigaut, state: "And even when I affirm something, I am still questioning."

Refusal, correction, or else stubbornness. In order to exclude

all biases and misunderstandings, a woman must constantly explain the words she uses. Marie Cardinal cites an example of this in *Autrement dit* (Paris: Grasset, 1977): "freedom" written by a man is understood immediately as freedom; the same word coming from a woman must be clarified if she doesn't want freedom to be understood as licentiousness. Thus, while ridiculing the title of writer for its mythical and masculine attributes, Cardinal insists on its use as part of the struggle:

> "Writer" and "literary" are words that need to be opened out, expanded, invigorated. I believe critics and readers must get in the habit of letting us use words as they are, without adding or taking away from them a feminine (and still less feminist) connotation when it is we, women, who are employing them. (p. 87)

A woman for whom the question of truth and authenticity presents itself as a vital necessity cannot, without feeling herself betrayed, use a language whose words reflect man's occupation of the territory. On the other hand, feminizing words would seem to be valorizing difference, creating a new alienation by the invention of a new specialized language. What to do? Here we are again faced with the impasse of extremes. The question seems all the more urgent because the attempts to respond to it have their own internal contradictions. No language to use just between us women!, says Cardinal. Let's use the same words without inhibition or compromise. "The public, once they've gotten over the initial shock, understands, especially women who in ever greater numbers want to express themselves" (p. 96). Which comes back to saying: let's understand words *among us*, the public will end up coming around and giving them the meaning we want. Two different approaches whose goal seems exactly the same.

In an article on "Contemporary Feminine Literature in France,"[4] Henri Peyre remarks that in composing a sonata or a novel, a man never feels the necessity to express his male self or to prove his artistic and literary virility. This reasoning leads

122

naturally to the conclusion that a woman, likewise, does not have to feel herself more of a woman in writing a work of imagination than the one who, for example, carves an abstract sculpture or drafts a university thesis. This observation, linked to the apprehension we observed on the part of women for a feminine touch added to or taken away from words, gives us much to think about. Certainly, challenging the solidarity of logocentrism and phallocentrism, unmasking the hypocrisy of a system—whose cracks have always existed even though not well known—in order to bring about a change in the goals and meaning of life, cannot be reduced to a simple valorization of artistic or literary femininity.

Having always assumed the right to speak for the other, men obviously didn't think about expressing the male condition in their works. Besides, isn't it redundant to try to prove literary virility in an already virile language? These questions remain foreign to the one who, in his limited world, moves about as master. His vision is a one-way street; his privileged position hasn't allowed him to benefit from that double vision inherent in any dominated person—male or female. There are exceptions naturally: sensitive, non-coded, mobile beings have always existed. And one sees more and more works appearing in which men conscious of their limits and respectful of differences, no longer claim to speak for women. The multiplication of voices constitutes a form of decentralization. The abdication of the author-God is here not an impoverishing of perception, but an enrichment through plurality.

A woman can, as a writer, not feel the need to show herself as a woman in her works. Can she, however, ignore the existence of a different reading of words? Isn't the author also the first [female] reader? An affirmative reply to these questions resides in the choice of a "bisexual-neutral" form of writing. The positions taken on this question are unequivocal. For Cardinal, technical, specialized language is read in the same way, whether it's used by a man or a woman. The latter, in choosing it, would immedi-

ately be taken seriously; the battle would be a draw. This often "hermetic and incomprehensible language", used mainly by thinkers and philosophers, would however, as in the past, have to be written for a privileged audience, an elite. Now, we notice today that these thinkers and philosophers have a great desire to reach an audience much wider than a specialized one; for that reason they are publishing with well-known and non-specialized houses such as Grasset, Seuil, Gallimard. Cardinal interprets this "inconsistency" as the result of an inner censorship which favors the use of technical language. This language, she specifies, not only has no sex, but *allows nothing of the body of those who are using it to pass through.* The serviceable words are without scars: "there's no way one can take hold of them" and "they usually haven't had the time to live." "Are they [Barthes, Deleuze, Foucault, Dollé, Poulantzas] so afraid of their *body* that they no longer have a *voice?* What are the true words they're hiding behind their erudition?" (pp. 90–95, italics mine).

For Hélène Cixous, scorn for a neutral language is directed mainly to the immense majority of a "species of women scribblers," a majority "whose technique is indistinguishable from masculine writing, and who either hide their womanhood or reproduce classical representations of women." To a notion of bisexuality conceived as fusion, erasure, traditionally thought of as "neutral" and as a fantasy of a total being—"Two in one, and still not even two"—Cixous opposes *another bisexuality*, that of the "discovery in oneself, individually, of the presence, diversely manifest and insistent according to each man or woman, of both sexes, non-exclusion of difference nor of sex, and from this 'permission' that one gives oneself, multiplication of the effects of the inscription of desire, on all the parts of my body and the other body." Two almost opposite ways of conceiving bisexuality or, as we have seen, feminism. This bisexuality "which doesn't nullify differences but vivifies them, pursues them, adds them, it happens that today for historico-cultural reasons, it is women who open up to it and benefit from it: in a certain way 'women

are bisexual.' Men . . . trained to aim for glorious phallic mono-sexuality . . . are afraid to be women."[5] Repressing feminity, it is difficult for a man not to see in a change to bisexuality a *Lack*[6] of virility, a sign of de-masculinization or of mental deterioration. Duality for him can be de-structuring, while for a woman, notes Eugénie Lemoine-Lucioni, it constitutes "a moment of release of *one of her possibilities*" (italics mine). Even in her "neutral" stage, the woman writer "doesn't ape, she is also the man [she is imitating]. But she never reduces herself to that alone."[7]

The space between or un-writing

Many women writers, like Marie Cardinal, refuse the existence of a feminine or masculine writing while admitting that sexist reading does exist. Writing cannot however happen without reading. These two activities, whose interpenetration is obvious, are inseparable. To read attentively is, in a certain way, to write through an intermediary; the writer is, also, the first reader of his/her text. What can one conclude from this? Would bisexuality then be an essential condition of all writerliness? It is at the heart of writing, agrees Gabrielle Frémont; "it is a masculine-feminine subject who writes—and who reads," affirms Christian David.[8] To this claim (the male writer now proclaims his right to bisexuality!), which expels differentiation, Cixous replies specifically:

> I will say: today writing belongs to women. This is not a provoca-tion, it means that: women admit the existence of the other. . . . For a man, it is much more difficult to let himself be traversed by the other. Writing is in me the passing through, entering, going out, staying, of the other who is me and not me, who I cannot be, but whom I feel pass through, who nourishes me . . . feminine, masculine, plural? . . . It's agonizing, it wears one out; and for men, this permeability, this non-exclusion, is a threat, intolerable. . . . By her openness, a woman can be "possessed," that is dispossessed of herself. But I speak here of femininity as keeping alive the other. . . . Loving to be other, another, without this having to entail neces-sarily the debasing of the same, of the self. ("Sorties," p. 158)

These lines incite women to become conscious of their predisposition for writing and inherent capacities as "subordinates" and "procreators." They do not banish men from an innovative position and do not exclude the ever-present exceptions mentioned above: complex, open men for whom the linking of femininity and bisexuality *has taken nothing away.*

Cixous is not alone in her statement. Many "great" masculine names put forth convergent points of view in their analyses. The philosophy of difference will replace that of truth and identity, notes Foucault. One of the three principles according to which the information revolution guides itself, observes Marshall McLuhan, is the "general shift from professional and specialized 'jobs' to open 'roles' which demand, instead of detachment and scientific objectivity, total commitment and full participation."[9] "In fact," he adds, "the information revolution gives the world to women because they are better equipped to play roles and to commit themselves in a personal manner than the male experts who have built a world of brick and iron" (p. 156). McLuhan's study of the change from "job" to "role," from forms of "hardware" (object) to "software" (information) and the manner in which he situates women in relation to this transformation, intersects and confirms on many points the demands of a different life and the convictions, reflected in Cixous's texts, about change through writing.

Resistance to renewal remains a mechanism for defending and preserving. We live in the electronic era of instantaneous information and of "software," but our thoughts and reactions are still in the mechanized period of "hardware." Still lingering under the system of centralization, contemporary society tends towards standardization; it needs "human atoms" which are all alike, and whose functioning in an aggregate mass would be without friction. Public opinion conforms to this social process of standardization (hidden behind the banner of equality) when it preaches with so much conviction that "the soul has no sex." Must one understand in this way those who declare plainly and

126

openly that "feminine writing doesn't exist"? Or/and should one refer to Leonardo de Vinci's phrase, even though it is trite, about works of art: "Greater knowledge equals greater love"? It is easy to eliminate the unknown; and we are invariably one step behind what is current. "The present is always invisible," observes McLuhan, "because it is an integral part of our environment and because it saturates, in the literal sense of the word, the total field of our environment" (p. 33). It is in this spirit also that one can explain the caution, suspicion, or skepticism detectable in certain writings, such as Anne D. Ketchum's article titled "*Towards* a Feminine Writing" (italics mine), whose epigraph quotes Perrault: "Sister Anne, my sister Anne, don't you see anything coming?" Is the situation really one "to cry over"? And is it only a matter of a few "very praiseworthy efforts tried so far" or of voices "heralding what is to come"?[10] The feminine practice of writing does not however currently situate itself at an "experimental" stage. It neither precedes nor does it aim for a more perfected state which will later be able to be defined or theorized. Thus Cixous's reminder:

> (1) . . . sexual opposition, which has always been made for man's benefit, to the point of reducing writing to its laws, is only an historico-cultural limit. *There are, there will be* now in an ever stronger and rapid manner a fiction which will produce clear effects of femininity. (2) . . . it is through *lack of understanding* that most readers, critics and writers of both sexes hesitate to admit or flatly deny the possibility or relevance of a feminine writing / masculine writing distinction. ("Le Rire," p. 146; italics mine)

And she doesn't hesitate to state elsewhere:

> I maintain, without equivocation, that there are *marked* writing styles, that writing has been up to the present . . . a place that has superficially carried all the signs of sexual opposition (and not difference) and where women have never had their say. (*Ibid.*, p. 42)

To distinguish and to set in opposition are not the same. To reduce feminine writing to a simple opposition is again to misun-

127

derstand it. The conventions of such an approach have been discussed above. One cannot approach the problem solely from the angle of a split between symbolic language-phallus-man / repressed language-hole-woman (Gabrielle Frémont); this over-simplification leads us straight to the criticism of categorization favored by the "hardware" system. The existence of "marked" or "pointed" writing practices (Annie Leclerc) raises however a multitude of questions, obvious but hard to answer. Aside from these different readings and listenings (thus utilizations) of signifiers, how do women distinguish, for example, their writing practices from those of men? How do they live out bisexuality in their languages?

We know Marie Cardinal's position: neither justify yourself nor explain yourself, "write brutally and disrespectfully." When writing, women should no longer excuse themselves nor put make-up on (themselves) in order to please. We must get rid of writing that is ornate, embellished with images, baubles, lace, disguises; that is "ravishing," but doesn't have "the brutal and simple strength of beautiful writing by men" (*Autrement dit*, p. 83). In order to avoid imprisonment anew in the feminine ghetto, it is important to use the same language without taking into account prohibitions on usage, without adapting it, without touching it up, and to force, by this disrespectful usage, the reader to open up the meaning of words. The change takes place here in the content of *the same form*. In addressing Annie Leclerc concerning the controversy raised by the word love, Cardinal expresses herself in this manner: "You don't need to explain. To whom would these explanations be addressed? To those who don't want to imagine that there is another writing, another discourse? Drop them" (*Ibid.*, p. 90). Cardinal's position emerges with more clarity: negating earlier the existence of a feminine or masculine writing and affirming here the presence of *another* discourse, Cardinal demonstrates that her refusal is aimed above all at the qualifier "feminine" and the label "feminist." What is,

then, for Cardinal and for those women who share her views, this *other* writing?

Let's retrace the path of Cardinal's thought on this subject. All her demands seem in fact to limit themselves to a release of the feminine *in the past* and to equality in the *established* use of words. The "I want to be free" of a woman must have the same "greatness" and "beauty" of the "I want to be free" of a man (p. 88). Cardinal ostensibly aspires to a writing whose "brutal and simple strength" is equivalent to man's. Desire for paternity? Inevitable recourse to the seal of approval from male authority? Not exactly. Cardinal wants, through an unchanged use of the material, to denounce the shortcomings of existing language and its failure to translate women's truths. For that we must, she says, "place ourselves on the border of our bodies, express the unexpressed" (p. 89).

This statement will not fail to arouse negative reactions. A woman's body? We don't want to hear any more about it! They talk about nothing but that! Both men and women do not hesitate to show their irritation or disgust as soon the association body/ feminine writing appears. "Writing the body?"—what could be more deceptive?, exclaim certain people through false questioning. Indignant commentaries and analyses continue thus to gush out around this notion, taken out of context from the stream of feminine discourse. Among this "inextricable jumble of ivy and vines" (Xavière Gauthier), what security must be felt when one seems to find a guiding thread? What could be more vain, in fact, than this attempt to enclose a parcel of air in the box of categories? Can one understand the new without abandoning the old criteria? To isolate the word body-writing from its web of meaning is to force it into a context to which it cannot be reduced.

In India, sadness was defined as resulting from the *loss* of something desired or from the *acquisition* of something not desired. "In the West," observes John Cage, "only part of that definition was given." In order to understand what "the other writing" *is*, one must know what it *is not* according to Cardinal. We

129

have seen that *it is not neutral:* it can hardly be identified with this asexual language which "lets nothing of the body which uses it pass through." *It is not respectful:* Cardinal refuses the hypocritical flourishes, such as the word "sanies" which a critic suggested to her in place of "dung" or "shit," on the pretext that the latter are "unbearable." Taking as an example Tournier's highly praised book, *Les Météores,* "a magnificent ode to homosexuality, to feces," Cardinal questions: "Why, when men speak about it, are they courageous and strong and why is it shameful when women speak about it? Why? Feces are feces" (p. 86). Other pertinent examples have been cited; many women writers (Gisèle Halimi and Simone de Beauvoir) have had to face the same prohibitions (p. 83). To dare to say anything that is not said. We often forget what this act still represents for so many women, especially when it must be done in front of or for an unknown public.

Writing is above all releasing oneself from external censorship. This task, which men don't accomplish without difficulty, demands even more from a woman for whom the margin of social acceptability remains minimal. Reading one of Annie Leclerc's manuscripts, Cardinal comments: "Sometimes it seems as if there is someone outside your text to whom you're accountable, someone who threatens you, who frightens you somewhere. You must not, this is no longer necessary" (p. 215). The need to justify (oneself) keeps the subject under supervision. S/he must necessarily depart from the fusioned neutral "he" and, without discarding anything, take on openly the existence of "she." For writing also means going beyond the internal censor—the censorship writers impose on themselves in order not to unmask and which privileges the use of technical asexual language (p. 93). Rare are those who, like Artaud, know "at what point in its carnal trajectory . . . the soul finds the absolute word, new speech, the interior land."[11] Words too close to life *expose.* They share with the readers an intimacy that demands an equal laying bare and commitment on their part. "Placing oneself level with the body"

in writing, is, among other things, putting one's finger on the obvious, on difference, on prohibition, on life.

The separation of art and life, so peculiar to the West, has been violently denounced since the beginning of the century in all artistic domains.[12] *To live and not to imitate*—this necessity, which has become a keyword in all intellectual circles, seems nevertheless to have suffered the unchanging destiny of ideas which remain at the level of a concept. The attempts to put this into practice are numerous, but often ambiguous, for they are often paradoxically limited to artistic preoccupations. One truth for daily life and another for conversations; women unanimously refuse this loss of the "substance" of words, this division between the Senses and the Intellect, this lack of rigor and of continuity in the practice of a theory whose defense constitutes, however, to varying degrees, a question of life or death. "Iconoclasts, yes," notes Laure, "but not fakes."[13] Whole in her actions, a woman cannot write or speak without also engaging her body:

> Listen to a woman speak in a meeting: she doesn't "speak," she launches her trembling body into the air, she *lets* herself *go*, she flies, she passes completely into her voice, it's with her body that she vitally sustains the "logic" of her speech.... She exposes herself. In truth, she materially incarnates what she thinks, she signifies it with her body. In a way, she *inscribes* what she says. (Cixous, "Le Rire," p. 44)

A woman "brings her story into the story"; in freeing herself from speech enslaved to mastery, "petty, reluctant speech . . . which engages only the smallest part of the body plus the mask" (Cixous), she cannot censure her body (or allow it to be censured) without censuring at the same time her breath. "Write the body" or write oneself.

Of this absolute proximity to the self, one example is striking. To evoke the name of Laure is to relive all the vibrations and flayings of a relentless struggle against the loss of one's own substance. Her cries haunt her writings. Ferociously insisting on the integrity of self, a "profound harmony between oneself and

131

all the moments of life" (*Ecrits*, p. 194), Laure—her whole self—
is in her writing. The poetic work is "rape of one's self,"
" 'communication' experienced as *nudity* (p. 116); access to it is
selective:

> The slow contrition of the weak
> They live from the life of cadavers
> To put on my door . . .
> "Here one lives naked"
> or they lived naked
> or she lives naked (p. 144)

Laure hates artifice in life as in words:

> We are all very learned apes. . . .
> Watch out: are they going to notice that *black* means
> *white*, but no, no, never.
> It's simple: no possibility of true exchanges . . .
> You ought to be a little more mistrustful—make my
> words resound the way one verifies one's change: the
> change from your coin.
> The "normal," infantile, voice, brooding ferocious
> irony. . . . But you are so well trained that you don't feel
> it.
> Who could suppose that one could go so far with dis-
> simulation that hides only oneself, and not actions, facts,
> self-serving, calculated goals. (p. 156)

In order to give back to words all their weight and meaning,
Laure deflects them from their customary meaning. She insists
on giving them a (her) soul, a substance whose sonority would
be that of the Pure Cry. She turns their meaning over and back
again, leads them to death through their own repercussions in
order to inhabit them more completely. "Life only gives in pro-
portion to what one gives to it," she writes; it's the same for
words.

Laure aspires to spend without reserve. She offers herself com-
pletely in order to receive the maximum from life, or, as Artaud
says, in order to "render the borders of what is called reality,

infinite." She writes in order to lose herself and to save herself/ run away [se sauver]—more precisely, in order to *burn/go through questions:*

> Decomposed life—to dissolve myself
> and then self-doubt up to the inmost depths of the
> death instinct . . . the light certainly of *doubt*—doubt
> which brushes *everything*
> This is not nihilism. (pp. 328–29)

Challenging oneself inevitably implies challenging the other, and the other in oneself. To refuse the transaction with integrity, is to bring out the neutral "il" (it/he):

> I am immobile and he/it goes ahead. . . .
> his gestures, his actions, the sound of his voice, weigh
> on me so strongly that life suffocates in my heart. . . .
> They've made us into beings who fear our own voice.
> (p. 200)

> Because he understands everything, doesn't he risk
> falling into indifference; and doesn't that universal identi-
> fication, assimilation, end up in alienation and the final
> loss of one's own substance. (p. 197)

> Above all, above all don't accept the presence which
> kills, annihilates your strength. Don't accept what lessens
> you. (p. 190)

> George . . . you think you have enslaved forever my
> existence—you see it all closed in, defined, limited—the
> limits which you predict, which are known to you and
> you leave . . . to live truly and secretly—or at least you
> believe that. (p. 317)

> loss of intelligence
> husband
> dissolution I should have living space
> common (p. 329)

The doubt of the God Bataille touches lightly all the pages of *Ecrits*—this "God Machiavelli Neurosis" who carries within him all the male values of the common man:

Man—God facing woman
Liberation? . . .
One crushes the other
 suppresses
 kills
 asphyxiates (p. 216)

Man: he enters by a small low door, crosses over a few steps and finds himself in a room. He is free from any hindrance
 then he comes out again face smooth as if purified, he goes out again by another door, another street he goes to the Communist meeting—he's going to speak
 he who just came from buying women. . . . How can beings respectful of the rights of future men—respectful of proletarians see a prostitute as a vehicle of their pleasure? They don't see the woman the human being come from where? oppressed by what or by whom in order to have come to that point? (p. 235)

In the shitholes
In the shitholes the heights
idealism, the people who go up on a high mountain and *are crushed* by that mountain. . . .
 Sincerity, you are a slit and a hole, abyss, you are not a summit. (p. 143)

In her quest for authenticity, Laure recalls, initially, Cardinal: the same renewal of content, the same desire to break through the superficiality and the limits given to words (the distress felt by Laure when faced with what is mediocre and common, is here also that felt by Cixous or women in general faced with the "deaf masculine ear which only hears in language what is spoken in masculine terms"), the same investment of herself in writing. "Only a perfect inner harmony, a perfect honesty, can make me

turn to the act of writing," declares Cardinal (*Autrement dit*, p. 54). The fierce struggle of these two women—Laure and Cardinal—against the loss of self reveals however adherence to that philosophy that Foucault calls the philosophy of identity and truth. In wanting Absolute Presence, they uphold the most profound goal of the metaphysics of *pure subjectivity*[14]—a goal whose pursuit ends in madness. The illusory search for a *pure* unseparated body is a journey to the end of the night. Laure is fully conscious of this; her disappointment as a writer, her agonizing sense of the limits of language, run through her *Ecrits:*

> *Cripure* is condemned in advance, even and especially it is Pure cry [*Cri pur*] (p. 205)

> The paper is smooth / smooth smooth
> one can't catch up with oneself / on paper
> Like a drowned person / who clings / to the rock. . . .
> the hackneyed words (p. 208)

Life moves and words are apparently fixed: "I will never be there where you believe you'll find me, there where you think you can finally grasp me" (p. 320). Laure writes in order to face the untranslatable, to denounce that impasse which returns as a leitmotif in her poems. She "writes the way one strips oneself . . . of writing" (Jérôme Peignot).

Body-writing challenges the flaws in the Western metaphysics of Presence. It remains an illusion, however, as long as its deepest aim coincides with that of the system denounced. The awareness of the impasse of such an approach has allowed literature to weaken the verticality of its evolution and to multiply its orientations at the base.

The refusal of a *dualistic* and *thing-oriented* philosophy is a work of *endless* locating and undermining. It appears indubitably vain and fragmented when it limits itself to a question of "content." Moreover, more and more women see writing as *the* place

of change, where the possibility of transforming social and cultural structures is offered. Going beyond the convention Presence-God-Author and feeling the urgency of a decentralizing movement, they take up speech not to identify it with themselves or to possess it, but to deliver it from its enslavement to mastery. The consequences of such a position disrupt our slightest actions, for they challenge an entire tradition based on the worship of illusory centers and are not satisfied with *reforms*. Women's writing thus frees itself from the desire for authenticity; it *inscribes the body of the subject* (and reciprocally) without being assimilated to it. *It is itself body*. Difference is thus conceived of not as a divisive element, but as a source of interactions; object and subject are neither in opposition nor merged with each other. *Rose saignée* by Xavière Gauthier, for example, opens with these lines:

> This is not a moment of my life. It's a piece of my thigh. I've cut it into slices, between which I've spread out a few faded rugs. This is not my story. It's an enclosure and I'm unbuttoning my face there.[15]

To sustain a body-writing while going beyond the subject/object identification. "Writing in order to forge an *antilogos* soul" (Cixous). The woman who begins her struggle from language is carrying out a many-sided task: she is trying not only to "express the unexpressable" (Barthes), she writes (in) the space where the question of saying, of being able to say, and of wanting to say/to mean is asked. "There is no real," observes Barthes, "which has not already been classified by men: being born is nothing other than finding this ready-made code and having to accommodate oneself to it." Whence this affirmation: "The raw material of literature is not the unnameable, but certainly the opposite, the named."[16] These reflections, pertinent in their way, nevertheless manifest certain lacks when it's a question of women's truths. Excluded from the named, she must also and ceaselessly work on language in order to make it permeable to feminine concepts. And for that difficult task, all the paths are lined with brambles.

136

Undoing, doing, and redoing interact mutually in their dispersion and continuity. Emma Santos lives writing as a series of deaths which allow her to be reborn to life. Her texts call for at least two simultaneous readings: the relation of dependency and rejection that Santos maintains towards psychiatry and the world of hospitals is also the one she engages with literature:

THE BODY DOCTOR IS AFRAID OF WORDS AND REJECTS ME. THE WORD DOCTOR NEGLECTS THE BODY AND REJECTS ME. I AM ALONE.[17]

WE CRAZY WOMEN, WE ONLY KNOW HOW TO DO ONE THING . . . : GIVE BIRTH TO MADNESS. . . . IN MY BELLY I HAVE ANOTHER BEING WHICH LIVES AT MY EXPENSE. I DON'T HATE HIM I LOVE HIM. . . . I LIVE, I LIVE AGAIN. LIFE IS IN ME. I HAVE IN MY BELLY A NEW RACE, TENS OF ABNORMAL CHILDREN. I PULL OUT FROM THE HOLE OF MADNESS A FETUS, A HUNDRED IDIOT FETUSES, MORE FETUSES. . . . I'M SETTING THEM DOWN ON THE OTHER SIDE OF THE HOSPITAL. MY LITTLE RUNTS ARE OVERRUNNING THE CITY OUTSIDE, MILLIONS OF ESCAPED EMBRYOS, THE EARTH COVERED WITH MY GERMS.[18]

AND YET I BELIEVE THAT THE LIVING-WORDS EXISTED BEFORE. SOMEWHERE THERE WAS AN INVISIBLE WAR WHICH DESTROYED EVERYTHING, A LONG STAY IN AN ASYLUM OF DRUGS, A CHEMICAL WAR OF CONSCIENCE. . . . I'VE FORGOTTEN. . . . MY FEMALE-FISH EGGS I DEPOSIT THEM AND I RUN AWAY HALF ASHAMED. I WRITE AS I AM WITH MY CHEWED NAILS, DECORATED IN THE DARK, REPAINTED RED IN HASTE. . . . I PUT BACK MY FINERY-WORDS IN MY STRAW BAG, MY GAME-WRITING, PLAY LITERATURE. AS I LEAVE, I'M SAD. SOLITUDE.

SHE LOCKS UP WORDS ON A PAGE THE WAY THE RETARDED ONES HIDE SLIPS OF PAPER, . . . A REASSURING WORLD. . . . I WRITE THAT I WRITE . . . I'M LOGICAL, I'M "THE ILLULOGICIAN."

MADNESS WAS QUEEN. . . . THE MADWOMAN YELLS. THE MADMAN KEEPS QUIET EXCEPT THE HOMOSEXUALS. . . . MAN HAD THE RIGHT TO SPEAK BEFORE BIRTH. WOMAN HAS TO CONQUER IT BY PASSING OFTEN THROUGH THE PATHS OF MADNESS AND THE SCREAM.

DIE IN ORDER TO BE REBORN, LIVE AGAIN WHEN ONE FEELS AGAIN THE ANUS, THE ASS.

WRITING IS DYING. I'M NOT A DRUG FOR SALE.[19]

The scream inhabits women's writings. Silence is heard there. Emma Santos is not alone in her solitude. Xavière Gauthier experiences her mute words as "what can be read in what has not been said. . . . The essential, what we didn't *mean to say* but what has been said without our knowing it, in the failures of the clear, limpid and easy speech, in all the slips of the tongue."[20] Hélène Cixous also experiences coming to language as a transgression and a rebirth:

> . . . I who had been nothing but the expression of hope in a language which had become extinct, no one spoke to me any more, not spoken myself I abandoned myself, I didn't believe myself anymore, my voice was dying in my throat, silence submerged it, I no longer heard anything but the silence.[21]

> No more body thus no more writing. . . . ("Le Rire," p. 48)

> When I write, it's everything we don't know we can be which writes itself from me, without exclusions, without foresight. (*Ibid.*, p. 54)

Write in order not to sink into the comfort of the drug or to become oneself a saleable drug through one's costume-words. In the hall of meaning, She suffocates, wanders into nonsense, dissipates, multiplies into millions of embryos, threatens, yells, then comes to haunt again the corridor of ordering thought, and deposits, while running away, her female-fish eggs. WHAT DOES SHE WANT? Neither being shut up in a hospital, nor the confinement of the "normal" false system. Emma Santos's drama is

138

that of a woman who, without refuge, wanders between two equally crazy worlds. LIVE. She wants to be reborn in order to live; savagely, she struggles against the corrosion of madness, but after each "recovery" comes back infallibly towards it like a child who asks for her wet-nurse:

IMPROVEMENT AND RELAPSE. THIS BACK AND FORTH THIS DANCE, TOSSED ABOUT REJECTED FROM BOTH SIDES OUTSIDE INSIDE. THE HOSPITAL AND THE OUTSIDE WORLD WERE SO ALIKE. (*L'Itinéraire*, p. 86)

In that chemical war of consciousness, another voice raises itself, light and insistent, Clarice Lispector's:

... I'm afraid, that to be understood ... I begin to "manufacture" a meaning, with that same sweet madness which was up until yesterday the sane method I used to insert myself into a system.[22]

... truth for me has never had any meaning. ... But if I don't speak I'll get lost and, having gotten lost, I'll lose you ... I can't already speak to myself, to speak from now on would be to precipitate a meaning, to imitate one who rushes to turn to the paralysing security of a third leg and doesn't move forward any more ... in order to move out and attempt to materialize what I'm experiencing, I need courage. It's as if I possessed some bank notes, but didn't know in which country they were legal tender.

It's going to take courage to do what I'm going to do: say something. Courage to lay myself open to the great surprise I will experience in front of the poorness of the thing said. I'll say it wrong and I'll have to add: it's not that, not that, still not that

What do you mean, if I've lost natural language? Am I going to have to, as if I were creating what has happened to me, manufacture my own language? I'm going to create what has happened to me. ... I'll speak in that somnambulous language which, if I were awake, would not even be a language.

... I feel less and less the need to express myself. Is that again something I've lost? No, already during the time when I was sculpting, I was seeking only to replicate and I was seeking it only with my hands.

139

... now that I scorn speech, I'm finally going to be able to start to speak. (*Ibid.*, pp. 28–31)

Speaking, writing, touching, are closely linked in women's context. Their not-wanting-to-say transcends a simple negation; it doesn't lead to disorder or to an exclusive parceling out, but to what Xavière Gauthier and Marguerite Duras call "an organic discourse."

We have seen, from the various examples given, how much "writing and voice braid, weave, themselves together" (Cixous). Women in writing want their words to be *cries, life*, capable of *touching* (other lives—things and beings) and *being touched* (being touched by the reader). They live, Cixous has noted, the speech act (oral and written) as "a wrenching, a launching of self, a diving:

> There is waste in what we say. We need this waste. Writing always involves slashing the exchange value which keeps speech on its track, giving to overabundance, to uselessness, their unauthorized share. That's why it is good to write, to allow the tongue to experiment with itself, as one tries out a caress. ... she writes, as one throws one's voice, forward, into the void. ("Sorties," pp. 171–73)

Unreserved speech "doesn't turn back on its tracks" in order to reassemble the fragments. It neither forces nor imposes itself; it tries itself out, like a *caress*—these lines throw a strangely "significant" light on the whole of Cixous's texts. They dissolve, in a way, the opacity so often attributed to them. Reading again, for example, these sentences in "Regarding the Apple of the Text":

> In the almost presence which stretches out boundlessly between the hand which drips words and the body which lets itself be assessed down to its guts, there are sensual delights ... if I desire them, [they] escape me, if not expected, they are in harmony, by surprise.
>
> Written caresses live? It depends on us to let them come near. But we can neither seize them, nor pursue them, nor give them back.[23]

140

... a hand ... having decided to make known how it knows, rests on the fruit, smoothly,—and by its skill in holding something, without taking it, in fingering/feeling it, in understanding its whole skin, makes acquaintance with it: it's *an apple,* touches it, so precisely, feels it living. (*Ibid.,* p. 413)

... a caress found me again, a hand made me a hand again. (*Ibid.,* p. 412)

Or again these passages in *Vivre l'orange* where Cixous weaves from *The Passion According to G.H.* a conversation with Clarice Lispector and women:

There are those. ... whose speaking is so profound, so intense, whose voices pass gently behind things and lift them and gently bathe them, and take the words in their hands and lay them with infinite delicateness close by things.[24]

... And to all of the women whose voices are like hands that come to meet our souls. ... And to all of the women whose hands are like voices that go to meet the things in the dark ... that don't catch, that attract and let come, I dedicate the orange's existence. (p. 17 [16])

Hand/writing carries with it life—one life gives, remakes, maintains another. It is the *mother:* the one who experiences childbirth neither as a loss nor as an augmentation of self, the one who "desires the other for the other" and "wants both herself and the other to be whole." The mother "outside her role, as a non-name" and as a restorative force "which doesn't let itself be cut but takes the breath away from the codes" ("Sorties," pp. 172–73). Cixous, for whom creation is a process of continuous childbirth, insists on writing as an "inscribing activity." Her texts, whose forms cancel themselves out as they appear, challenge the work's status as *object* (temporal, finite). Infinitely dividing and multiplying, they are engaged in "a movement of otherness which never comes back to the same" (Derrida) and in

no case let themselves be determined by a course going from a beginning to an end:

> Admitting that writing is precisely working (in) the in-between, examining the process of the same and the other without which nothing lives, undoing the work of death, is first of all wanting two and both, one and the other together, not frozen in sequences of struggle and expulsion or other forms of killing, but made infinitely dynamic by a ceaseless exchanging between one and the other different subject, getting acquainted and beginning only from the living border of the other: a many-sided and inexhaustible course with thousands of meetings and transformations of the same in the other and in the in-between, from which a woman takes her forms. ("Le Rire," p. 46)

Woman is a *whole*—"a whole composed of parts which are wholes"—from which language is born and reborn. Her fluid, distended, overabundant writing challenges the divisive and classifying world of meaning; it "can also only continue, without ever inscribing or distinguishing contours, daring these dizzying crossings of other, ephemeral and passionate visits in him, in them, men and women" (*Ibid.*, p. 50). The speed with which Cixous writes and inundates the trade with her texts forces the reader to re-evaluate the book market in general and the dominant male economy of well-finished products.[25]

Forming, deforming, informing, malformed, many forms [difforme, dix formes]? We are fully into the electronic era of "software" or of instantaneous information. Using McLuhan's definition of the auditory space in which tribal man lives, we can also say that the writerly space is "a sphere whose center is everywhere and periphery nowhere. That demands a high level of participation but excludes the idea of goal and direction" (p. 118). Perhaps life appears less agonizing when decentralization (and decentering) are no longer understood as chaos or absence—the opposite of presence—but as a marvelous expansion, a multiplicity of independent centers. Such an understanding can allow us, following Clarice Lispector's example, not to succumb to the

need for form, linked to the terror of finding oneself without boundaries. *The Passion According to G. H.* is a slow and persistent labor which takes shape from an absence or rather a pulverization of form:

> . . . a form provides an armature for the amorphous substance—the vision of a piece of meat that would have no end is a mad vision, but if I cut that meat in pieces and distribute it according to the progress of time and appetite, then it will no longer be perdition and madness: it will be humanized again. . . . since I will inevitably have to divide that monstrous meat . . . let me at least have the courage to allow that form to shape itself by itself, just as a crust grows hard by itself . . . allowing a meaning, whatever it may be, to come to the surface. (p. 23)

The entire book—form and content—can be found in these lines. One can, however, say the same of each sentence etched; they all carry within them the heart of the writing. *The Passion According to G. H.* is an endless vision divided up into assimilable portions. This dividing up does not break the continuity of the text, it scans it, gives it a solemn and steady march rhythm. Each chapter thus closes with an ending that is also the beginning of the next chapter; each closure opens out onto a new closure.

Form makes content (and vice versa). Cixous's "L'Essort de Plusje" ["The Flight/Going Out of the More than I"] is another example where the shattering of the signifier implies that of the signified:

> With the beat of a drunken wing or book [ivre-livre; allusion to Mallarmé], every life-text must reach the open sea. . . . there must be some nowhere a relationship between "pierre" and "je" [rock and I]; between "pierreje" [rockI] and "pierge" [?] or "vierge" [virgin] and "verge" [rod/penis]; and between "terre" [earth] and "tiers" [third] or "iciel" [heresky?], and between "tirer" [shoot] and "atteindre" [reach] or "éteindre" [extinguish], and between "éteindre" and "tuer" [kill]; and between "tueur" [killer] and "tuteur" [tutor]; and between "infliction" and "infiction" [non-fiction?]. . . . If the bow here is drawn and shoots blindly in the direction/un-erection of the unknown female, then the air stirs/arrows ["sagitte"], the cloud

bursts and spurts out/ejaculates a "pluieje" [I-rain] of eggs which sprinkles/bumps ["aspèrege"] the page: a certain new item unsettles the climate heretofore assured of its durability/earthiness ["terrenité"]; mother page gasps for breath, criss-crosses, and suffers/offers herself ["s'ouffre"] elsewhere. Thus/at the same time nothing wrings/flies/comes out ["il en essore rien"].[26]

The text body-cry-hand-mother-life is a text which, decentralized, divests itself of Presence and circulates like a gift. In order for a life to sustain another life, the hand should have the right touch—neither disengaged nor possessive—or the "author" should let herself be traversed by the other ("a relationship between 'pierre' and 'je'; between 'pierreje' and 'pierge' or 'vierge' and 'verge' . . . ") without trying to seize it, catch it or suffocate it by her presence, should be sufficiently "rich in humility, inflexible enough in tenderness to *be no one*" like an apple or a rose, "being pure joy before all naming" (*Vivre l'orange*, pp. 41, 37 [40, 36]; italics mine): "The one who lives totally for others, the one who lives his or her own generosity gives, even if his/her life takes place in the secrecy of a cell. Living is a gift so great that thousands of people profit from each life lived" (*Passion*, p. 188). One can in fact recognize the relationship "between 'tirer' [shoot] and 'atteindre' [reach] or 'éteindre' [extinguish], and between 'éteindre' and 'tuer' [kill]; and between 'tueur' [killer] and 'tuteur' [tutor]." Living without enslaving (oneself), is to understand the flight of "plusje" [morethanI] and of the "pluieje d'oeufs" [I-rain of eggs] necessary for any liberation. "There are in the heart," says Artaud, "more than ten thousand beings: and I is nothing but one being." De/personalization or non-obstruction is not a loss; it allows the emergence of possible being:

Finally, finally my envelope had actually burst and without boundaries, I was. From not being, I was. To the end of what I was not; for "I" is only one of the momentary spasms of the world. (*Passion*, p. 199)

In her own name she would have died of asphyxia. But once emerged from the membrane of self, spread out unto all the ways,

coming to dwell at the brink of all sources. (*Vivre l'orange*, p. 37 [36])

Transcendance of the (un)known opens out onto an limitless field. Everything remains to be done.

My sister lives in the South. I went to see her after the re-unification. More than 20 years of absence, of suffering and separation. But my sister did not choose exile. We are too attached to our

family. My sister sat still. She was staring at me as if I came from another planet. I could see a glimmer of revolt in her eyes. Suddenly her cold, grave voice told me: "You, my little sister... the socialist doctor!..

She stood up from her chair, took my hand and led me to a mirror. "Look at yourself at least once!" I have not, indeed, looked at myself in a mirror for years, and I saw an old, worn out woman...

Peace restored, our problems have increased, professional relations have deteriorated. Equality between men and women still figures on the program,

but the relations between women themselves are more uncomfortable. The officer in charge is a woman, but she is not a doctor. Her function is above all political, she is

there to control the ideological aspect of the profession. A conflict has arisen between her and the health technicians. It's a problem of power

—political power versus professional competence.

SV

8
Questions of Images and Politics[*]

Let me start by asking myself: what do I expect from a film? What I expect is borne out by what I work at bringing forth in my own films. The films I make, in other words, are made to contribute to the body of film works I like and would like to see.

Through the way a film is made, the way it relates to its subject, as well as through the viewers' receptions, I expect that it solicits my critical abilities and sharpens my awareness of how ideological patriarchy and hegemony works.

> The commercial and ideological habits of our society favor narrative with as definite a closure as possible once the narration is consumed one can throw it away and move on to buy another one.
>
> clear linear entirely digestible.

More and more, there is a need to make films politically (as differentiated from making political films). We are moving here from the making of a genre of film to the making of a wide range of genres of film in which the making itself is political. Since women have for

* Lecture delivered at the "Viewpoints: Women, Culture & Public Media" Conference at Hunter College, New York, November 1986. First published in *The Independent* (Film & Video Monthly), Vol. 10, No. 4 (May 1987).

147

decades worked hard at widening the definition of "political"; since there is no subject that is "apolitical" or too narrow, but only narrow, apolitical representations of subjects, a film does not necessarily need to attack governmental institutions and personalities to be "political." Different realms and levels of institutional values govern our daily lives. In working to shake any system of values, a politically made film must begin by first shaking the system of cinematic values on which its politics is entirely dependent.

never installed within transgression never dwells elsewhere

Patriarchy and hegemony. Not really two, not one either. My history, my story, is the history of the First World/Third World, dominant/oppressed, man/woman relationship. When speaking about the Master, I am necessarily speaking about both Him and the West. Patriarchy and hegemony. From orthodox to progressive patriarchy, from direct colonization to indirect, subtly pervasive hegemony, things have been much refined, but the road is still long and the fight still goes on.

Hegemony is most difficult to deal with because it does not really spare any of us. Hegemony is established to the extent that the world view of the rulers is also the world view of the ruled. It calls attention to the routine structures of everyday thought, down to common sense itself. In dealing with hegemony, we are not only challenging the dominance of Western cultures, but also their identities as unified cultures. In other words, we call attention to the fact that there is a Third World in every First World and vice-versa. The master is made to recognize that his culture is neither homogeneous nor monolithic, that he is just an other among others.

What every feminist, politically made film unavoidably faces is at once: 1) the position of the filmmaker 2) the cinematic reality 3) and the viewers' readings. A film, in other words, is a site that sets into play a number of subjectivities—those of the filmmaker, the filmed subjects, and the viewers (including here those who have the

means or are in a position to circulate, expose, and disseminate the films).

The assumption that the audience already exists, that it is a given, and that the filmmaker merely has to gear her making towards the so-called needs of this audience, is an assumption that seems to ignore how needs are made and audiences are built. What is ideological is often confused with what is natural—or biological, as is often implied in women's context. The media system as it exists may be most efficient for reaching the audience desired, but it allows little direct input from the audience into the creative process (critics and citizen groups are not defined as part of the audience for example).

A responsible work today seems to me above all to be one that shows, on the one hand, a political commitment and an ideological lucidity, and is, on the other hand interrogative by nature, instead of being merely prescriptive. In other words, a work that involves her story in history; a work that acknowledges the difference between lived experience and representation; a work that is careful not to turn a struggle into an object of consumption, and requires that responsibility be assumed by the maker as well as by the audience, without whose participation no solution emerges, for no solution exists as a given.

The logic of reaching "everybody" often encourages a leveling of differences—a minimum of elements that might offend the imaginary average viewer, and a standardization of content and expectations. To work against this leveling of differences is also to resist the very notion of difference, which defined in the Master's terms, always resorts to the simplicity of essences. Divide and conquer has for centuries been his creed, his formula of success. But for a few decades now, a different terrain of consciousness has begun to be explored among marginalized groups. A terrain in which clear-cut divisions and dualistic oppositions—such as counter-cinema versus Hollywood, science versus art, documentary versus fiction,

149

objectivity versus subjectivity, masculine versus feminine—may serve as departure points for analytical purposes, but are no longer satisfactory, if not entirely untenable, to the critical mind.

I have often been asked about what some viewers call the "lack of conflicts" in my films. Psychological conflicts are often equated with substance and depth. Conflicts in Western contexts often serve to define identities. My suggestion to this so-called lack is: let difference replace conflict. Difference as understood in many feminist and non-Western contexts, difference as foregrounded in my film work, is not opposed to sameness, nor synonymous with separateness. Difference, in other words, does not necessarily give rise to separatism. There are differences as well as similarities within the concept of difference. One can further say that difference is not what makes conflicts. It is beyond and alongside conflict. This is where confusion often arises and where the challenge can be issued. Many of us still hold onto the concept of difference not as a tool of creativity—to question multiple forms of repression and dominance—but as a tool of segregation—to exert power on the basis on racial and sexual essences. The apartheid-type of difference.

Let me point to a few examples of practices of such a notion of difference.

The positioning of voices in film: *In documentary practice, for example, we are used to hearing either an* unified *voice-over, or a string of* opposing, clashing *views from witnesses which is organized so as to bring out objectively the so-called two sides of an event or problem. So, either in unification or in opposition. In one of my films,* Naked Spaces, *I use three different voices to bring out three modes of informing. The voices are* different, *but* not opposed *to each other, and this is precisely where a number of viewers have reading problems. Some of us tend to consume the three as one because we are trained to not hearing how voices are positioned and to not having to deal with difference otherwise than as opposition.*

The use of silence: *On the one hand, we face the danger of inscribing femininity as absence, as lapse and blank in rejecting*

the importance of the act of enunciation. On the other hand, we understand the necessity to place women on the side of negativity (Kristeva) and to work in "undertones" (Irigaray) in our attempts at undermining patriarchal systems of values. Silence is so commonly set in opposition with speech. Silence as a will not to say or a will to unsay, a language of its own, has barely been explored.

The Veil: *If the act of unveiling has a liberating potential, so does the act of veiling. It all depends on the context in which such an act is carried out, or more precisely, on how and where women see dominance. Difference should neither be defined by the dominant sex nor by the dominant culture. So that when women decide to lift the veil, one can say that they do so in defiance of their men's oppressive right to their bodies; but when they decide to keep or to put back on the veil they once took off, they may do so to reappropriate their space or to claim anew difference, in defiance of genderless hegemonic standardization. (One can easily apply the metaphor of the veil here to filmmaking.)*

Making films from a different stance supposes 1) a re-structuring of experience and a possible rupture with patriarchal filmic codes and conventions; 2) a difference in naming—the use of familiar words and images, and of familiar techniques in contexts whose effect is to displace, expand, or change their preconceived, hegemonically accepted meanings; 3) a difference in conceiving "depth," "development," or even "process" (processes within processes are, for example, not quite the same as a process or several linear processes); 4) a difference in understanding rhythms and repetitions—repetitions that never reproduce nor lead to the same ("an other among others"); 5) a difference in cuts, pauses, pacing, silence; 6) a difference, finally in defining what is "cinematic" and what is not.

The relationship between images and words should render visible and audible the "cracks" (which have always been there; nothing new . . .) of a filmic language that usually works at gluing things together as smoothly as possible, banishing thereby all reflections, supporting an ideology that keeps the workings of its own language

151

as invisible as possible, and thereby mystifying filmmaking, stifling criticism, and generating complacency among both makers and viewers.

Working with differences requires that one faces one's own limits so as to avoid indulging in them, taking them for someone else's limits; so as to assume one's capacity and responsibility as a subject working at modifying these limits. The patriarchal conception of difference relies heavily on biological essences. In refusing such a contextualization of difference, we have to remain aware of the necessary dialectics of closure and openness. If in breaking with patriarchal closures feminism leads us to a series of must's and must-not's, then this only leads us to other closures. And these closures will then have to be re-opened again so that we can keep on growing and modifying the limits in which we tend to settle down.

Difference is not otherness. And while otherness has its laws and interdictions, difference always implies the interdependency of these two-sided feminist gestures: that of affirming "I am like you" while pointing insistently to the difference; and that of reminding "I am different" while unsettling every definition of otherness arrived at.

The Third Scenario:
No Light No Shade

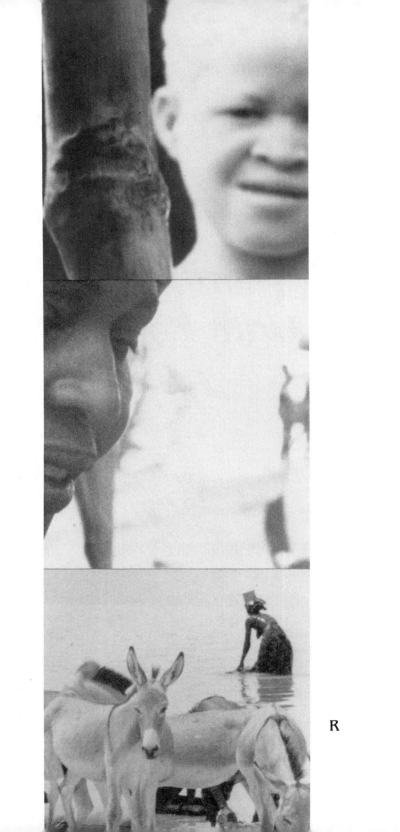

R

9

*Bold Omissions and Minute Depictions**

Thanks to Ayi Kwei Armah, I know the screens of life you have left us: veils that rise in front of us, framing the world in neat pieces. Until we have grown tall enough to look over the next veil, we believe the little we see is all there is to see. From veil to veil, the bitter taste of surprise in disfranchisement keeps on renewing. But again and again, we hold fast to what our eyes perceive; again and again we fool ourselves, convinced at each step, that we have grown wise. Recently, in a casual conversation, two visiting writers from Martinique and Guadeloupe remarked with a certain bewilderment that the question of migration was again enjoying a great vogue in the States and that "they all talk about identity and marginality." Finding myself deeply implied in this "they" despite the fact that my friends tacitly included me on their side while talking, I was suddenly hit by a brief but sharp feeling of confusion as to where my identity lay. Since *they*, in this context, pointed both to the trendy Euro-American intellectuals eager to

* First published in *Moving the Image: Independent Asian Pacific American Media Arts 1970–1990*, Russell Leong, ed. (Los Angeles: Visual Communications Southern California Asian American Studies Central, Inc., and UCLA Asian American Studies Center, 1991).

recycle strands of subversion and to those for whom the migrant's condition continued to be an everyday reality and an ongoing border struggle, it was difficult to react quickly without speaking simply for or against. Caught between two fixed closures—American and Asian—I was at the same time grateful to be treated as an outsider to the passing trends of discursive thought in North America, and repelled by my friends' apparent refusal to identify (even strategically) with the fight against marginalization. However, their remarks did have a strong destabilizing effect. I was assaulted by intense skepticism as I realized the intricacy of my own participation in what had been indirectly pointed to here as a spurious, fashionable preoccupation of the West raised up for the sake of Western vanguardism and its desire to conserve itself as sovereign Subject of radical knowledge. For the above writers, the word "marginality" clearly did not make sense, nor did its juxtaposition with the notion of "identity" seem any more revealing. They thus reacted to its use with astonishment, if not with sarcasm: "What marginality? Marginal in relation to whom? to where? to what?"

Perhaps vindicating and interrogating identity takes on a peculiarly active significance with displacement and migration. It becomes inevitable with the questioning of established power relations, or with the daily meddling with the ruling culture. For those who feel settled at home in their land (or in other lands) where racial issues are not an everyday challenge, perhaps self-retrieval and self-apprehension are achieved without yielding to the urge to assimilate, to reject, or to fight for a space where identity is fearlessly constructed across difference. A familiar story of "learning in America" is, for example, the one lived by artist Wen Yi Hou when she left Mainland China to further her education in the States:

> I became aware of my minority status only in America. . . . I asked people there [at the University of California San Diego], "Why did

156

the school select me?" They said when they saw my slides, they were surprised by my paintings. They were modern and very western. How could that happen in Red China? I was surprised that shortly after I started the program, I was asked why my paintings were not traditional Chinese paintings. I was depressed. I did not have any value as a Chinese artist in their minds. My feelings of worthlessness as an artist intensified in San Diego. There was a group of American graduate students who talked about the Eastern influence on Western art. I was in the seminar, but no one talked to me or looked at me. I worried about how they could talk about Eastern cultures and yet they would not even look at a person from the East. I was the subject of the lecture but was excluded.[1]

Hear how the story happened again; watch the scenario of disfranchisement repeat itself across generations; smell the poison taking effect in the lives of those who dare mix while differing. The predicament of crossing boundaries cannot be merely rejected or accepted. It has to be confronted in its controversies. There is indeed little hope of speaking this simultaneously outside-inside actuality into existence in simple, polarizing black-and-white terms. The challenge of the hyphenated reality lies in the hyphen itself: the *becoming* Asian-American; the realm in-between, where predetermined rules cannot fully apply. Presumedly, the Real Chinese artist should abide by Chinese aesthetics, the authenticity of which is naturally defined on *their* (Euro-American) terms. After all, who would dispute the fact that Western influence should be challenged in its global domination? But again, who never hesitates to take the licence to decide what is Western and what is Eastern in this context? Indeed, no statements about the negative nature of such an influence could be more dogmatic than those often made by Euro-Americans for the benefit of their non-Western *protégés*. "Yes, the white world is still a pretty dark one for the man of color," noted Ezekiel Mphahlele.[2] It is always mind-boggling to recognize how readily opposed liberal Westerners are to any discrimination in the public treatment of people of color while remaining blind to it in

more individualized relationships or when dealing with differ-
ence on a one-to-one basis.

A lesson learned from the failure of Negritude is that any
attempt at pegging things and reclaiming a denied heritage to
construct a positive identity should remain at its best, diacritical
and strategical, rather than dogmatic and originary. (The term
négritude, created by poet Aimé Césaire to denote a quality com-
mon to the thought and behavior of black people, was champi-
oned in the fifties by the Society of African Culture in Paris as a
concept capable of defining and exalting the negroness of artistic
activity.) Racial and sexual discriminations are based on as-
sumptions of biological essences, and with such an affirmation
as "Emotion is completely Negro as reason is Greek" (Léopold
Sédar Senghor), Negritude, like "Feminitude" (or reactive femi-
nism), ends up trapping itself in what remains primarily a defen-
sive stance. *In my struggle to overcome the artistic difficulty that
arises when one is angry most of the time and when one's sense of
values is continually being challenged by the ruling class, I have
never thought of calling my negritude to my aid, except when
writing protest material. But is not this elementary—shall I call it
"underdoggery"?—that Senghor is talking about? Even he must
know, however, that his philosophy will contain his art only up to
a point: it won't chain his art for long* (Mphalele).[3]

If Negritude tended to oversimply and to reentrench black
values in its assertion, it was mainly because it heavily indulged
in binary oppositional thinking. As Wole Soyinka put it, it re-
sulted from the adoption of "the Manichean tradition of Euro-
pean thought," therefore borrowing "from the very component
of its racist syllogism."[4] However, as a Vietnamese proverb says,
"Bound to be round is the dweller in a calabash / Bound to be
long is the dweller in a tube." Separatism as a strategy, *not*
as an end point, is at times necessary for the emergence of a
framework that promotes and entitles second-class citizens to

articulate problems related to their condition. Highly privileged are those who can happily afford to remain comfortable in the protected world of their own, which neither seems to carry any ambiguity nor does it need to question itself in its mores and measures—its utter narrowness despite its global material expansion. When the footprints made by the shoes are not readily confused with the shoes themselves, what Negritude has also achieved can never be belittled. Due to it, the creation of a new multicultural alliance with the world's dispossessed became possible. It is in having to confront and defy hegemonic values on an everyday basis, in other words, in assuming the between-world dilemma, that one understands both the predicament and the potency of the hyphen. Here, the becoming Asian-American affirms itself at once as a transient and constant state: one is born over and over again as hyphen rather than as fixed entity, thereby refusing to settle down in one (tubicolous) world or another. The hyphenated condition certainly does not limit itself to a duality between two cultural heritages. It leads, on the one hand, to an active "search of our mother's garden" (Alice Walker)—the consciousness of "root values" or of a certain Asianness—; and on the other hand, to a heightened awareness of other "minority" sensitivities, hence of a Third World solidarity, and by extension, of the necessity for new alliances. Unavoidably, the step backward is constantly also a step forward. The multidimensional desire to be both here(s) and there(s) implies a more radical ability to shuttle between frontiers and to cut across ethnic allegiances while assuming a specific and contingent legacy.

Cultural difference is not a totemic object. It does not always announce itself to the onlooker; sometimes it stands out conspicuously, most of the times it tends to escape the commodifying eye. Its visibility depends on how much one is willing to inquire into the anomalous character of the familiar, and how engaged one remains to the politics of continuous doubling, reversing,

and displacing in marginality as well as to the necessity of changing both oneself-as-other and other-as-oneself. *Fervently we have wanted to belong somewhere at the same time that we have often wanted to run away. We reached out for something, and when by chance grasped it, we often found that it wasn't what we wanted at all. There is one part of us that is always lost and searching. It is an echo of a cry that was a longing for warmth and safety. And through our adolescent fantasies, and however our adult reasoning may disguise it, the search continues* (Mai-mai Sze).[5] The quest for this other in us can hardly be a simple return to the past or to the time-honored values of our ancestors. Changes are inevitably implied in the process of restoring the cultural lineage, which combines the lore of the past with the lore of the complex present in its histories of migrations. As soon as we learn to be "Asians in America"—that is, to come to a rest in a place supposedly always there, waiting to be discovered—we also recognize that we can't simply be Asians any longer. The fight has to focus on our physical and political hereabouts, so that "here in San Francisco/there is Saigon/ their locks of mouths/ damming the Pacific!" (Stella Wong)[6]. Listening to new sounds in the attempt to articulate a specific and transcultural between-world reality requires again, that the step backward be simultaneously a step forward. As Al Robles puts forth in these lines: "A Filipino fisherman once said / that looking for your roots / will get you all tangled up / with the dead past . . . / If the mind bothers with the roots / It'll forget all about the weeds . . . "[7]

> *I am not a painter who has come to America to paint China.*
> *I am a painter from China who came to America to continue painting.*
>
> > *Why paint?*
> *People need to paint and painting needs people.* (Wen Yi Hou)[8]

What is Chinese in America? An artistic event is often presented as a thought, a feeling that has found its form in its

160

formless nature. To paint is to continue painting. The becoming is not a becoming something; it remains active and intransitive. While, for example, for Thomas Mann "a spiritual—that is, significant—phenomenom is 'significant' precisely because it exceeds its own limits," for Andrei Tarkovsky the film image as acute observation of life is linked to the Japanese Haiku, which he wrote, "cultivates its images in such a way that they mean nothing beyond themselves, and at the same time express so much that it is not possible to catch their final meaning . . . the great function of the artistic image is to be a detector of infinity . . . [and to give] the beholder a simultaneous experience of the most complex, contradictory, sometimes even mutually exclusive feelings."[9] People need to paint and painting needs people for, in this mutual need, they both exceed their limits as people and as painting. This is the challenge of the hyphen. Chinese artist Shih-t'ao (1630–C.A. 1717/1720) evolved his philosophy of painting around the fundamental notions of "the form of the formless" and "the sound of the soundless."[10] The basic urge to manifest (*not* to arrest) the Formless in form seems, indeed, to be what Tarkovsky yearns for through the many words he uses to explicate an aesthetics that remains implicitly admiring of the Haiku as well as of other Asian sources, such as Kurosawa's poetic approach in his *Macbeth*. What Tarkovsky tries to retain and "make it incarnate, new each time," is the Formless, or as he said it, the life principle itself, *unique* in each moment of life. Thus, form is not intended to express form, but rather, formlessness. The non-consumable relationship between form and formlessness or between art and life defies every binarist attempt at reducing it to the old dichotomy of form and content. In Tarkovsky's definition, "the image is not a certain *meaning*, expressed by the director, but an entire world reflected as in a drop of water."[11]

Transformation requires a certain freedom to modify, appropriate, and reappropriate without being trapped in imitation.

Chinese traditional arts, for example, do not speak so much of beauty or of aesthetic, as of the spirit—the *ch'i*. What can be taught and assimilated, indeed, is technical knowlege; not the *ch'i*—the principle of life that is unique to each artistic moment, event, and manifestation; or the breath that sustains all processes of movement and change. To excel only in the mechanics of a language, be it verbal, visual, or musical, is to excel in imitation—the part that can be formulated, hence enclosed in formulas. Form as formulas can only express form; it cannot free itself from the form-content divide. However, a film can be made the way a tale is spun by many storytellers of Asian and African cultures. Nothing is explained, everything is evoked. When explanations were requested, the storyteller would pause, listen carefully, and after due consideration, repeat exactly the passage relevant to the question. No more, no less. Here, there is no necessity to reduce the plural meaning of the story to some flat explanatory answer, and the questioner is invited to listen again more mindfully to what he or she has missed. Since form cannot be separated from content—the form of the story being (integral to) the story itself—there is no other way to say it without re-forming it (that is, un/intentionally modifying, augmenting, or narrowing it). One of the characteristics of Shih-T'ao's principles in painting is precisely the *yugen*, translated as "subtle profundity" or "deep reserve." The quality emphasized here is the ability to imply, rather than to expose something in its entirety; to suggest and evoke, rather than to delineate laboriously. "Such works," wrote Shih-T'ao, "enable us to imagine the depth of content within them and to feel infinite reverberations, something that is not possible with detail painted minutely and distinctly."[12]

The realm of a film is that of a mediating elsewhere, albeit one deeply rooted in reality. It seeks the truth of reality, or the *ch'i* of life's fictions, but is neither dream nor reality. Its meaning is never simply true nor false. For it is thanks to its falsity (recre-

ation through the mediation of the cinematic apparatus) that a truth is made perceptible to the spectator. In confusing meaning with truth or imposing it as truth, a form of literalism, of narrow-mindedness and of ensuing terrorism is accorded the name of "realism." Such glaring "misnaming" in film history ultimately serves to mask the process in filmmaking by which meaning is fixed and formulas are prescribed. Thereby, the oppressive cinematic conventions that serve the ideology of power are naturalized, and representation, lacking *yugen*, no longer vibrates; it ceases to be political, while meaning becomes merely a pawn in the game of power. *The stereotype is not a simplification because it is a false representation of a given reality. It is a simplification because it is an arrested, fixated form of representation. . . .*[13] To disturb the comfort, the security, the fanaticism of meaning is a critical task that allows film to partake in the politics of everyday life as well as in the challenge of the dominant ideology of world cinema.

One of the ways by which feminism defines itself as a politics of everyday life, thereby breaking down the barriers separating the public and the private spheres of activity, is precisely to continue redefining the nature and boundaries of the political in relation to the personal. Much has been said concerning the "misuse" of the personal in attempts to radicalize consciousness. And much has also been voiced on how sexual politics can lead straight to identity politics, which tends to collapse the personal and the political instead of maintaining the tension between the two so that, in the absence of the one or the other, the state of depoliticization that occurs can no longer go unnoticed. Still, feminism continues to be a political critique of society and what it has contributed is the possibility of a new way of understanding subjectivity, a radically different aesthetic, a rewriting of culture in which women are addressed as social and political subjects. As bell hooks remarks, "to begin revisioning we must acknowledge the need to examine the self from a new, critical

standpoint. Such a perspective, while it would insist on the self as site for politicization, would equally insist that simply describing one's experience of exploitation or oppression is not to become politicized. It is not sufficient to know the personal but to know—to speak it in a different way."[14]

Listening to new sounds, speaking in a different way, manifesting the Formless. There would be no "new," no "different" possible if it were not for the Formless, which is the source of all forms. The belief that there can exist such a thing as an outside foreign to the inside, an objective, unmediated reality about which one can have knowledge once and for all, has been repeatedly challenged by feminist critics. For centuries, this belief has most perniciously served to reduce the world to the dominant's own image, and the fight against "realism" is, in fact, not a denial of reality and of meaning, but rather, a determination to keep meaning creative, hence to challenge the fixity of realism as a style and an arrested form of representation. Claire Johnston argued in her famous essay on "Women's Cinema As Counter-Cinema":

> Within a sexist ideology and a male-dominated cinema, woman is presented as what she represents for man. . . . What the camera in fact grasps is the "natural" world of the dominant ideology. . . . Any revolutionary strategy must challenge the depiction of reality: it is not enough to discuss the oppression of women within the text of the film: the language of the cinema/the depiction of reality must also be interrogated, so that a break between ideology and text is affected.[15]

Realism as one form of representation defined by a specific attitude toward reality is widely validated to perpetuate the illusion of a stable world (even when it depicts sickness, poverty, and war), in which the same "how-to-do's" are confidently standardized and prescribed for different realities. Gaps and cracks of the systems of filmmaking and filmviewing are carefully made invisible so that the flow of events can continue to provide the

164

spectator with a sense of gradual, linear acquisition of knowledge. This is, in fact, the way the West has envisioned much of its art for centuries. If eighteenth-century Chinese artists used to judge Westerners' skill in engraved illustrations as "nothing but artisanry" and their methods "good only for catching likeness," the "Chinese image" long remained an example of what the Western painter should avoid, since it was viewed as being deficient in three-dimensionality. It was not until the late nineteenth century, when the rejection of illusionism spread among artists of the West, that the non-illusionistic art of the Chinese started to "make sense" to them. History abounds with instances where, for example, established representational devices used by early Europeans for picture-maps to display or isolate the object of study in its most readable and informative aspect, were adopted by the Chinese for purposes other than legibility and information. The illusionism of exactitude in representation and of three-dimensionality on a two-dimensional medium could hardly be what the Chinese would search for at the time, no matter how intrigued they could be with the European pictures. Not only did they consider the Europeans to be quite incapable of depicting landscape (rocks, trees, rivers, mountains, which demanded more than illusionistic technique), but they also did not accept these pictures as true representations of real scenes.[16] Imitation of the forms of nature (or rather the viewing of nature as arrested forms) had apparently little to do with manifestation of the *ch'i* and the Formless that is life or the source of all forms. In working with the sense of the unknown instead of repressing it, in bringing infinity within sight, traditional Chinese arts choose to suggest always *more than what they represent*. Thus, "if one wishes to paint a high mountain, one should not paint every part, or it will not seem high; when mist and haze encircle its haunches, then it seems tall."[17]

> *The work of the mountain does not lie just with the mountain, but with its quiescence . . . the work of the water does not lie just with the water, but with its movement. Moreover, the work of antiquity does*

165

not lie with just antiquity, but with its freedom from error. The work of the present does not lie with just the present, but with its freedom. (Shih-T'ao)[18]

The Chinese are known to their neighbors (the Vietnamese, for example) as a strongly practical and realistic people. Realism in this context requires that life be intimately understood both in its flow and its temporary pauses or specific instances. To face reality squarely and sensitively, without positive or negative escapism, is to see "the small in the large and the large in the small; the real in the illusory and the illusory in the real" (Shen-Fu). The idea of realism in art, and more particularly in realistically powerful media like photography and film, should be linked with the principle of life (and death) by which things, endowed with existential and spiritual force and never static, continue to grow, to change, to renew, and to move. The freedom implied in the internal and external projection of these "landscapes of life" on canvas, on celluloid, or on screen, lies in the availability of mind—and heart—that declines to limit one's perception of things and events to their actual forms. Such freedom also allows for the fearless assumption of the hyphen—the fluid interplay of realistic and non-realistic modes of representation, or to quote a Chinese opera expert, of "bold omissions and minute depictions."[19]

Illustration on next page.

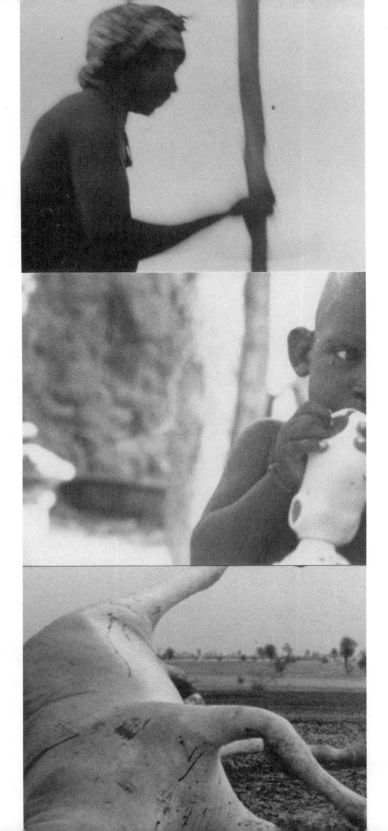

R

10

Aminata Sow Fall and the Beggars' Gift*

Criticism of the African novel has been strongly reproached by Charles R. Larson for adopting either an anthropological and culturalist methodology that fails to consider works for their literary value, or an exclusively literary approach that relies strongly on traditional Western criteria. This attitude, detrimental to African literature, leads either to paternalistic praise, indicating no effort at serious reflection, or to rapid judgments such as: simplistic style; loosely connected narration; weak dialogue; lack of characterization, motivation, and psychological depth. These "flaws," considered weaknesses, constitute however a *choice* by which the African novel differentiates itself from the Western novel. Larson's analysis in *The Emergence of African Fiction* (Indiana University Press, 1971) states this explicitly: "Mannerisms of language [. . .] constitute one of the basic differences (and barriers) immediately recognizable in the African novel written in a European language" (pp. 11–12).

* Originally published in French as "Aminata Sow Fall et l'espace du don," in *Présence Africaine* (Paris), No. 120, (1981), and in *French Review*, Vol. LV, No. 6, (May 1982), this essay was translated into English by Elizabeth C. Wright (San Francisco State University).

Linguistic distortion also implies distortion of borrowed literary forms. The public "has too long read African writers solely to see what they could learn about Africa—and not for what they could learn about literature itself" (p. 25). Transformation is thus a primary concern for every novelist anxious to manipulate writing in order to make it permeable to African ways of thought. "Certainly nothing can be more alien to the African writer than the form of the novel in its present state," says Denis Williams of Guyana, "it is perhaps the most conservative of all the major arts [. . .]. The novel, and particularly the realistic novel, has developed at the behest of a mind very different from that of the African" (cited by Larson, p. 25).

From *Le Revenant* [*The Ghost*] (Dakar: Nouvelles Editions Africaines, 1976) to *La Grève des Bàttu* (Dakar: Nouvelles Editions Africaines, 1979) [*The Beggars' Strike*, trans. Dorothy S. Blair (Longman, 1981)] the change is decisive. One can see in Aminata Sow Fall a clear desire to disengage herself from the traditional novel's conventions. From the linguistic standpoint, the search for a spoken level of writing stands out clearly, which offers a possible response to the impasse confronting African writers who use European languages when the question comes up "For whom should we write?" If the maintenance and development of vernacular languages is undeniably necessary for every colonized society, the zeal deployed by non-African critics in preaching the return to traditional idioms often indicates an attachment to the imported standards of "well written" or "well-spoken" and a total intolerance for any linguistic deviation judged as impoverishment, incorrectness, or "bastardization of a speech which is no longer either English nor African" (Lilyan Kesteloot on Amos Tutuola). However, as Chinua Achebe notes, "the price a world language [. . .] must be prepared to pay is submission to many different kinds of use" (cited by Larson, p. 24).

The characters of Aminata Sow Fall speak a Senegalized French; which leads to deliberate repetition of clichés, the play of stereotypes in the dialogues, and the frequent use of Wolof to

170

express aspects of reality foreign to the borrowed language. When Mour Ndiaye in *La Grève* remarks, for example, that his former boss, a European, "treated the inhabitants worse than dogs" and exclaims: "But no! [. . .] I'll show him I'm a man!" (pp. 10–11 [All page numbers refer to the French NEA edition]), his words are echoed a few pages later by the very people he oppresses, that is, the beggars:

> They [the subordinates of Mour] are crazy, they strike out like madmen, [. . .] they forget we're men. (p. 18)

> Just because we're beggars, they think we're not men the same as they are! [. . .] It's too much, it's too much. Is this the way to treat a human being? [. . .] They're mean! [. . .] they're worse than mad dogs. (p. 29)

> Are we dogs? [. . .] We're not dogs! You know very well we're not dogs. They've got to be convinced of this too. (p. 31)

> Show them that we're men just like them! (p. 33)

And Kéba Dabo, Mour's assistant, shows his disgust towards the same beggars in this manner:

> I'm convinced that with daily round-ups, appeals to reason and dignity [. . .] we'll manage to get rid of them. These people aren't animals after all, they're still men! (p. 21)

The same phrases, the same key words, the same appeals to morality in three different contexts. Simplemindedness? Weak dialogue? Some readers criticize the lack of individuality in Aminata Sow Fall's characters ("her characters never evolve very well as personalities," notes T. N. Hammond). And yet, all the humor and/or irony of the language lies in this resurgence of stereotypes. This kind of speech expresses itself by taking off its mask; it doesn't aim to overwhelm the readers with conflicting feelings but invites them to *participate* lucidly in the troubles of men who, through their anger, vanity, and frustration reveal

171

above all their limitations. The insistent repetition of stereo-typed expressions is in a way a denunciation of the emptiness of words, hackneyed words which no longer mean much and whose voicing transmits nothing but sound. We are convinced not by the "deepening" (a key word in Western metaphysics) of charac-terization but by the repetition of a few truth-vehicles. Paradoxi-cally, the use of a "hollow" language is exactly what gives to *La Grève* its "depth" of thought. What is true, say the Wolof proverbs, is what is obvious ("lu ne fànn"), what everyone asserts ("lu nëpp waxay dëgg,"). The work of the writer thus consists in circulating these truth-sounds and in displacing them by multiplying or varying their contexts, thereby alleviating their authority. Noth-ing exists by itself; an enunciation is only defined in relationship to its verbal surroundings.

If the Wolof expressions are always accompanied by French equivalents or carefully translated in footnotes in *Le Revenant*, this is not so in *La Grève*. Only the words or phrases whose explanation seems absolutely necessary to the understanding of the narrative are put in a glossary. The rest forms the untranslat-able portion of the Senegalese experience. Everything happens as if the desire to be understood by a foreign audience is no longer an essential concern. This is, of course, not a process of elimination or closure, but a change of priorities. The choice of addressing a popular African audience, ambiguously stated in the first novel, is clearly affirmed in the second.

Among the characteristics of the "African mind," Denis Wil-liams mentions the sense of duration and the need for total immersion in an experience.[1] Now, "the Novel," as Roland Barthes remarks, "is a Death; it transforms life into destiny, a memory into a useful act, and duration into directed and mean-ingful time."[2] In order to reduce life's complexity to a causal chain, to provide an illusory image of order in the world, the novelist has recourse to the techniques of narration—establish-ment of a space to be covered with a beginning and an end, adoption of chronology and/or linear plot, unvarying use of the

preterite [*le passé simple*, the traditional tense of written narration in French; no longer used in ordinary spoken language] and the third person. *Le Revenant* did not escape these norms, but *La Grève* opens up a new direction: by doing away with the preterite, organic to the security system of high literary culture [Belles-Lettres], and by replacing it with "forms which are less ornamental, fresher, denser, and *closer to speech* (the present or the past perfect tenses)," this last novel "contains the breadth of existence itself, not its significance." For the use of the preterite, the typical novelistic convention, is a "lie made manifest": "thanks to it, the verb expresses a closed, defined, substantive action;" it furnishes to the consumers of novelistic art "the security of a credible fiction nevertheless continually manifested as false."[3]

The other distance from the norm found in *La Grève* is the frequent use of demonstrative adjectives. These transform the act of reading into one of *listening* and contribute strongly to the creation of a spoken level of writing mentioned above:

> This morning the newspaper again spoke about the human congestion caused by these beggars, these *talibés*, these lepers, these cripples, these derelicts. (Open lines, p. 5)

> There is something distinguished about him, this Nguirane Sarr, maybe because he always holds his head up very high and slightly inclined to the left. (p. 15)

> A true businesswoman, this Salla Niang, who had formerly worked as a "maid of all tasks" ["bonne à tout faire"]. (p. 16)

> She promises to become a strong-minded one, this Raabi. (p. 48)

> Mour rose quickly to catch him. He's become pitiful, this Mour! (p. 97)

Inserted in the middle of a description, the familiar tone of this oral style can be disturbing at first, but its continual reappearance gives it the aspect of a pointing finger. Similar to the play of stereotypes in the dialogues, it unmasks the falsity of the

novel; making us complicitous with the author (and not with the characters, for doesn't Aminata Sow Fall call on us explicitly to share her opinion when she comments with us: "He's become pitiful, this Mour"?), this technique invites us to *participate* in the course of the narration. In other words, the use of demonstrative adjectives allows the narrator to punctuate her novel with stops, during which she addresses herself directly to her reader-confidant.

This affirmative intervention of the author's subjectivity into the narration is not far from the use of the existential "I," a solution today's writers offer in place of the classic "he" or "she," and which allows them to *work at the limits of the novel*. Sow Fall's descriptive technique is a compromise between what Barthes calls traditional rationality and properly novelistic rationality; or, in other words, between the illusory objectivity of an omniscient Author-God—the female or male novelist who holds all knowledge "innocently mixes what s/he sees, what s/he knows, what her/his character sees and knows"—and the subjective objectivity of a single viewpoint whose rigor and continuity form the work's quality.[4] In *La Grève*, this mixture of narrative consciousnesses is particularly noticeable when there is introspection on the part of the principal characters such as Mour, Lolli, Kéba, and Salla. A striking example would be the portrait that the author traces of Lolli when Mour imposes a co-wife on her: the reader is constantly wondering "who's speaking?" The subject of the seen and the known changes lightly back and forth; the author's voice inserts itself into Lolli's consciousness on many occasions, without openly revealing its presence. We, the readers of today, have become more demanding, warier, and "nobody is entirely misled by this convenient procedure that," according to Nathalie Sarraute, "consists, for the novelist, in parsimoniously apportioning bits of himself, which he invests with a certain likelihood by dividing them, necessarily somewhat at random [. . .] among his characters. By a process of decortication, the reader then removes these bits and places

174

them, as in a game of lotto, in corresponding compartments he has discovered in himself."[5] In fact, Sow Fall's compromise solution results from her hesitation between the notion of "depth" and that of "participation."

La Grève seems to be exclusively appreciated for its critique of a system which marginalizes the poor for the benefit of a minority at the top. Why this limitation? We read, as criticized earlier, African works for what they tell us about Africa, not for what they teach us about literature. And the African public? Its readers, in the majority, seem to remain quite attached to a certain notion of commitment ["engagement"] or, since this word never fails to incite strong controversy, to the idea *of immediate usefulness.* The artist, the African intellectual, must often confront a society more preoccupied with urgent problems of development than with the demands of art. This utilitarian tendency that is accepted or questioned according to the situation, in the manner of Ayi Kwei Armah and Wole Soyinka, often constitutes an obstacle to the artist's creativity or need to innovate and causes a large part of the African urban public to consider any concern for form (and therefore for content, since the separation of these two elements is the product of a fundamentally static and dualistic thought) as a kind of intellectualism directly attributed to "Westernism." One of the examples which could be mentioned would be the work of the filmmaker Djibril Mambeti Diop. His film *Touki Bouki,* little known to the general public, has had fairly negative reactions from the film viewers of Dakar. During one of its showings at the Blaise Senghor Center (1979), the Senegalese spectators, feeling attacked, were almost unanimous in their condemnation: "What does the film mean? . . . We can't follow it! . . . White intellectualism! Such films should not be made any more!" Completely favorable to the narrative and politicized films of Ousmane Sembène, this audience proved to be very little disposed to accept a work demanding a great deal of visual participation, because this puts the emphasis on the

175

particular qualities of film as an artistic medium, and because it is grounded not in absence but in narrative fragmentation.

The limits of art, naturally, exist to be expanded. No problem can be isolated from its social context. However, the reality confronted by the artist/writer such as Soyinka and Armah remains that of often not being understood by one's own people, working with material considered pointless in relation to other tasks of nation-building. Novels that can be quickly consumed are disappointing. Thus, for them to be better appreciated they need to be judged by their political content and defined as social criticism. Sow Fall also contributes to limiting the boundaries of her own book by *giving* (herself) to it too explicitly. In order to involve the reader actively, a work should offer (itself as) a balance between what is said and what is not said; it should be clear while still maintaining its shadow areas. In *La Grève,* the complexity of the relationship between the bureaucrats and the beggars is lessened by the author's clear bias and the intervention of her thoughts. The reader knows from the first pages on that the narration will be partial without the author deliberately signaling or acknowledging it. In describing, for example, what Kéba knows of his own feelings towards the beggars, Sow Fall adds: "He forgot the hunger and poverty which compelled some of them to beg in order to remind those who are better off that paupers also exist" (p. 7). Everything is laid out. The reader's objectivity is scarcely called upon. Hasn't a character in the novel, Galaye, said to a woman beggar: "*You mustn't choose,* you mustn't minimize *what you are given*"? (p. 57, italics mine).

However, the significance of Sow Fall's works goes far beyond the framework of a realistic tableau. The problems taken up are linked, as we have seen, to those of language and the novel; they constitute not only a critique of the established system, but also and above all a questioning of fundamental human values. Values which, for the sake of analysis, I would group under the name of *gift.* The multiple faces worn by the gift and its close relationship with oppression form a complex fabric that Sow Fall

176

unceasingly takes apart and puts together again in her narrative scenes, beginning with those describing women. To say that *Le Revenant* and *La Grève* speak above all to women is, according to the idea that one has of feminism, to limit them or to open them up. The protagonists of these two books, Bakar and Mour, are men; however, they never appear without the presence or gaze of a female character. Every question raised leads to the subject of women.

Life is a kind of *lottery*: to some it "gives only in proportion to what is given to it". It is around this small truth that all of Yama's action in *Le Revenant* unfolds. This intelligent woman, determined to follow her chosen path, has quickly understood that in a society where money is King (not Queen), poverty is a dead end. From then on, it's a question of decoding the machine's mode of operation, of mastering the rules of the game in order to come out always a *winner*. Therefore, giving can never be conceived without receiving. It is by calculating her moves in this way that Yama becomes the wife of an extremely rich trades- man and a great "diriyanke" herself. Generosity is nothing other than a currency to be exchanged and *the gift, the art of managing one's reputation.* Crazy? Bakar thinks his sister is "a dirty social climber, a damned hung-up woman who's ashamed of me" and concludes: "I'm not welcome because I have nothing!" (p. 84). However Yama doesn't confuse the means and the end. Money has never blinded her; she uses it as an instrument to "be on top," not as a goal in itself. The examples are numerous: her lack of concern for the bills that are thrown at her in praise of her dance, which earned her the conquest of her future husband; her indifference at the end of the book towards the "sarax" that her brother comes to get: contrary to what Bakar thinks, what puts her beyond her depth is not the taking back of the bundles col- lected at the funeral, but the reappearance of Failure—the return of a brother whom she thought she could remove from her life and whose presence brutally reminds her of her defeat.

For the male reader, it is easy to take sides: Yama is definitely

crazy. She offers the typical image of the woman who has interiorized all the corrupted values of a debased society. She represents a system of which her brother is only a victim. Bakar, who has become antisocial since his conviction for embezzlement, says it clearly in his denunciation: "I gave her, at the end of each month, a tidy sum. And she didn't scorn me then [. . .]. What a despicable life where self-interest pushes people to the basest actions! [. . .] Scorned, mistreated, cursed, because I became bankrupt when they pushed me into it!" (pp. 88–89). For the female reader, it is difficult to accept the conservatism of such a denunciation. Popular opinion says: "What separates two men, is money and women." And the latter remain the constant butt of two accusations: that of leading, by their thirst for property, man to his debasement; that of constituting, by their ignorance and instinct for self-preservation, an obstacle to the march of progress. It is sufficient, however, to notice the close connection between property and progress to remark to what extent these accusations contradict each other. Women probably yield more easily to appearances, to illusory traps—as urban Africans generally say—and delight in "the trivial"; but how can such obvious facts be stated without questioning the root of the evil? Without seeing the oppressed woman, conditioned by whom and for whom in order to reach that point? In fact, what Bakar reproaches Yama for is to have gone further than men, to the limits of corruption. As long as his sister serves his own self-interest—didn't he wager his entire future on Yama's beauty?—her actions are praised and admired; but as soon as he discovers, through a trifling incident, that she is master/mistress of the situation, she becomes "a dirty social climber."

Yama scorns Bakar not because he is needy but because she is *whole*. Success is only obtained, in her eyes, at the price *of giving without reserve*. Petty giving done only from the tip of the fingers is non-committal and doesn't bring much in. It is not enough to participate in society's game in order to profit from it, one must also know how to tame it and anticipate its setbacks. Bakar, by

his opportunism, is a mediocre player and his sister's refusal, whatever lack of morality it may show, is part of the rules of the game. There lies the essential difference between Yama's approach and her brother's: since her actions are lucid and performed with integrity, she has never felt the need to *disguise herself* in order to mimic the hypocrisy of the system. Bakar's use of "xeesal" creates here an ingenious inversion of masculine and feminine roles. In order to attack the denegrification process which constitutes one of the crucial problems of the modern African woman, Sow Fall chooses an indirect approach: that of showing a man obliged to endure the alienating experience of skin-whitening.

> Now I'm going to do as they do, enter into their pantomine [. . .].
> A few touches of xeesal, and I will be another person, alienated,
> depersonalized as they all want to be. Everything happens now just
> as it does in the theater, what is natural and true no longer has any
> standing. It's a game to see who can disguise themselves the most,
> who can feign best, who can dissemble with the most subtlety. No
> one is himself or herself anymore, and wanting to maintain one's
> moral integrity, refusing to participate in society's lie, is a sure bet
> for seeing oneself considered as a marginal element. (p. 106)

> Our sisters are courageous! How much time and effort lost [. . .].
> It's incredible how much artifice costs!" (p. 110)

Bakar's analysis comes to be seen as one of the most pertinent lessons he has been able to draw from his bankruptcy; and the hypocrisy displayed at the false funeral shows him to be absolutely right. His accusations directed against women in particular—and generally approved by men (cf. p. 119)—seem inappropriate however when they concern Yama:

> In order to honor my disappearance, all these women put on their
> most beautiful finery [. . .]. We're definitely in the time of xeesal!
> If one cared to count those who haven't adhered to the sect, they
> would be very few . . . But if I think about it, Yama doesn't bleach
> herself! That woman will always remain a mystery to me. (p. 120)

179

For the beggar, writes Sow Fall, "the contract which links each individual to the society can be summed up by this: giving and receiving" (p. 30). *La Grève*, while developing its own solid theme, presents itself as a variation of *Le Revenant*. The problematic of the gift is expressed in a more direct, but also denser and more complex, manner. The superpositions of situations which allow us to link the beggars' struggle with that of the colonized and of women are numerous. For example, the description of Lolli's reaction to polygamy, immediately followed by that of the beggars terrorized by government roundups, places in parallel two examples of oppressed people's behavior: "After the storm, resignation" (p. 47); the same submission to the social contract, the same hope for rehabilitation, the same divergence of tactics between the old and the new generation. Men must become aware, the author indicates, "that women are complete beings, with rights and duties" (p. 42). "Raabi, my daughter", says Lolli, "there are things that you cannot understand. If I left this household today, my father and mother would curse me, as would all the members of my family [. . .] without work, all alone, what would I do with you if I took you with me? and if I left you here, think about the pain that would cause me." Thus, "after sulking the first few days, [her] zeal to regain her master's favor redoubled" (pp. 47–48). As for the beggars, "they want a solution which stipulates that they be considered full citizens" (p. 51; cf. also p. 30) and they reason in the same manner as Lolli faced with the fear of losing everything: "What will we do? Must we be entirely impoverished? [. . .] Nguirane, what you talk about is not feasible [. . .]. By refusing, we'll harm no one but ourselves" (p. 51).

The course of events show Nguirane Sarr to be right. The beggars succeed, through the strike, in sharpening peoples' consciousness of the importance of their role. Unfortunately it is not the same for Raabi's demands. The beggars' fortunate outcome incites us, however, to raise questions about the women's struggle. *Give, the better to oppress* seems to be the motto of the men in power.

180

Dependency (economic and mental) often puts women and the colonized in the beggar's position. "People give," remarks Nguirane, "out of an instinct for self-preservation" (p. 32). Nothing, in the end, is more ironic than the inconsistency of the men's conduct. "Isn't it me," shouts Mour as his hand threatens Lolli, "who feeds and supports you? And tell me what contract binds me and prevents me from taking a second wife if I want to?" (p. 44). The contradictory nature and narrowness of this logic do not unfortunately appear obvious to those who, in their small universe, reign as masters. When it's a question of serving their own interests, men conceive of work only in terms of payment; when it's a question of valorizing the rights of women, men find it absurd that they demand to be paid for their services (needless to say, the housewife *works* even if she is helped by a maid, just as men give to their subordinates all the burdensome tasks) and appeal to the duties of love. The ambiguity of giving and of duty is manipulated at will by men according to the circumstances.

"Everyone gives for one reason or another," states Salla Niang the beggarwoman, "we [the beggars] are as useful to them as the air they breathe" (pp. 53–54). Men are perfectly conscious of women's role, but as Salla also remarks, "they always pretend to look down upon those whom they need" (p. 34). Thus, her last boss who established his reputation by denouncing the scourge of the marabout system, never goes out "without coating himself with the contents of seven jars filled with mixtures of powders and fermented roots." Teasing his maid (Salla) or treating her roughly according to his wife's absence or presence, he is part of that community which, like Mour, subjugates through dependency: "Ah!," he says to his wife, "over nothing more than a maid, you dare to question my authority! One of these days, I'm going to ask her to pack her things. And you'll follow her!" (pp. 34–35). Whether she is maid or mistress of the household, a woman living in a male system where giving limits itself to monetary exchange, is quickly downgraded to the rank of the needy. The best example of men's inconsistency is Salla's portrait of Galaye,

181

former head of the workers' union in a private company. Sow Fall's critical eye here reveals to us two sides of the same problem. The injustice that Galaye endures from his boss, the colonizer, is unconsciously projected onto the beggarwoman of his choice: if the colonizer refuses to respect the work code, it's under the pretext that his company has been "created to *help* the State and the workers" (p. 55; italics mine); the latter should, in other words, be grateful for everything the righteous souls bring them whatever it is. On the other hand, if Galaye obligates the aged beggarwoman to accept a blank paper—which, according to the marabout's instructions, is indispensable for obtaining a job—it is also under the pretext that "beggars can't be choosers" (p. 57). Colonizer and colonized here join hands.

A gift cannot be refused. The beggars' rebellion, however, which consists among other things in spitting on miserly alms, puts into questions this postulate sanctified by common sense. Charity as "divinely recommended" no longer intimidates. A human being, even the most needy, reserves the right to say no. Kéba Dabo's character here plays a rather interesting role; he presents, following his mother's example, another face of the oppressed. Being a beggar takes on in his context the sense of man's total decline: by his subjugation to material existence, he has abandoned the choice of living or dying. Like the familiar couple of violence and non-violence, Kéba and the beggars in fact defend two different strategies in the same struggle: to inflict shame upon those who are better off, either by aggressiveness, or by silence or defiance of the material world. The success of the beggars' strike tends to prove Kéba right (one can also see it as a balance between the two strategies) for his principles, although still immature because they are too personal, are close to Ghandi's. "My love for the poor of India," declared the latter, "has hardened my heart to the point that I prefer to see them die of hunger than to see them reduced to begging." Urging people to give up their possessions in order to help the poor, Gandhi refused nevertheless to help others live by charity—especially

when they were in "good health" and not invalids. The habit of alms-giving leads the people to laziness and hypocrisy, instead of encouraging them to work. Giving, conceived as an act of charity, degrades the one who offers as much as the one who receives; because of this it must strip itself of all mystification and present itself here as *a simple ex-change* (not as a pressure tactic or self-valorization). The poor "earn"—through work—everything "given" to them, even if the amount of their "payment" can't be measured by a fixed standard and sometimes remains symbolic.[6] For most Third World countries, the importance of such an argument is irrefutable. What can one say about nations, about charitable or benevolent organizations that, without ever questioning the act of giving and receiving, believe grossly and materially that they are giving/helping (a visible action) at the very moment when they are taking/despoiling (an invisible action)? Man has a right to act, not to the fruits of his acts, maintains Gandhi. It is the "giver" who should thank the "acceptor," notes a Zen monk (Seisetsu). The "true" gift is innocent; for, as the *Tao-te-king* warns, "Goodness is not eloquence."

11

The World as Foreign Land[*]

The story of otherness and of marginality has recently become so central to theoretical discussion that it is difficult both to respond satisfactorily to the demand and to take on the dubious role of the Real Other to speak the "truth" on otherness. The subject has gained such interest that in the last two years, I, probably like a number of my friends and colleagues here, have found myself involved in more than a dozen symposia, conferences, and media arts events, as well as in publications that concern themselves with the question of representation of the Other. Although always ongoing, or revived and displaced as a tool of resistance among the marginalized sections of society, the theorization of racial and sexual otherness has become not only recognized and accepted as a legitimate area of investigation; it is occupying a central position within the renewed terrain of cultural critique. This is at the same time very exciting and extremely alarming, for what was once a site of imposition is

* Essay commissioned for the conference "High Culture/Popular Culture: Media Representation of the Other" held at the Rockefeller Foundation's Bellagio Study and Conference Center in Italy, February 27 to March 24, 1989; to be published in *Other Representations: Cross-Culture Media Theory*, ed. by John C. Hanhardt and Steven D. Lavine.

now reappropriated both as fighting ground by the named "others," and as a site for pilgrimage by the Master and his heirs.

The game, allowing the Other an apparent aura, can be very misleading. The fight is always multiple and it needs to be carried out on many fronts at once. Participation never goes without a certain vigilance. What is given in the context of power relations and its systems of dependence is likely to be taken back according to where the wind blows. *Flies meet death in sweet honey* (Vietnamese proverb). Even and especially when an other is being priviledged, she is constantly subtly reminded of the favor she enjoys, and as I have stated elsewhere, of her status as "foreign workers," "migrants," and "permanent sojourners." Moreover, she cannot speak and participate in the production of theories of resistance without bearing in mind she is among those who have been provided with the opportunity to speak her condition. The postcolonial other is here caught in the regime of *visibility* as deployed by the West in a wide range of humanistic and anti-humanistic discourses to conserve its leading position as Subject of knowledge. Thus, in designating herself as one of the designated others (a form of self-location and self-criticism within established boundaries), it is also necessary that she actively maintains the dialectical relation between acceptance and refusal, between reversing and displacing that makes possible the ceaseless questioning of this regime.

The place of otherness is fixed in the west as a subversion of western metaphysics and is finally appropriated by the west as its limit-text, anti-west. . . . Colonial fantasy is the continual dramatization of emergence—of difference, freedom—as the beginning of a history which is repetitively denied (Homi K. Bhabha).[1] In the process of decentralization, what is at stake is obviously not only the Master as sovereign subject of knowledge, but also the fantasized Other as authoritative subject of an other knowledge. A speech that can only advance by questioning its own authority

186

opens its doors wide to (both creative and coercive) appropria-
tion. A speech that looks back on itself runs the risk of destroying
itself. But it is a risk she necessarily takes, for what she has to
lose is precisely what keeps her invisibly under the Master's
tutelage. There does not seem to be any easy way out; any touch-
stone for guidance; or any arcane place for return. Can change,
indeed, come about and new forms of subjectivity emerge when
"representing them, the intellectuals represent themselves as
transparent" (Gayatri Chakravorty Spivak)?[2] When denouncing
Them, language (verbal, visual, musical) reproduces, *visibly*, the
very forms of ideological impostures it attacks?

A space is created and offered, but it would have to remain
unoccupied. Accepting negativity (otherness as defined by the
master) has led to a new positivity (identity as reclaimed by the
other), which in turn opens to a set of new negativities and
positivities (the questioning and renaming of otherness, through
the unnaming of both the master and his other). She can only
build from the visible as she unbuilds the invisible, and vice-
versa. For when she builds and builds only (positivist affirma-
tion), she runs the risk of expanding his property at her own cost;
and when she unbuilds, and unbuilds only (nihilist negation),
she tends to fall into the habit of negating for the sake of his alter
ego. The space of creativity is the space whose occupancy invites
other occupancies. To return to a denied identity and cultural
heritage is also to undermine the very notions of identity and
ethnicity. Thus, if she negates, it is also to refute negation—
joyfully. *She had not drawn something out of nothing (a meaning-
less act), but given to nothing, in its form of nothing, the form of
something. The act of not seeing had now its integral eye. The
silence, the real silence, the one which is not composed of silenced
words, of possible thoughts, had a voice* (Maurice Blanchot).[3]

The space offered is not that of an object brought to visibility,
but that of the very invisibility of the invisible within the visible.
It is thus the space of an activity in which everything takes on a

187

collective value in spite of skepticism. The political domain not only penetrates every statement, it is also informed by and reflected in the means by which the statement is carried out. In voicing her difference, she questions the status of the individual both by affirming what makes her truly different as an individual, and by refuting the system of individualization that isolates her as a person from other individuals, sets her up against her communities, destroys the sense of collectivity, forces her back on herself, and confines her to an identity (double-)bind. The challenge is directed at all forms of institutionalized inquisitions that aim at determining who she is, while ignoring who she really is—individually, collectively. To say this, however, is also to say that in the space of creative (re)invention where the desire to re-circulate domination is constantly lurking, it is necessary to keep on thwarting direction, affirmation, negation as soon as they settle down as tools of resistance. Walking on beaten paths, she may laugh, and laugh at herself for she may realize she must and she can, at any moment, stray from the itinerary chosen, get rid of many of her fears, and take pleasure in making abrupt turns and repeated detours, so as to outplay her own game, rendering impotent the master's world of refined dissections and classifications. In uncertainty and in necessity, she un-builds; she builds and builds up to no total. No total she can possess while carrying out the ceaseless work of dispossessing—herself and the possessors.

> *Someone said to Bahaudin Naqshband:*
> *"You relate stories, but you do not tell us how to understand them."*
> *He said:*
> *"How would you like it if the man from whom you bought fruit consumed it before your eyes, leaving you only the skin?"* (Idries Shah)[4]

Authorized voices authorize themselves to be heard. *I am like you. Undermining and authorizing, authorizing at times to de-authorize, and authorizing also to authorize myself and the un-*

authorized. "The cultural universality of American and Holly-wood-style cinema results from a historical violence," said the Moroccan filmmaker Moumen Smihi; "the Chicago gangster universe, the love stories of the Western petty bougeoisie, all this would remain opaque to numerous publics were it not for the steam-roller of cultural imperialism."[5] Universal communication partakes in the frenzy of the visible that characterizes the age of mass media. It is the effect of social multiplication and mutilation of images through which the whole world is gathered within the fold of the known and the visible, and becomes appropriable. And it is at once the violent triumph and the irrevocable decentering of the place of mastery—of Western vision as knowledge. Displacement (of universal communication), as the tales of Idries Shah relate, "is like the condition of a plant or another growing thing. To place oneself at the head of something which is dying is to partake oneself of the dying capacity of that thing. Individual parts can continue to flourish, especially if reinforced by something with greater truth. But the plant itself, when it has the power of death in it, will transfer that tendency of death to whatever connects with it as a whole."[6]

Knowledge (a certain knowledge) cannot merely be rejected (in a contaminated world where every gesture reverberates endlessly on others). But it has to be exceeded. Thus, it is through the individual parts, and through the relations between fragments in the process of decentralization that change continues to engender change. Monologism objectivizes all reality and cannot conceive of the other as another consciousness, even when the other is given the status of subject. With the other becoming at once object of study and subject of otherness, the desire to expose the wrongdoings inflicted on this other's image and to denounce misrepresentations in the media tends to dominate the entire field of analysis. It is as if the projected images continue to have their effect, captivating the eye analyzing them, moving it from indignation to intoxication. The game is played on both sides

189

with the same weapons, and the scores of writings, films, and videos that study *images* of women and of minorities often repeat themselves within a limited number of propositions. The corrective stance adopted to rehabilitate the image of the other through a critique mainly focused on stereotyping in the media has become too self-sufficient, and therefore, too predictable to continue to offer a productive place for analysis. Certainly, the reality of the humiliated can never be exhausted, but the indictment of the master's monologism and of the forms of power he circulates runs the risk of wearing thin as the words of resistance around certain themes on the oppressed become too familiar to the oppressor. There is, indeed, no small, worn-out subject, but only narrow, predictable representation.

Recirculating a limited number of propositions and rehashing stereotypes to criticize stereotyping can, however, also constitute a powerful practice. There is really no tool that cannot be used differently and displaced in its prescribed function. Repetition does have a role to play in a world where, although "everyone knows" and "everyone is in the best seat," nobody hears with the normalization of lip sync sound and nobody sees with the naturalization of the clichéd image. The questions "what is seen?" and "what is heard?" never actually lose their pertinence. Repetition as a practice and a strategy differs from incognizant repetition in that it bears with it the seeds of transformation. When repetition calls attention on itself as repetition, it can no longer be reduced to connote sameness and stagnancy as it usually does in the context of Western progress and accumulation, and its globally imposed emancipatory projects. When repetition reflects on itself as repetition, it constitutes this doubling back movement through which language (verbal, visual, musical) looks at itself exerting power and, therefore, creates for itself possibilities to repeatedly thwart its own power, inflating it only to deflate it better. Repetition outplays itself as repetition, and each repetition is never the same as the former. In it, there is circulation, there is intensity, and there is innovation.

World as a Foreign Land

I predict a babel
of unoxidized steel
or of crossed blood
mixed in the dregs of all surges!
After the red man,
after the black man,
after the yellow man,
after the white man,
there is already the man of bronze
sole alloy of the soft fires
we have still to ford. (Tchicaya U Tam'si)[7]

Repetition sets up expectations and baffles them at both regular and irregular intervals. It draws attention, not to the object (word, image, or sound), but to what lies between them. The element brought to visibility is precisely the invisibility of the invisible realm, namely the vitality of intervals, the intensity of the relation between creation and re-creation. "Just as every film is political, I think every film is also autobiographical," Moumen Smihi affirmed when he was asked how much of *El Chergui* was about his own "Moroccan-ness."[8] Autobiographical strategies offer another example of ways of breaking with the chain of invisibility. Diaries, memoirs, and recollections are widely used by marginalized people to gain a voice and to enter the arena of visibility. As formats, they are, with a few exceptions, often sent back to invisibility, since they easily fit in one of the drawers of the compartmentalized world of Western thought and its refined systems of classification. As strategies, again, they retain all their subverting potential. For with the displacement effected on the opposition between the private and the public—prominent in the critical works of peoples of color as well as of the women's movements—autobiographical forms do not necessarily implicate narcissism, and the personal becoming communal no longer functions as mere privileged access to the private realm of an individual. Memories within come out of the material that precedes and defines a person. When she creates, they are the subsoil of her work. Thus, autobiography both as singularity and as

191

collectivity is a way of making history and of rewriting culture. Its diverse strategies can favor the emergence of new forms of subjectivity: the subjectivity of a non-I/plural I, which is different from the subjectivity of the sovereign I (subjectivism) or the non-subjectivity of the all-knowing I (objectivism). Such a subjectivity defies the normality of all binary oppositions including those between sameness and otherness, individual and societal, elite and mass, high culture and popular culture.

What else does the media dream of if not raising up events by its very presence? Everyone deplores it, but everyone is secretly fascinated by this eventuality. Such is the logic of simulacra: no longer divine predestination, but the precession of models, which is no less inexorable (Jean Baudrillard).[9] In a world where seeing is believing and where the real is equated with the visible (the all-too-visible, the more-visible-than-visible), the human eye and its perfected substitute, the mechanical eye, are at the center of the system of representation. The photographed image not only assures a new hold on the visible (the mechanical eye can affirm "with blows and hammers" where the human eye hesitates), it also functions as an authentication of the identity of the visible. Reality thereby is redefined in terms of visibility; and knowledge, in terms of techniques, information and evidences. Everyone deplores this, but everyone is secretly fascinated by it. What then is media in this context of visibility? Is media mainly contained in film, television, or radio? How should one call this present event in which a speech is heard and a speaker-image-spectacle is seen? Why this visible interest for the other of the West, the other of man, the other of the heterosexual now, here, today? In the relentless task of attacking and correcting the other's representation through media images, the very question of media is often left intact. Yet a debate on media is bound to remain reformatively circular as long as media is not apprehended in its excessive, non-containable dimension.

192

World as a Foreign Land

[A man of learning asks another man:] "Why do you . . . always use analogies? Such forms are good enough for the ignorant, but you can speak clearly to people of sense." [The other man said:] "Experience shows, alas, that it is not a matter of the ignorant and the wise. It is a matter that those who are most in need of a certain understanding, or even a certain part of understanding, are always the least able to accept it without an analogy. Tell them directly and they will prevent themselves perceiving its truth." (Idries Shah)[10]

In this paper, the discussion on media and representation may be said to have begun with a look at power relations in the production of tools of resistance, and an excursion into different forms of reflexivity and subjectivity. Of equal in/significance is the play of a game that repeats and displaces the visible/invisible duality inherent to a regime of visibility whose standards continue relentlessly to contaminate the world, even in its most remote parts. This discussion could also be said to have begun with a notion of limit-text, not necessarily anti-West or anti-man, but perhaps *anti*-anti-limit-text. A text that acknowledges its experience of limits without being subject to normalized limitations; hence, a text that poses problems of classification because its boundaries constantly undergo mutation. Intertextuality of surfaces; irreducibility of the plural of meaning. To work in the materiality of what remains for the industry a mere instrument for entertainment or for communication with its politics of "dialogues," "participation," and "exchange" is to place oneself from the start in the position of the foreigner, the exiled of language. As participants to the regime of visibility, we are at once the victims and the passively active producers of this media-culture whose theorization requires that we inquire into our own theorizing-contributing activities (or our being-the-place-of-media/otherness-production) while voiding at the same time the sovereignty of the subject of theory, shifting thereby ceaselessly the subject/object boundaries set up for analytical purpose.

Home for the exile in a secular and contingent world is always provisional. The safe ground and secure delimitations of the

193

familiar territory take on different oppressive faces as home can also become prison, while the prison is not a prison when willing slaves either prefer not to recognize, or remain blind to the false humanity and disguised barbarity that allow them to live with the illusion of a reassuring order. *"Be quiet," the old man said to him. "It's not your job to tell us what we can and can't do. Everyone here has his own prison, but in that prison each person is free"* (Blanchot).[11] In the Home, no one escapes the spectacle of happiness, it's the rule! Yet, for those who remain strangers in their homeland and foreigners in their new homes, feeling repeatedly out of place within every familiar world, it is vital to question settlement, as well as to make it easier for the diversely unsettled ones to bear the anxieties of unwonted seclusion. Home and language in such a context never become nature. What in their underlying assumptions tends to recede into dogma or orthodoxy has to be made visible in their skillfully kept invisibility. *As soon as you found a little open space, it meant that you were shut up in a garden, and to discover a new exit you had to climb stairs and plunge on through constructions you had no way of knowing would ever lead you outside* (Blanchot).[12] Edward Said reflecting on exile, and on the necessity to refuse a state of affairs where everything one says or thinks, as well as every object one possesses is ultimately a mere commodity, quoted these lines from a twelfth-century monk from Saxony, Hugo of St Victor: "the man who finds his homeland sweet is still a tender beginner; he to whom every soil is as his native one is already strong; but he is perfect to whom the entire world is as a foreign land."[13]

To create is to understand; and to understand is to re-create. Media not as mere product contained in film, television, journals, or radio, but as activity of production—that is, as site of intercreation and interrelation—allows one to break away from such binary oppositions as those of supplier and consumer, of maker and viewer. The two are joined here in a signifying practice, where the maker constantly reads and re-reads, and is the first

194

as well as the *n*th . . . viewer of her own text, while the viewer is the co- and re-creator of the media text in the diverse readings it is able to engender. Thus, the media text which challenges its commodity status by letting itself be experienced only in an activity of production (the producing subject being immediately contemporary to the process of the act), radically acknowledges the plural texture of life—of intervals among words, images, sound, silence. It invites the perceiver/reader to follow what the creative gesture has traced, therefore rendering visible how it can be unmade, restored to the void, and creatively re-made. It reflects on itself as social/textual activity by apprehending the same language with a foreigner's sight; hearing, looking, and listening with intensity in unexpected places; making mistakes repeatedly where it is not supposed to; displacing thereby the stability of correct syntaxes and fixed nominations.

High culture has often been defined as creator-oriented, in contrast to popular culture which is considered to be user-oriented. With the dizzying tendency of the West to link all values back up with the Same, such a convenient opposition serves the specific function of maintaining intact the relation of dependency between supplier and consumer. *The capitalist system which can produce exceptional works . . . , which can somehow exercise self-criticism in isolation, which can "put its own finger on its own wound," is at the same time incapable of handling its own venom that qualitatively and quantitatively saturates the air— like air pollution* (Jorge Sanjines).[14] Popular taste is repeatedly said to expect an easy invisible technology. The more sophisticated the technology, the higher the need to reassure the user of the effortlessness of its consumption. ("Just push the button, the machine does it all!") In the realm of the image, for example, taking pictures as well as viewing them requires no skill, no expert knowledge, but also and more significantly, no thinking. ("So you want to make us work with your films! Do you realize what it means for people who come in expecting entertain-

ment?") What, indeed, is this maximal consumer society if not a society that operates with violent break-ins, always dividing and alienating at the same time as it works at filling in blanks, holes, gaps, and cracks; rendering invisible the open wounds; evading cleverly all radical reflection upon itself; and tolerating no single moment of undecisiveness, blankness, or pause for fear of having to face its own void? Entertainment is here only defined according to specific ideological interests. (Disturbing these interests and the way they keep their hegemonic mechanisms reassuringly invisible has always provoked violent responses, whose reactionary depth would not otherwise emerge into visibility.) Knowledge thereby continues to belong comfortably to the expert and the professional. Everyone deplores this, but everyone reverts to it, as soon as (effortless) consumption is thwarted.

The argument sounds familiar; only the combination is displaced. Even when users are pitted against creators, the defense of their position and their needs serve to further the cause of those who own knowledge-properties. A further example can be provided here in: Who-Is-Your-Audience? ("When I see someone in the room moving in his seat, I start worrying because I really care for my audience," declares a man proudly, whose film has just been "successfully" screened.) The question "who is your audience?" used to occupy an important role in the notion of engaged art. Today, it still retains its righteousness in specific instances, but loses its pertinence in a context where the questioning of the relation between filmmaking and filmviewing already works as structural element in the filmic process. The need to identify the audience and the tendency to take it as a given seems to be directly related to a notion of film that objectifies and separates film from audience: the film is thus a thing, the audience is another; or, filmmaking is creating while filmviewing is consuming. High culture in such a context is conveniently mystified as the exclusive realm of the creators, while popular culture remains equally mystified as that of the passively de-

196

manding consumers who, more often than not, are presented by their very advocates as being fixed and unchanging in their ideology of consumption, unwilling or unable to think for themselves. Structures of domination are thus consolidated by means of unending confrontation between adversaries.*We can agree, I think, that invisible things are not necessarily "not-there"; that a void may be empty but is not a vacuum. In addition, certain absences are so stressed, so ornate, so planned, they call attention to themselves; arrest us with intentionality and purpose, like neighborhoods that are defined by the population held away from them. Looking at the scope of American literature, I can't help thinking that the question should never have been "Why am I, an Afro-American, absent from it?" It is not a particularly interesting query anyway. The spectacularly interesting question is "What intellectual feats had to be performed by the author or his critic to erase me from a society seething with my presence, and what effect has that performance had on the work?"* (Toni Morrison).[15]

Perhaps communication has something to do with cancer, as Jean-Luc Godard puts it. Television either "sprays" or it "floods." "[It] communicate[s] so readily that nothing gets through. It is only when you disrupt sound and image, when one can hear nothing, that it becomes clear that something is not getting through, that it becomes possible to listen."[16] With its system of spraying or flooding, communication is *merchandise.* Key word of the positive sciences and of the politics of "dialogues," "participation," and "exchange," communication holds to an established model of sender, receiver, message, channel, and is, indeed, often reduced to the mercantile level of human relations. *The massive production of films and television programs transmitting ideological viruses are infiltrating the brains of half of humanity, and this phenomenom, which in part may be unconscious, is also organized and directed by capitalism which has a clearly developed consciousness of its own evilness. The economist Lerner maintained that the degradation of the popular mentality was necessary in the interests*

197

of mercantilism. . . . Imperialism has everything to gain from this cerebral conditioning which numbs all resistance and turns its victims into its accomplices (Jorge Sanjines).[17] Thus, a "political" attitude toward the dominant system of communication and consumption is, in a way, one that constantly reactivates the multi-faceted struggle against forms of domination, of exploitation, and of submission perpetuated by an ideology of visibility kept invisible in its mechanisms. The difficulties are further heightened and extended as the critical task can only be effectively carried out from a certain place of visibility. Visibility of s/he who speaks, shows; visibility of he who coordinates gestures, voices; visibility of we/they who look, listen, thread, and weave; visibility of it, which materializes itself in the process (of being launched into communication) as that social place which leaves no languages, no production (creative, analytical), no mastering, safe.

Social questions investigated through technical questions (and vice-versa) in media immediately engage questions of strategies and of play, that is to say of the *relation* between mediamaker, mediaviewer, *and* the media-image/word/sound. As Bolivian filmmaker Sanjines and the Ukamau group affirmed, "it is impossible to conceive of a revolutionary work of art where there exists a dichotomy between form and content . . . [because] the getting to the bottom of things demands forms that engage our reflection, which must be permanently activated."[18] Therefore, it is crucial to bring about ways of looking and of reflecting that make it impossible to engage in any discussion on a subject (the content, the Cause) without engaging at the same time the question of how (by what means) it is materialized and how meaning is *inter*-produced in the process. What seems necessary in all critical/political undertakings are, on the one hand, displacements that would disrupt the series of exchange on which the present organisation of information and entertainment is founded. For the investigation of reality through film, for example, cannot neglect

the reality of film in the very process of investigation. But what seems no less necessary, on the other hand, are displacements that exceed mere displacing strategies. For strategies without play and play without music is, in the end, like a conversation among deafs. "There are none so deaf as those who don't want to hear," and displacing established values does not simply consist of moving them around, but rather of *outplaying* them, producing a different hearing and, therefore, rendering them impotent by their own criteria. To listen, to see like a stranger in one's own land; to fare like a foreigner across one's own language; or, to maintain an intense rapport with the means and materiality of media languages is also to learn to let go of the (masterly) "hold" as one unbuilds and builds. It is, to borrow a metaphor by Toni Morrison "what the nerves and the skin remember as well as how it appeared. And a rush of imagination is our 'flooding.' "[19] What she wishes to leave the reader/viewer with, finally, is not so much a strong message, nor a singular story, but as Tchicaya U Tam'si puts it, "the fire and the song."[20]

NS

12

*Holes in the Sound Wall**

Your soundtrack is a disaster!
*Why? I asked HIM who knows the rules of precedence. Who can
evaluate with certainty what ranks above what ranks below in the
art of ordering film sound. There are many not-to-do's in the field
and a small quarrel may bring about many a ruin.*
(Silence. *Surprised? Indignant?*) . . . because . . . because of the
silences . . . the . . . the repetitions!
*Don't I know? Haven't I learned through COMMON SENSE that
nothing is more dreadful to the trained ear than sounding HOLES?
Haven't I noticed through the many films I saw that one of the
golden rules of sound cinema is not to leave any empty section
on the soundtrack, not even in moments where silence serves as
dramatic sound?* Above all, no hole. Please no hole. And should
there be any, let's block it up. With music. *This, Henri Colpi
rightly observed, is one of the cineastes' cries of terror. Music makes
such a successful marriage with the moving image that not using
it so as to cover up silence, to combat audience disturbance, and
to breathe into the shadows on the screen some of the life that
photography has taken away from them seems like an irremediable
error, an utter loss, a . . . di-sas-ter.*

* First published as "Ear Below Eye," *Ear: Magazine of New Music*, Vol. 9, No.
5/Vol. 10, No. 1 (Fall 1985).

Good film music was formerly differentiated from bad film music by its "inaudibility." It played in such a way as not to impinge on the viewing, and ear always came after eye in the creative process. Belonging to an area of secondary perception, it was more likely to escape critical evaluation, therefore to manipulate affection. In a sound film, there is always something to listen to: either continuous music from the beginning to the end, or sporadic music with sound effects (things crumpling, rustling, rubbing against each other, footsteps, machines running) and especially chatters, a surfeit of dialogues. With this constant train of sounds/OMNIPRESENCE, silence is avoided like a dis-ease/ABSENCE/DEATH.

Music should not disturb the representative continuity. Should not call attention to itself/detract from the images/ remind men and women of their mortality. *BE DISCREET.* Have a regular and cohesive structure *that cements and gives shape to an otherwise incoherent amorphous film. Remove the sound (from it) and we would be confronting a profoundly disjunctive set of images. We might find ourselves yawning at moments of intense actions and laughing at death scenes. In other words, emotional UNDER-scoring is lacking. Filmmaker loses his-her power to transmit* the message, *filmviewers* fail *to interpret it. MUSIC IS THE OPIUM OF CINEMA. Music determines characters, expression, mood, atmosphere, transition, orientation, meaning. Music drowns out all life noises that accidentally break in on the created world/ Reserved realm that has the force of neither life nor death, is neither one nor the other but ONLY an imag-inary site where both remained unassumed, both are re-presented, SEEN or HEARD with enough distance to banish temporarily all fears, to divert temporarily the pangs of death from life/Music more often than not dictates how the viewer should respond to the images. Without the thousand and one anchorings achieved through sound, the film would disperse in numerously diverse directions, giving rise to ERRORS OF INTER-PRETATION. Says Hanns Eisler,* the magic function of music . . . consisted in appeasing the evil spirits unconsciously dreaded The need was felt to spare the spectator the unpleasantness

202

involved in seeing effigies of living, acting, and even speaking persons, who were at the same time silent. The fact that they are living and non-living at the same time is what constitutes their ghostly characters, and music was introduced . . . to exorcise fear or help the spectator absorb the shock. *The soundless image is mortal (death has already occurred or will soon ensue): it drifts on to infinity, without ever taking root, hence its dreamlike reality—a dream within a dream. A dream that soon becomes a nightmare with deafness, muteness, and death scenes in it. A DREAM then, whose nightmarish potentials must be blocked by the insertion of a descriptive music that would make it resemble REALITY—on the one hand less of a dream because it is temporarily rid of its ghostlike features, on the other hand more of a dream because it grows unconscious of its unreality in its perfective efforts to imitate-duplicate reality. We surely don't mind (if not enjoy) seeing violence and death on film (representation of death), but we hardly tolerate seeing them built in the very sound-image relationship that makes up the film (representation as death process). Acknowledge them as part of filmmaking.*

SILENCES are holes in the sound wall/SOUNDS are bubbles on the surface of silence. Sound like silence is both opening and filling/ concave and convex/life and death. Sound like silence may freeze or free the image. In many civilizations, definitions of music and silence are interchangeable. Music is life. But entering into LIFE is also entering into the DEATH process. Every day lived is a step closer to death and every sound sent OUT is a breaking IN on silence. Music goes on permanently and hearing it is like looking at a river which does not stop running when one turns away. The eye hears and the ear sees. Music is neither sound nor silence. It is contained in each and encompasses both; invisible and intangible by nature, it is especially effective in bringing forth the tangible and the visible. As the Hindus put it: "the great singer has erected worlds and the Universe is her-his song." In the realization of a film sound-track, clear distinctions have been made between speech (dialogue,

voice-over, or oral testimony), noises (sound effects), and music. More often than not, these three elements are used as subservient INSTRUMENTS to promote an end instead of being dealt with as autonomous TOOLS for creativity. They are constructed as signifying units to help the spectator to assimilate the narrative. Thus, language is consumed exclusively as meaning, noises are reproduced mainly for their informative power, and music is tailored to fit the film's action. There is, on the whole, no room for silence (environmental sounds from the movie-house). The need to fill in every blank space that would reveal the "unrealistic" nature of the image is usually greater than the impulse to break open/in and out the sound-image wall to unveil the void of representation. A certain repulsion for silence is widely shared among filmmakers. Many of us prefer to turn a deaf ear to the death bell—DEATH STROLLS BETWEEN IMAGES—and to make of Art a human aspiration for immortality, a product SEPARATED FROM LIFE, invented so as to postpone death to infinity. The stance is, naturally, highly paradoxical: to turn away from death, one must also turn away from life. Thus, even in experimental films where the conventional narrative structure is questioned, the audience often faces a soundtrack whose continuous, drug-like flow of music does not fail to compromise the subversiveness of the visuals by indulging the viewers in an "artificial paradise" from which they cannot depart without wanting immediately to return. Drift on uninterruptedly. From one paradise one inebriation one oblivion to another. Above all, no hole. Please no hole. And should there be any, let's block it up. With music. *While the images reach a high stage of deconstruction (or do they?), the sound is satisfied with tying some pop, rock tunes, reintroducing thereby in a forceful manner the mainstream devices (of description, expression, association, identification) the images attempt at undermining. INTERNALIZED AESTHETIC CLAP-TRAP. The effect of music combined with film differs from that of film or music alone. One can easily annul the other when their relation is taken for granted, that is to say when their interaction is not thoroughly questioned. The myth of storytelling in music is still very alive in*

the film world. To challenge the monotonous universe of illustrative logic in which film music usually moves, it is therefore necessary to play an exacting game with all securely anchored audio-visual habits.

Silence: people having faith in each other. If the main motive of cinema is not expression nor communication, not telling a story nor illustrating an idea, then . . . the coast is clear(ed). Everything remains to be done in the field of film music. Everything seems possible and the constraints are above all a question of relationship. (Relationships that are determined by a specific situation—here, a sound film—but that also exceed it: they interweave beyond the limits set; relate one work to the other, film to life/death; expand layers of reading/listening; connect film, filmed subject, filmmaker, filmviewer, and context in which film can exist. One way of defining filmmaking is to say that it consists of entering into relations with things and people and making as many of these relations come into view/hearing as possible.) Whether noises are music or not, for example, depends on the hearer's way of living: how one listens to them, absorbs, and recreates them. This no longer sounds new to our ear. Yet looking at the widespread practices of sound cinema, I cannot help asking: why use noises so consistently for their informative power? Why not explore at the same time their musical potentials? Move from that which is easily identifiable to that which is at the limit of being identifiable. Listen to them non-knowingly but alertly. Enjoy their materiality. SUSPEND the MEANING of sound, by multiplying their naturalist-realist role to the point where no single anchoring is possible, no message can be congealed, no analysis can be complete. Let it go; let it exceed all control, for an excess of intentions (conscious control) is always mortal. A sound that one does not recognize (because it is decomposed, recomposed, changed—cut, repeated, emphasized differently) provokes, among other reactions, a renewal of attention for the image whose (form and) content becomes the only point of reference left, and vice-versa. One may also want to use codes so as to displace more effectively

205

their informative content. Intermittently give the illusion of real (synchronized) sound so as to reveal more keenly their illusive nature. A soundtrack can lure the spectators into a definite mood and take an abrupt turn as soon as they enter into it, thereby keeping constantly open the space of their desire for the finished product. The same holds true for the use of voices and dialogues. Language exceeds meaning. I define it first and foremost as the music of a body and a people. The eternal chatter that escorts images is an oppressive device of fixed association. To bring out the plural, sliding relationship between ear and eye and to leave more room for the spectators to decide what they want to make out of a statement or a sequence of images, it is necessary to invent a whole range of strategies that would unsettle such fixedness. Here, silence and repetitions can play an important role. Cutting a sentence at different places, for example, assembling it with holes, repeating it in slightly different forms and in ever-changing verbal and visual contexts help to produce a constant shift and dislocation in meanings. Silences and repetitions are rejected as a failure of language when they are experienced as oblivious holes or as the utterance of the same *thing* twice *or more. WE SHOULD NOT STAMMER, so goes the reasoning, for we only make our way successfully in life when we speak in a continuous articulate flow. True. After many years of confusions, of suppressed voice and INARTICULATE SOUNDS, holes, blanks, black-outs, jump-cuts, out-of-focus visions, I FINALLY SAY NO: yes, sounds are sounds and should above all be released as sounds. Everything is in the releasing. There is no score to follow, no hidden dimension from the visuals to disclose, and endless thread to weave anew.*

Illustration on next page.

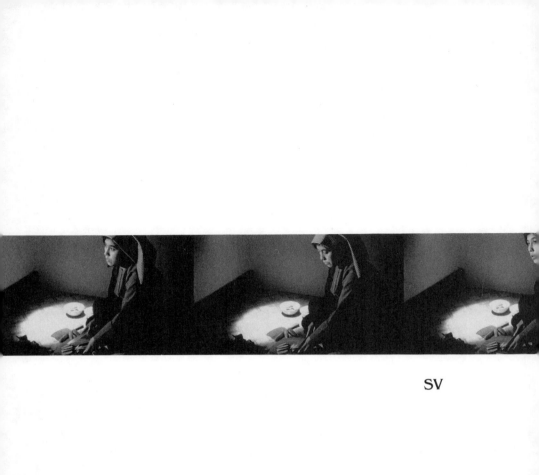

SV

13

The Plural Void:
Barthes and Asia[*]

Writing, says Barthes, is in its own way a *satori*. It corresponds to that Zen event which in *L'Empire des signes* (Geneva: Skira, 1970) is defined as "a loss of meaning," a "seismism . . . which perturbs the thinking subject: it produces a *speech-void*. At the same time, this void makes writing possible; it is what permits Zen, in the suspension of all meaning, to "write gardens, gestures, houses, bouquets, faces." (p. 10).[1] These statements present the two inseparable faces of a single entity. They open, as would a dice throw, a text in which the (named) Void moves beneath multiple forms, showing us at each pause in its displacement, a new face. This philosophy, this doctrine, which when referring to Barthes I will call the notion of the Void, is not confined to *L'Empire des signes*. It belongs to a network of closely connected signifiers and signifieds where Barthes chooses to be situated.

In *Essais critiques* Barthes had already remarked that literature is only form and indirect illumination: "if you treat an

* First published in *Sub-Stance*, Vol. 11, No. 3, (Winter 1982) (c. The Regents of the University of Wisconsin System). Originally written in French, it was translated for *Sub-Stance* into English by Stanley Gray (University of Illinois at Urbana-Champaign).

indirect structure directly, it escapes, it empties out, or on the contrary, it freezes, essentializes."[2] The observation clarifies (and is clarified by) Barthes's reading of Japan. It recurs in his texts, each time reformulated as if to make his concept of the writer-public experimenter more concrete:

> he knows only one art: that of theme and variations. On the side of the variations will be found . . . his *content;* but on the side of the theme will be found the persistence of *forms* Only, contrary to what happens in music, each of the writer's variations is taken for an authentic theme, whose meaning is immediate and definitive.[3]

Barthes sees Japan as an immense reservoir of empty signs. Packages, bows of respect, Tokyo's inner city, *haïku, Bunraku,* all inspire a meditation on semantics. "The Japanese thing is not enclosed . . . nor formed by a sharp contour, a design, which would then be 'filled' by color, shadow or brushwork; around it there is a *void,* an empty space making it matte*" (*L'Empire,* p. 58). On the other hand, a Japanese box, for example, does not function as a temporary accessory to the object it contains; as envelope it is itself an object. Although its value is related to what it conceals, "that very thing which it encloses and signifies is postponed for a very long time" (p. 61). Like a rigorously arranged bouquet which invites the perceiver to follow what the creative hand has traced, thus frustrating the simple decoding of a symbolic message, "the package is a thought":

> It is seemingly in the envelope that the work of *fabrication* is invested, but for this very reason the object tends to lose its existence, becomes a mirage: from one envelope to the next, the signified takes flight and when it is finally grasped . . . it seems insignificant, valueless, abject: . . . to find the object which is in the package, or the signified which is in the sign, is to throw it away. (p. 61)

* The term "matte" (*mat, mate* in French) is used by Barthes to describe texture, colors, sounds, the surface of a text. It may mean such things as lusterless, without resonance or echo, flat, "literal" (as in a text by Robbe-Grillet). Translator's note.

Framed by void and framing nothing (or framing a nothing), the Japanese thing shows itself as essentially form *and* emptiness. If it is approached directly, i.e. as mere container, it either flees, empties itself of content, or else it congeals in its function as envelope. In either case, one is left holding an empty skin. The desire to grasp typically confuses illusion and reality or, to use a well-known Zen expression, the finger and the moon. Barthes's remarks here recall his earlier views on literature: "Whoever wishes to write with exactitude," he has said, "must proceed to the frontiers of language"; "the most 'realistic' work will not be one which 'paints' reality, but one which, using the world as content, will explore as profoundly as possible the *unreal reality* of language."[4] Writing like *satori* in no ways means God's illuminative descent; it is rather an " 'awakening to the fact,' a grasp of the thing as event, not as substance" (*L'Empire*, p. 101; italics mine).

Postponement is a type of indirection. It has become almost commonplace today to say that the interest of a game, trip, or quest lies not in the goal but in the route taken (or more precisely, *given*) to reach it. The goal is at most a pretext or provisional halt. The verbs "to play," "to travel," "to search," "to write," are often used in an absolute sense, not introducing a complement. Following Barthes, in "To Write: An Intransitive Verb,"[5] we should use (in French, at least) the *passé composé intégrant* (instead of the *passé composé dirimant*) to say "Je suis joué(e)," "je suis voyagé(e)," "je suis cherché(e)" (without complement), "je suis écrit(e)," just as one says (writes) "je suis né(e)." These expressions are not meant to convey an idea of the passive. They diminish "asymptotically" the distance between subject and act: the agent is here not posited as preexisting but as immediately contemporary to the process of the act, being both "effected" and "affected" by it. Similarly, "there is always a little *something* in the [Japanese] package," although this something cannot be grasped, nor separated from what conceals and protects it without appearing at the same time as "insignificant." And the enve-

lope, grasped directly, also loses its *raison d'être*. The package's existence depends on the interdependence of the two elements and it is in order to *designate* this reality more effectively that the work-investment seems to be in the envelope, that Japanese boxes contain Japanese boxes *ad nihilum*, that the Japanese bouquet invites us to retrace its arrangement, thereby showing us how it may be unmade and restored to the void. A mirage, the envelope is realistic by virtue of consciousness of its unreality. To seize it as a substance is to take for the moon the finger which points to the moon. To fix it as mirage is to encounter the void. One annihilates what one names. Writing, as Barthes says, produces a "vide de parole." For this reason, "*The Name does not cross its lips*, it is fragmented into practices, into words which are not Names. Bringing itself to the limits of speech, in a *mathesis* of language which does not seek to be identified with science, the text undoes nomination."[6]

For the writer, to undo the work of death means to deconstruct, to dislocate the entire system of Western rhetoric. Bathing everything with meaning, "like an authoritarian religion which imposes baptism on whole populations," this system has always aimed at "banishing from discourse the scandal of nonsense" and its imperative is still the "desperate filling-in of any blank space which would reveal the void of language" (*L'Empire*, pp. 90–92). Denouncing such an operation leads, in Barthes's case, to a definition of literature as "consciousness of the unreality of language."[7] *Haïku* provides a useful example:

> The number and dispersion of *haïkus* on the one hand, the brevity and closure of each of them on the other, seem to show an infinite division and classification of the world and to set forth a space of pure fragments, a swarm of events which, owing to a sort of disinheritance of signification, neither can nor should coagulate, construct, direct, terminate." (*L'Empire*, p. 101)

Haïku is thus a grasping of the thing in its "fragile essence of appearance." It brings forth that "strictly speaking ungraspable

moment in which the thing, though nothing but language, will become speech," (p. 100). Like that of the package-mirage, the content of *haïku* is so insignificant, so ordinary that "the paths of interpretation, by which we [in the Western world] seek to perforate meaning, that is to say by forcing its entry . . . cannot but fail, "because the reading process called for requires one to "*suspend*, not evoke language" (italics mine, p. 94).

Because of its brevity, *haïku* is often referred to a "silence," a heavy, deep, mystical silence, and is attributed to a "sign of a full language" (pp. 92, 96). As a "vision lacking commentary," *haïku* will nevertheless not allow commentary. *Haïku* cannot be explicated, merely repeated; nor can it be deciphered, analyzed, or developed without subjection to the processes of metaphor or syllogism. In fact, "it is not a rich thought reduced to a brief form, but a brief event which assumes immediately its adequate form" (p. 98). Its rightness is owing to "a merging of signifier and signified, a suppression of border-lines, leaks of significance or interstices which ordinarily exceed or open up the semantic relationship" (p. 99). "What is set forth is matte. It can only be repeated" (p. 97). "What is sought is the very founding of the sign" (p. 96).

> The aim is not concision (that is to say an abbreviation of the signifier without reduction of the density of the signified), but on the contrary to act upon the very root of meaning, so that this meaning . . . is not interiorized, not made implicit the aim is not to submerge language beneath the mystical silence of the ineffable but to arrest the spinning verbal top, whose girations whirl us in the obsessional game of symbolic substitution. (p. 98)

Haïku is written in perfectly readable discourse; it cannot therefore be called nonsense, nor can meaning be imposed on it. The exemption from meaning within meaning itself is to be understood not as abolition, but as "suspension" of meaning.

Haïku is one of those forms of courtesy in Japan which signify "nothing." If the bow of respect displays itself above all as graphic form free from all expression of vanity or humiliation

213

("two bodies which write themselves without abasement," p. 88), *haïku* is like "a polite host who permits you to make yourself at home, with all your obsessions, values, symbols" (p. 89). It is an empty mirror, a "symbol of the void of symbols," which receives but does not conserve, which *"captures only other mirrors* and whose infinite reflection is emptiness itself (which is to say form, as we know)" (italics mine, p. 104). *Politesse* in no way expresses submission or lack of personality, as some Westerners may think; it is, says Barthes, "a practice of the void" (p. 86):

> There is a moment when language ceases (a moment obtained by much practice), and it is this echo-free cutting-off which produces both the truth of Zen and the form, brief and empty, of *haïku*. (p. 96)

> All of Zen—*haïkai* is merely its literary branch—has thus the appearance of a vast operation aimed at *stopping language* . . . at drying up the irrepressible chatter of the soul; perhaps what is called, in Zen, *satori* . . . is nothing more than a panicking suspension of language, the blank which effaces within us the reign of codes, the shattering of that inner speech which makes us persons. (p. 97)

The Void: a tissue which is formed as its meshes (mirage, event, nothing, unreal reality, the matte, suspension) takes shape. And it is in relation to the Void that these meshes are woven. Writing unravels (délie; dé-lit) and weaves (relie; relit); it repeats tirelessly the same gesture. "Rain, Sowing, Dissemination. Web, Tissue, Text, Writing," notes Barthes (p. 14), and further: "the Sign is a fracture which opens only upon the face of another sign" (p. 72). Barthes's writing is a Japanese package which one must endlessly undo: from envelope to envelope it defers its closure, and what it encloses is "postponed for a very long time." The Name "is fragmented into practices, into words which are not Names," and the words, like chameleons, change color to suit their surroundings. Even when they are defined, they continue to say: and/not that, and/not that yet, while renewing themselves

at each reappearance. Every definition, complete in itself, bears the traces of another definition; nothing is final: "the author [*écrivain* rather than *écrivant*] knows that his language, intransitive by choice and by labor, inaugurates an ambiguity, even if it appears to be peremptory, . . . that it can have no other motto but Jacques Rigaut's profound remark: 'and even when I affirm, I am still questioning.' "[8] Thus, having written a text on China, Barthes asks this question:

> We cannot speak, and surely not write, without being subject to one of these modes: either affirming, or denying, or doubting, or questioning. But cannot the human subject have another desire: to *suspend* his utterance without, however, abolishing it?

and goes on to describe his own work as follows:

> On China, an immense topic and, for many, one which inspires passion, I tried to produce—my truth was in this—a discourse which would be neither assertive, nor negative, nor neutral: a commentary whose tone would be one of "no comment": an acceptance . . . and not constrained to either approbation or rejection.[9]

Barthes seeks a certain suspension in his discourse, a suspension experienced as "a blank which effaces in us the reign of codes" and as a regenerative place of rest: "Pleasure's force of *suspension* can never be overstated: it is a veritable *époché*, a stoppage which congeals all recognized values (recognized by oneself)."[10] This is what is seen in the image of the "suspended garden" which he associates with his seminar in Paris:

> A peaceful gathering in a world at war, our seminar is a suspended place; it takes place each week . . . supported by the world which surrounds it but also resisting that world, quietly accepting the immortality of being a fissure in the totality pressing in from all sides (or one should say, rather, that the seminar has its own morality).[11]

Defying commentary, this suspended discourse can be situated, in *Alors la Chine?* as a response to ethnocentrism and its ally, phallocentrism:

By producing a subdued mirage of China as something placed outside of the domain of brilliant colors, strong flavors and brutal meanings (all of these having some connection with the everlasting parade of the Phallus), I wanted to bind in a single gesture the feminine (maternal?) infiniteness of the object itself . . . and the right to a special discourse, a discourse which drifts slightly, or which speaks the desire for silence This is not a gratuitous hallucination: it seeks to respond to the way that many Westerners produce their own hallucinations of the People's Republic of China: in a dogmatic, violently affirmative/negative, or falsely liberal mode. (p. 14)

The association suspension/feminine conjures up a cloud of images and sentiments: pause, peace, acceptance (not espousal nor rejection), effortless slipping, desire for silence and mother. The mother: "role-free, as non-Name (non-nom) . . . who refuses to be fragmented but suffocates codes" (Hélène Cixous); she who in her maternal love wills herself whole and the other whole and is therefore neither assertive, nor negative, nor neutral. And Barthes is not reluctant to refer this "special discourse" to Taoist "wisdom" (p. 14), a reference which we have already discerned in the symbol of the empty mirror and which is even more clearly justified by these lines taken from the *Tao-Te-King:*

> A large kingdom is the low ground toward which all
> streams flow
> the point towards which all things converge
> the Feminine of the universe. (61)
>
> Know in yourself the masculine
> Cling to the feminine
> Make of yourself the world's Ravine. (28)[12]

To approach the Unknown, that feminine or maternal infinity which is China, Barthes affirms that his preoccupations have little to do with the description, deciphering, or production of a meaning. He is concerned with the approach itself, with the discourse produced and with the confection of the envelope: China, writes Barthes, overflows meaning in a extraordinary way

(*La Chine*, p. 14). It cannot therefore be grasped by the forced entry of meaning. It is, in fact "pale," "colorless," and "peaceful" (does not the word "chinoiserie" convey the notions of *excessive* subtlety, useless and *extravagant* complication which Westerners associate with China?); it is, in short, rather like the Japanese thing. It is not, nor can it be, circumscribed by "a strong contour . . . which would then be 'filled in' by color." To approach Her as closely as possible, Barthes chooses a pluri-dimensional procedure aware of itself as an unreal container (the irreality of language) of another unreal container (the irreality of "China" and what She, an indirect envelope, includes): "The intellectual (or the writer) has no site—or this site is nothing other than indirection itself: it is to this utopia that I have tried to give a (musically) adequate discourse" (p. 14). We have here again the Japanese boxes, one inside the other *ad nihilum*, with the infinite play of mirrors.

Barthes's writing produces a "Displacement: it is not the truth which is true, it is the relationship with the lure which becomes true. To situate myself within truth, a stubborn persistence is sufficient. Affirmed endlessly, in the face of all opposition, a 'lure' becomes a truth . . . Truth would seem to be that which, in the fantasy, must be postponed, but not denied, extracted, betrayed . . . Truth: *that which is marginal*."[13] This last statement derives from a Zen example. It illuminates Barthes's literary moves and casts another light on the notion of the Void. As we have affirmed, the Void or *śūnyatā* suggests Nothingness or Relativity, but does not signify them. Closely linked with the notion of Non-Identity, the Void is however a synonym for *tathatā*, the Non-Void or, more precisely, the This (le *Tel*). This apparently contradictory coupling is, naturally, intentional. It prevents the conceptualization of the Void, for the "true Void" is not a concept, it is the void of the *tathatā* (Thich Nhat Hanh).

An "adequate discourse" in Barthes's mind is a discourse aware that it is essentially language and which, like *haïku*, "is not at all an exact painting of the real, but a merging of signifier and

217

signified." A commentary resisting comment, it wants to be *matte:* the reader cannot evaluate, classify, or reduce it to an interpretive system—every criticism based on *vraisemblable* is declared non-pertinent. On the other hand, she/he constantly recovers it (*resasse*) by *quoting;* redoubles it (*dédouble*) by repeating its gesture, meshing in this way knowledge with the "machinery of infinite reflexivity"; she/he *displaces* it to a realm where it is not foreseen; indefinitely *fractures* and *reconstitutes* it. Like photography, a just discourse is "the absolute Particular, sovereign Contingency, matte and somehow stupid, the This."[14] It neither expresses nor describes, it *designates* and reproduces the gesture of a small child who points at something saying only "This!" in an unmediated movement free from any sense of finalism (c.f. the This and the example of the child recur obsessively in several texts by Barthes, including *L'Empire, Fragments d'un discours amoureux* [*A Lover's Discourse*] and *La Chambre claire* [*Camera Lucida*]. Breaking with the notion of development, Barthes's writing proposes variation: instead of following an itinerary moving from beginning to end, the song alternates between moments of "Here" (*Voici*) and "There" (*Voilà*). Why is this or that discourse, object, moment chosen? Because: "The other whom I love shows me the particularity of my desire."[15] Reciprocal designation determines the This and its uniqueness. As with *haïku*, what occurs is an event which suddenly finds its appropriate form. Writing does not seek possession through affirmation or denial; it has, in fact, no purpose. It simply dramatizes language, and unfolds the "goings and comings of a desire."

"To know that writing is neither compensation nor sublimation, that it is situated precisely *in that place where you are not—* is the beginning of writing."[16] *Satori* cannot be *obtained* (through effort or discipline). No profound vision is required for the comprehension of the Void; it emerges where it is forgotten, when one looks at the marginal and juggles other words. Likewise, it is inexact to conceive of the suspension of language as "a moment

obtained by much practice" (quoted above): the realization of silence implies the intervention of the "I." Barthes seems more consistent with his writings on Asia and closer to oriental thinking, when he speaks of "the shattering of that inner speech which makes us persons." For the new to be, all must reach an end. Writing is born when the writer is no longer. Which does not mean that he/she withdraws, but he/she dies in himself/herself in order to exist simultaneously with the text.

In *Fragments* (*A Lover's Discourse*), the "I" functions as does Tokyo's inner city: it subsists not in order to propagate some power or other, but to nourish the whole textual movement with its central void, thus obliging the imaginary to deploy itself around it, in detours and returns on the circumference of an empty subject. The ego-mirror is the equivalent of a polite host who allows "thousands of subjects" to make themselves at home in his dwelling and to speak through him. His/her portrait, structural and non-psychological, dramatizes an *utterance* (*énonciation*). As in the seminar, what is produced is a work written *in front of* or *with* others, a propagation of a desire for a Text, a chain in which "the object is a matter of indifference, but subjects operate." The writer's role is comparable to the gesture of "circulating the ring" so that "each can take his turn as master of ceremonies."[17] The gesture of initiation is not, however, as simple as it may seem. How does one "pass the deal (word)" when one is a "master"? "Each time that I try to hand the direction of the seminar over to others, it returns to me: I can't get rid of my 'presidency.' " "We should write in the present tense," concludes Barthes, "we should display the *process of enunciation*."[18]

"He whose discourse is non-instrumental" is the Father, the One who Speaks. But "He who points to the one who speaks, who designates enunciation, is no longer the Father."[19] The writer forms and is formed by a layering and separation of the "I." He is a plurality of subjects of speaking and of speech, and of the denunciation of these. The gesture of denunciation is infinitely repeated. We return here to that "mirage-displacement" which

ceaselessly postpones and defers (the Father) and which thus provides a method for the abdication of power. In *Fragments* the writer speaks through a Someone (*On*) who is distinguished from the "I" of the discourse. These superpositions, detectible also in *L'Empire, La Chine, Camera Lucida*, do not obliterate the presence of the Father; they fragment it, thus lightening and retarding his power.

Intent on unveiling the process of the book, Barthes often gives us the how and the why of what is written. He wishes somehow to reproduce the double gesture of *Bunraku*, which is to be read on two levels, that of the marionette and that of the manipulator. "It [*Bunraku*] displays both gesture and act, exposes at once art and its production" (*L'Empire*, p. 67). *Fragments* begins, similarly, with the two questions: What is the need for such a book? How is it made? The situation of *L'Empire* and *La Chine* is more complex: what he seeks here is not to decipher Asia, but rather to assess his own position vis-à-vis exoticism, ethnocentrism, and, above all, to assess his own hermeneutic posture, his role as decoder. Consequently, he takes great care in *L'Empire* to situate his work and to set aside any desire to conform to the "real." He neither claims nor desires to analyze an oriental culture; what he looks for is the "possibility of a difference": "to undo our 'real' by means of other *découpages*, other syntaxes, to unveil the extraordinary positions of the subject in his enunciation . . . to descend to the untranslatable, feel its shock without protection, to the point that all that is Western in us is convulsed, along with the rights of the Father Language" (*L'Empire*, p. 11). Suspended between the fictive and the real, Barthes's Japan parries or blocks any criticism based on the *vraisemblable*. We read the author reading Asia. He writes, not because he has "photographed" Japan, but because "Le Japon l'a étoilé d'éclairs multiples" and has placed him in the "situation of writing" (p. 10). The unknown he confronts is neither Japan nor China but his own language, and through it, that of all the West. Subject and object are inseparable: "the question asked indiscreetly

about meaning is turned into the question of meaning" (*La Chine*, p. 8). In fact, what is given us to read in these books is neither the observed nor the observer but the observing: "The eye by which I see God is the same eye by which He sees me."[20]

"The *énoncé*," writes Barthes, "is given as the product of the absence of a speaker. As for the *énonciation*, by exposing the site and the energy of the subject . . . it plays the role of giving voice to a subject who is at once insistent and invisible."[21] Hence, whatever the object chosen may be—Photography, the Lover, the Seminar, Asia—it is in what shows the writer's engagement with language that his subjectivity must be sought and defined. "I am indifferent to the Orient," Barthes has said (*L'Empire*, p. 7); the Orient can only illuminate his own truth, that of his desire to produce an adequate discourse (*La Chine*) or that of "being a subject torn between two languages, one expressive, the other critical; and at the heart of this critical language, between several discourses, those of sociology, of semiology and of psychoanalysis."[22] Through persistent interrogation of the material which defines him, the writer dramatizes a "body in situation." Barthes sees in this gesture a sort of rape, "as if, in order to fall in love, I had to accept the ancestral formality of rape, that is to say surprise."[23] "The greatest transgression," he says elsewhere, "is to surprise the Father in the process of *énonciation*."[24] While the taste for transgression shows a continued attachment to the Father, in *Bunraku* the simultaneous display of art and its production remains an empty gesture. In this perspective, we can better understand Barthes's procedure in *La Chambre claire* (*Camera Lucida*): the observations aimed at situating the writer's work are no longer affixed to the beginning or the end of the text as if to underline the separation of product and production, but are incorporated into the text itself. Through this more indirect approach to "the science of the subject" Barthes seems to free himself from the clearly justifying and arrogating tone used earlier to clarify his position. "Language is always assertive," he says, "even and essentially when it is surrounded by a cloud of

oratorical precaution."[25] Rejecting any reductive system, Barthes will quietly abandon a particular language to look elsewhere as soon as he feels that this language is "tending to reduction and reprimand."[26] Beyond the cleavage I/one, he moves towards an "absolute subjectivity [which] is achieved only in a state, an effort of silence . . . to say nothing, to shut my eyes, to allow the detail to rise of its own accord into affective consciousness."[27]

Illustration on next page.

SC

14

*The Other Censorship**

Art criticism constitutes a constant reminder of how fragile the boundaries of both art and of criticism are, and how necessary their mutual challenge remain. What is involved is not only the specificity of art versus that of criticism, but also a certain disrespect for their unique properties as practices. The site where the two closely relate is also the very site where they intensively resist one another.

In critical inquiry, both the the search for a unifying principle and its constant differing/deferring remain compelling. A challenge issued at the continual attempts made to perpetuate the divide between art and theory is one by which critical activity does not merely result from the accumulative knowledge of two separate practices. The latter's boundaries need to be exceeded, for when art continually resists theorization while theory persists in challenging the limits of aestheticism, neither art nor theory can remain untouched in their mutual counteraction. If art is to function critically, if it is to bring a transformative effect to bear on theory while questioning its own status as art, it would

* A shortened version of this article was published in c. *Artforum*, "Critical Reflections" series, Vol. 28, No. 10 (June 1990).

unavoidably have to push itself to the frontier of what is art and what is non-art. To engage in critical practice is to shuttle incessantly between borders, with no one border having fixed priority over the others.

While theory is bound to proceed from a philosophical and historical awareness of "the end of art," the questions of art continue to be called on to open up the boundaries of philosophy and politics. Theory is not necessarily art, and art not quite theory. But both can constitute "artistically" critical practices whose function is to upset rooted ideologies, invalidating the established canon of artistic works and modifying the borderlines between theoretical and non-theoretical discourse. *You see, that's why I work like a dog and I worked like a dog all my life. I am not interested in the academic status of what I am doing because my problem is my own transformation. . . . This transformation of one's self by one's own knowledge is, I think, something rather close to the aesthetic experience. Why should a painter work if he is not transformed by his own painting?* (Michel Foucault).[1] Recast in a critical light, the relation between art and theory does not lead to a simple equation and collapse of the fundamental assumptions of the two. Rather, it maintains the tension between them through a notion of the *interval* that neither separates nor assimilates.

In a world of reification, of fixed disciplines and refined compartmentalizations, to affirm that "I am a critic, not an artist," *or vice-versa*, is to resort to a classification and a professional standard that ultimately serve to preserve the status quo. It is to reproduce a discourse that states little more than the site it comes from, as it tends to gloss over the field of struggle, the mesh of established relations within which positions and postures are defined (even when the latter are taken up precisely to transform it). Attempts to probe the workings of these games of power (rather than merely condemn them from an unreflectively judg-

226

mental articulatory place) will remain futile if one is content to assert one's position as an expert, whose authority derives from the specialization of knowledge—here, from a certain expertise in "artistic" matters. Similarly, to deny one's critical responsibility is to entrust these matters to professional experts who are then allowed, via mutual consent between artist and critic, to legalize their control not only over the determination of the way things are, and are to be made, but also over the reasons why their role is indispensable: how criticism should be done and by whom; what shall be valued as "art," for whom this art will be produced, and how it will be administered. The waning of the hegemonic professional ethos is a necessary condition for the emergence of new relationships and complex forms of repressed subjectivities.

Critical practice is often reduced to a matter of evaluation and judgment or, of declaring what is not right in the state of things. Yet, if criticism is indispensable to socio-political—in fact, any— transformation, it is because of its potential to set into relief the frame of thought within which operate the practices we accept. In showing that what tends to be taken for granted can no longer be so, criticism requires that change be effected on the frame itself. Thought cannot simply be ignored in the name of art and its resistance to theory. Nor can it merely be substituted by the quantified social as in the conventional rhetoric of militancy. "Bourgeois" anti-intellectualism often hides behind an undifferentiating rejection of academicism and elitism. (The hegemony of institutionalized need and normative judgment notwithstanding, it never seems to be at issue whether every intellectual activity must by definition *be* "academic.") Proceeding essentially by reductive classifications and binary oppositions, it works at obscuring the processes of change, hence at denying the fact, as Gramsci remarks, "that there is no human activity from which every form of intellectual participation can be excluded: *homo faber* cannot be separated from *homo sapiens*. Each man

. . . carries on some form of intellectual activity, that is, he is a 'philosopher,' an artist . . . and therefore, contributes to sustain a conception of the world or to modify it, that is, to bring into being new modes of thought."[2] Those who reject thought as a crucial aspect of human relations often do so by sacralizing either the aesthetic or the social as the only reality, turning a blind eye on the vital role of intellectual activity in everyday behavior, in every social organization, and even in silent habits.

The resistance to theory, or to forms of theorizing that tend toward universalization and idealism constantly runs the risk of reinstituting naively naturalized theoretical concepts as alternatives to theory; as if a pure, self-evident, and pre-theoretical state of meaning can always be returned to, whenever immediate access to language is thwarted. Such concepts are often the result of a nostalgic desire for a return to "normalcy"—a state of validated "common sense" in which polarizing opinions and uncomplicated familiar forms of analysis, interpretation, and communication can be made possible once again. Ironically enough, accessibility in such a context takes on a universal character: to be "accessible," one can employ neither symbolic and elliptical language, as in Asian, African, or Native American cultures (because Western ears often equate it with obscurantism); nor poetic language (because "objective" literal thinking is likely to identify it with "subjective" aestheticism). The use of dialogical analytical language is also discouraged (because the dominant worldview can hardly accept that in the politics of representing marginality and resistance one might have to speak at least two different things at once). *There is a kind of resistance to reading the complexity of black experience as modern subjectivity. And for me when white people say I don't understand, I find this difficult. . . . It's as if there's a kind of naivety, that they come to a place where we're all going to talk "sense" anyway* (Isaac Julien).[3] Accessibility, which is a process, is often taken for a "natural," self-evident state of language. What is perpetuated in its name is a given

form of intolerance and an unacknowledged practice of exclusion. Thus, as long as the complexity and difficulty of engaging with the diversely hybrid experiences of heterogeneous contemporary societies are denied and not dealt with, binary thinking continues to mark time while the creative interval is dangerously reduced to non-existence.

Critical work is made to fare on interstitial ground. Every realization of such work is a renewal and a different contextualization of its cutting edge. One cannot come back to it as to an object, for it always bursts forth on frontiers. The solution, however, is not an improved method, a better theoretical model, or an "alternative" view. Instead, critical strategies must be developed within a range of diversely occupied territories where the temptation to grant any single territory transcendent status is continually resisted. Can art, indeed, be used to point to the limitations of theoretical discourse in its systematic form without supplanting it, and without ending up being mystified itself? The politics of exclusion has never really succeeded in challenging theory in relation to art (or vice-versa); it only results in furthering division and isolation, and ultimately, it contributes to preserving hegemonic forms of individualism. Thus, strategies developed could explore to a fuller extent the dynamics of *relations* by linking up with an elsewhere(-within-here) of theory and of art, one that exceeds both knowledge and aestheticism.

When binaries no longer organize, the difficulty then becomes speaking from no clearly defined place. This shifting multi-place of resistance differs in that it no longer simply thrives on alternate, homogenized strategies of rejection, affirmation, confrontation, and opposition well-rooted in a tradition of contestation. *Let us not reduce the question of difficulty to whether the room is too dark. . . . [The third scenario] is the scene where this new thing is worked out, and the difficulty we are having is the difficulty of that discourse emerging* (Stuart Hall).[4] The challenge has to be

229

taken up everytime a positioning occurs: for just as one must situate oneself (in terms of ethnicity, class, gender, difference), one also refuses to be confined to that location. If art can be neatly contained in systematic forms of closure, if it can be made to be an object of knowledge, then it no longer is art. Its very "essence" rests upon its elements of inexplicability and of wonder. Or else, why would anyone engage in artistic work, whose value lies precisely in its inability to prove itself worth the price or the attention demanded? Few, probably, would contest this point, although many would reject it when it serves to depoliticize the aesthetic experience.

Art is political. But one also has to understand that the uses to which it is put are not its meaning. Its status as object and commodity is not its meaning: there are many objects and commodities. They are not all art. What makes art different? Exactly the ways in which it is not an object, can never in its nature be a commodity (May Stevens).[5] The ability to confer aesthetic status on objects and representations that are excluded from the dominant aesthetic of the time is a way of asserting one's position in social space. It is a way of defying the ethical censorships of the ruling classes whose aesthetic intolerance and aversion to different lifestyles defines them as the possessors of legitimate culture. Problems of exclusion and of commodification in the artworld as well as in the theory milieux have always been intimately linked with sexually and racially discriminating practices. Not only women of color, for example, are barely accepted as "artists" or as "theorists" (not to mention "feminist theorists"); but, when they are (reluctantly) admitted into these owned territories, they are also, depending on the circumstances, either intransigently expected to abide by what the dominant eye sees as their "ethnic heritage," or backhandedly blamed for this very ethnic loyalty (such as choosing ethnicity over gender in the feminist struggle). Assumptions on the role of art in communities of people of color are naturalized to the extent that Caucasian critics never hesitate to

claim that they find it difficult to conceive of Black, Chicana, Asian, or Native American women's experiences. They maintain that they can't presume to speak for them (under the pretext that they are not familiar with the latter's histories), thereby patronizing these artists with the latter's original "you-have-to-be-one-to-know-one" strategy. (Male artists of color do not seem to fare much better.)

This almost uniform silence of the critical media is all the more malign given the nationwide action against censorship recently sparked by the attempted suppression of works by Robert Mapplethorpe. (In the past, the question of censorship has time and again surged with the challenge of works by certain white male artists.) The furor surrounding Mapplethorpe tends to obscure the Other Censorship—less visible, hence construed as less relevant: that censorship, as Adrian Piper reminds us, "of art made by women artists of color [which] has been, until very recently, an entrenched practice in the artworld."[6] No matter how enduring this other censorship proves to be and how damaging its action remains for the artworld, the resistance to even acknowledging its existence continues blindly to uphold itself. Thus, in the name of Civil Liberties, Freedom of Expression, and First Amendment rights, the focus in censorship debates has repeatedly been the legal defense and protection of white male artists' privilege of exhibiting works whose explicit/implicit racial or sexist stance is stridently ignored. The colonialist creed "Divide and Conquer" will persist as long as issues of censorship, racism, and sexism continue to be treated as unrelated. As Juan Sanchez asks, "Where do we people/artist of color fit in? Do we defend to preserve a system that never considered us in the first place or do we wage a battle within a battle and hope that we not only help the same constitution but also advance and improve our racist situation?"[7] (More precisely, where do gay artists of color fit in such a battle?)

231

The Third Scenario

The denial of problems of race and gender in the practices of art and of criticism is also the fear to grow and to grope at the same time while walking on uncharted or unfamiliar ground. Histories have to be produced to live on; they do not exist as self-evident or dead knowledge; nor can they be apprehended in the refusal to learn and the building up of frontiers through specialized (ethnocentric) knowledge. *In a friendship, race is just one more index of singularity. It becomes a symptom of alienation when it demarcates group allegiances. . . . My work is an act of communication that politically catalyzes its viewers into reflecting on their own deep impulses and responses to racism and xenophobia, relative to a target or stance that I depict* (Adrian Piper).[8] To make a claim for multi-culturalism is not, therefore, to suggest the juxtaposition of several cultures whose frontiers remain intact, nor is it to subscribe to a bland "melting-pot" type of attitude that would level all differences. It lies instead, in the intercultural acceptance of risks, unexpected detours, and complexities of relation between break and closure. Every artistic excursion and theoretical venture requires that boundaries be ceaselessly called to question, undermined, modified, and reinscribed. By its politics of transformation, critical inquiry is ever compelled to look for different approaches to the aesthetic experience, different ways of relating to it without categorizing it. Different inquiry by its very inquiry; different attitudes of self through knowledge, different knowledge of the self through the selves within (without) oneself. To maintain the indeterminacy of art, criticism is bound to test its limits, to confront over and over again the legitimation of its own discourse, hence to bring about its own indeterminacy.

In Chinese philosophy, such an apparently paradoxical stance is pivotal to the Yin-Yang principle or the Vital Breaths of life. This "third scenario," as Stuart Hall has called it, or the non-binarist space of reflection and its struggle in the politics of location, is hardly "new": one does not so much invent the new

as provoke new relationships. Indeed, without the intervention of the Void, the realm of the Full governed by the Yin and the Yang is bound to remain static and amorphous."*A film I can't even talk about because I am living it*" (audience's response to Tarkovsky's *Mirror*).[9] In the dynamic process of mutual becoming, the Breath of the Median Void dwelling at the heart of all things draws and guides the two Vital Breaths, maintaining them in their relation to no-thingness, thereby allowing them access to separation, to transformation and to unity. These are said to be the three basic meanings of the Void, whose role is not simply passive, since by its mediation, the nature of any opposition, any antinomic or complementary pair, is bound to change. *I simply cannot believe that an artist can ever work only for the sake of "self-expression." Self-expression is meaningless unless it meets with a response. For the sake of creating a spiritual bond with others it can only be an agonising process, one that involves no practical gain*" (Andrei Tarkovsky).[10] Thus, Chinese thought which is rooted in the crossing double movement of the Void and the Full, and within the Full, that of the Yin and the Yang, remains profoundly ternary rather than dualistic. At the heart of the Yin-Yang system, the Void constitutes the *third term*, and with it, a binary system becomes ternary (the Void being the interval between the Yin and the Yang), while the ternary system tends ceaselessly toward the unitary (the oneness of the Yin-Yang circle).

The Chinese traditional Arts fully understand the vitality of this "third term" in binarist relation. In its physical inscription of the gestural movement, Chinese calligraphy, for example, refuses to be a mere system of support for the spoken language. It materializes the tension between a required linearity and an aspired-to spatial freedom (the oneness of brush strokes, also known as the free origin of painting and "the root of ten thousand forms"—a concept that can easily fall prey to Western mystification as a result of dualist thinking). Similarly, through the action

233

of the Void, large unpainted areas of white paper crucially con-
tribute to the tonality, the composition, and the mood in Chinese
painting. The double intersection of the Host-Guest (passive-
aggressive, *pin-chu*) and the Opening-Closing principles (*k'ai ho*),
as well as the simultaneous division of a landscape into three
planes (near, middle, far) and two grounds (upper and lower
sections) show us other ways to imagine the Middle Ground.
Here, no duality is inferred in the Two, no uniformity implied in
the One, but above all, no *compromise* meant by "middle."
Rather, what is involved is a state of alert in-betweenness and
"critical" non-knowingness, in which the bringing of reflective
and cosmic memory to *life* —that is, to the *formlessness of form*—
is infinitely more exigent than the attempt to "express," to judge
or evaluate.

Critical work requires a difficult mode of attention: one sees
and listens to it happening; one plays (with) it as one experiences
it in/as an activity of production. One does not really catch it,
nor does one speak *about* it without contingent detours and de-
manding patience. It can constitute a unique event (despite its
antecedents), whose resistance to any single guiding schema is
bound to create a handicap for immediate comprehension or
immediate gratification. It appears at once limpid and paradoxi-
cal, unitary and ternary. And, although spontaneous connection
with it is always possible through the force of the message,
through the quality and beauty of the material, insightful under-
standing of it is more likely to be gained from remaking the
course of the work itself—the frame, the flow, the fire, whose
workings and vitality inspire other frames as they open up to
other possibilities.

"Anybody who meets beauty and does not look at it will soon
be poor," says a Yoruba song of divination. "The straight tree is
the pride of the forest. / The fast deer is the pride of the bush. /
The rainbow is the pride of heaven . . . " Beauty is the "mediat-

ing" breath in art: if blue is a beautiful color, one which many people are fond of, it is because, as a Yoruba schoolboy once stated, "it is midway between red and black."[11] Through this mediating activity, one cannot single out or give prejudicial preference to any one element, either of content or of form, without detriment to the whole. Thus, the one who will soon be the poorest of all must be one who can only conceive of beauty in terms of fixed oppositions (objecthood versus nothingness). Art is neither an appropriation nor an approximation of beauty. By indulging in beauty, limiting its access and ownership to connoisseurship; by taking it for granted, or rejecting it as a form of luxury, declaring thereby that its power is irrevocably dead (since it has served too long as an escapist tool to protect the breed of experts named "aesthetes"), one so impoverishes oneself as to be deprived even of that which cannot be possessed and remains formless form. This, arbitrarily concluded, must then be named, in the context of material abundance and overdevelopment, the Other Poverty.

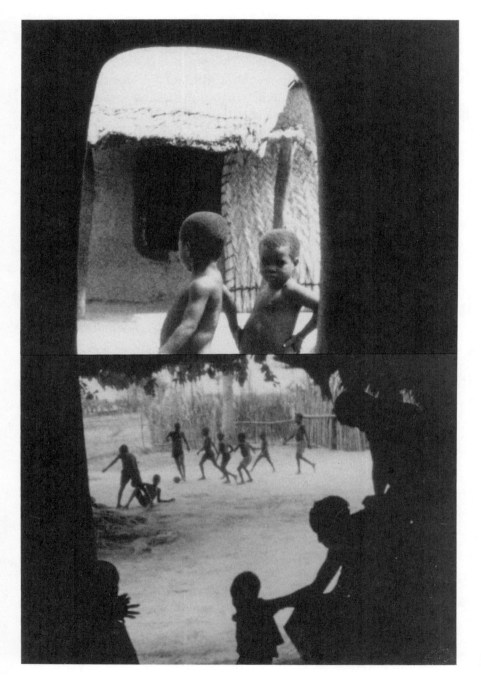

NS

Notes

Yellow Sprouts
pp. 1–8

1. *The Inner Teachings of Taoism*, T. Cleary, trans. (Boston: Shambhala, 1986) p. 6.

2. Gerald Vizenor, *Griever: An American Monkey King in China* (New York: Illinois State University and Fiction Collective, 1986), p. 227.

3. Quoted in Francois Cheng, *Chinese Poetic Writing*, D. A. Riggs and J. P. Seaton, trans. (Bloomington: Indiana University Press, 1982), p. 71.

4. See *Women in Chinese Folklore* (Beijing: Women of China, 1983), pp. 29–43.

5. Ting Lan, "Woman Is Not the Moon," in Emily Honig and Gail Hershatter, eds., *Personal Voices: Chinese Women in the 1980's* (Stanford: Stanford University Press, 1988), p. 329.

6. Quoted in Elizam Escobar, "The Fear and Tremor of Being Understood: The Recent Work of Bertha Husband," *Third Text*, Nos. 3–4 (Spring–Summer 1988): 119.

7. Quoted in Bertha Husband, "A Deep Sea Diver in the Phantom(ly) Country: Art and Politics of Elizam Escobar," *ibid.*, pp. 113; 116.

8. Walter Benjamin, *One-Way Street and Other Writings* (London: Verso, 1978; rpt. 1985), p. 123.

9. Judit, "Alliances," *Companeras: Latina Lesbians*, ed. Juanita Ramos (New York: Latina Lesbian History Project, 1987), pp. 245–46.

10. Quoted in *Chinese Poetic Writing*, p. 108.

11. Sun Bu-er, "Ingestion of the Medecine, " *Immortal Sisters: Secrets of Taoist Women*, ed. and trans. T. Cleary (Boston: Shambala, 1989), p. 47.

12. Audre Lorde, "Age, Race, Class, and Sex: Women Redefining Difference," *Out There: Marginalization and Contemporary Culture*, ed. Russell Ferguson, et al. (New York: The New Museum of Contemporary Art and M.I.T. Press, 1990), p. 287.

13. Quoted in Gerald Vizenor, "Socioacupuncture: Mythic Reversals and the striptease in Four Scenes," *Out There*, p. 419.

14. Soseki, *Oreiller d'herbes*, R. de Ceccatty and R. Nakamura, trans (Paris: Editions Rivages, 1987), p. 137.

1 Cotton and Iron
pp. 11–26

1. A. Hampaté Ba, *Kaydara* (Dakar: Les Nouvelles Editions Africaines, 1978), p. 17.

2. *Ibid.*, pp. 13–14.

3. Gloria Evangelina Anzaldúa, "Del Otro Lado," in *Companeras: Latina Lesbians*, ed. Juanita Ramos (New York: Latina Lesbian History Project, 1987), p. 3.

4. *Ibid.*

5. Alicia Dujovne Ortiz, "Buenos Aires (An Excerpt)," in *Discourse*, 8 (Fall–Winter 1987): 80.

6. Maurice Blanchot, *The Writing of the Disaster*, trans. A. Smock (Minneapolis: University of Minnesota Press, 1986), p. 12.

7. Ortiz, "Buenos Aires (An Excerpt)," p. 96.

8. Gayatri Chakravorty Spivak, "Explanation and Culture: Marginalia," in *In Other Worlds: Essays in Cultural Politic* (New York and London: Methuen, 1987), p. 381.

9. Audre Lorde, "Age, Race, Class, and Sex: Women Redefining Difference," *Out There: Marginalization and Contemporary Culture*, ed. Russell Ferguson, et al. (New York: The New Museum of Contemporary Art and M.I.T. Press, 1989), p. 284.

10. Michel Foucault, "The Ethic of Care of the Self as a Practice of

Freedom," in *The Final Foucault*, eds. J. Bernauer and D. Rasmussen (Cambridge: MIT Press, 1988), p. 4.

11. Huanani-Kay Trask, "From a Native Daughter," in *The American Indian and the Problem of History*, ed. C. Martin (New York: Oxford University Press, 1987), p. 172.

12. Michel Foucault, *Politics, Philosophy, Culture: Interviews and Other Writings 1977–1984*, ed. L.D. Kritzman (New York and London: Routledge, 1988), pp. 103–104.

13. Monique Wittig and Sande Zeig, *Lesbian Peoples: Material for a Dictionary* (New York: Avon Books, 1979), p. 97.

14. Foucault, *Politics, Philosophy, Culture*, pp. 106–7.

15. Hélène Cixous, "Castration or Decapitation?," *Out There*, p. 353.

16. Joy Harjo, "The Story of All Our Survival," in Joseph Bruchac, *Survival This Way: Interviews with American Indian Poets* (Tucson: Suntrack and University of Arizona Press, 1987), p. 90.

17. Linda Hogan, "To Take Care of Life," in Bruchac, *Survival This Way*, p. 120.

18. Leslie Marmon Silko, *Ceremony* (New York: Penguin, 1977), p. 132.

19. Ivan Illich, *Celebration of Awareness* (New York: Anchor, 1971), p. 13.

20. Luce Irigaray, "Sexual Difference," in *French Feminist Thought: A Reader*, ed. Toril Moi (Oxford and New York: Basil Blackwall, 1987), p. 124.

21. Hélène Cixous, "Castration or Decapitation?," p. 355.

22. Olive Shreiner, "Three Dreams in a Desert. Under a Mimosa-Tree," in Charlotte H. Bruner, ed., *Unwinding Threads: Writing by Women in Africa* (Nairobi: Ibadan and London: Heinemann, 1983), p. 106.

23. Maurice Blanchot, *Vicious Circles*, trans. P. Auster (Barrytown, NY: Station Hill Press, 1985), pp. 25–26.

24. Haiku by Sampu, in Stewart Holmes and Chimyo Horioka, *Zen Art for Meditation* (Rutland, VT and Tokyo: Charles E. Tuttle Company, 1973), p. 62.

2 The Totalizing Quest of Meaning
pp. 29–50

1. *One-Way Street and Other Writings* (London: Verso, 1979), p. 95.

2. J. Kowallis, trans. (Beijing: Panda Books, 1986), p. 164.

3. Quoted in G. Roy Levin, *Documentary Explorations: Fifteen Interviews with Film-Makers* (Garden City, NY: Doubleday & Company, 1971), p. 66.

4. Benjamin, *One-Way Street*, pp. 109; 111.

5. See Jean Franco's re-reading of her work in *Plotting Women: Gender and Representation in Mexico* (New York: Columbia University Press, 1989), pp. 23–54.

6. In *Grierson On Documentary*, Forsyth Hardy, ed. (1966; rpt., New York: Praeger, 1971), pp. 146–47.

7. "Film as an Original Art Form," in *Film: A Montage of Theories*, R. Dyer Mac Cann, ed. (New York: E.P. Dutton, 1966), p. 183.

8. *Living Cinema: New Directions in Contemporary Film-making*, trans. I. Quigly (New York: Praeger, 1973), p. 37.

9. In Levin, *Documentary Explorations*, p. 135.

10. *Documentary Expression and Thirties America* (1973; rpt., New York: Oxford University Press, 1976), p. 73.

11. Quoted in *Living Cinema*, p. 26.

12. "Building a New Left: An Interview with Ernesto Laclau," *Strategies*, No. 1 (Fall 1988): 15.

13. In Levin, *Documentary Explorations*, p. 119.

14. *Grierson on Documentary*, p. 249.

15. In Levin, *Documentary Explorations*, p. 119.

16. *Alexander Kluge: A Retrospective* (The Goethe Institutes of North America, 1988), p. 4.

17. John Mercer, *An Introduction to Cinematography* (Champaign, Il: Stipes Publishing Co., 1968), p. 159.

18. In Levin, *Documentary Explorations*, pp. 121; 128.

19. *Alexander Kluge: A Retrospective*, p. 6.

20. *Ibid.*, p. 66.

21. This distinction motivates Dana Polan's argument in "A Brechtian Cinema? Towards a Politics of Self-Reflexive Film," in B. Nichols, ed., *Movies and Methods*, Vol. 2 (Los Angeles: University of California Press, 1985), pp. 661–72.

22. "Women's Cinema as Counter-Cinema," in B. Nichols, ed., *Movies and Methods*, Vol. 1 (Los Angeles: University of California Press, 1976), p. 215.

23. Kowallis, *Wit and Humor*, p. 98.

24. Henk Ketelaar, "Methodology in Anthropological Filmmaking: A Filmmaking Anthropologist's Poltergeist?" in *Methodology in Anthropological Filmmaking*, N. Bogaart and H. Ketelaar, eds. (Gottingen: Herodot, 1983), p. 182.

25. *Did the Greeks Believe in Their Myths? An Essay on the Constitutive Imagination*, P. Wissing, trans. (Chicago: University of Chicago Press, 1988), p. 115.

26. See James Clifford, "Of Other Peoples: Beyond the 'Salvage Paradigm,' " in *Discussions in Contemporary Culture*, Hal Foster, ed. (Seattle: Bay Press, 1987), pp. 121–30.

27. See *Theories of Primitive Religion* (Oxford: Clarendon Press, 1980).

28. "Récents développements de la théologie africaine," *Bulletin of African Theology*, 5: 9. Quoted in V. Y. Mudimbe, *The Invention of Africa: Gnosis, Philosophy and The Order of Knowledge* (Bloomington: Indiana University Press, 1988), p. 37.

29. Jay Ruby, "Exposing Yourself: Reflexivity, Anthropology and Film," *Semiotica*, 30, 1–2 (1980): 165.

30. In *The New Generation. 1960–1980*, Uma da Cunha, ed. (New Delhi: The Directorate of Film Festivals, 1981), p. 114.

31. Kowallis, *Wit and Humor*, p. 39.

32. Benjamin, *One-Way Street*, p. 14.

33. *The Gaze of Orpheus and Other Literary Essays*, P. Adams Sitney, ed., L. Davis, trans., (Barrytown, NY: Station Hill Press, 1981), p. 104.

34. Johnston, "Women's Cinema as Counter-Cinema," p. 214.

35. *Empire of Signs*, R. Howard, trans. (New York: Hill & Wang, 1982), p. 70.

4 Outside In Inside Out
pp. 65–78

1. Title of an article written by Zora Neale Hurston. It was most likely a response to a question Hurston felt her white acquaintances were always burning to ask her. In Alice Walker, ed., *I Love Myself* (Old Westbury, NY: The Feminist Press, 1979), pp. 152–55.

2. Clifford Geertz, *Local Knowledge* (New York: Basic Books, Inc., 1983), p. 56

3. *Ibid.*, p. 57.

4. Evelyn Baring, Lord Cromer, *Political and Literary Essays, 1908–1913* (1913 rpt., Freeport, NY: Books for Library Press, 1969).

5. Geertz, *ibid.*, p. 58.

6. Hurston, *I Love Myself*, pp. 156, 160.

7. Vincent Crapanzano, "A Reporter At Large," *The New Yorker*, March 18, 1985, p. 99.

8. Claude Lévi-Strauss, "Anthropology: Its Achievements and Future," *Current Anthropology*, 7 (1966): 126.

9. *Ibid.*

10. Stanley Diamond, "A Revolutionary Discipline," *Current Anthropology* 5 (1964): 433.

11. Julio Garcia Espinosa, "For an Imperfect Cinema," in Michael Chanan, ed., *Twenty-Five Years of the New Latin American Cinema* (London: BFI and Channel 4 Television, 1983), pp. 28–33.

12. See Sol Worth and John Adair, *Through Navajo Eyes* (Bloomington: Indiana University Press, 1972). Quoted lines are on p. 11.

13. Diane Lewis, "Anthropology and Colonialism," *Current Anthropology*, 14 (1973): 586–7.

14. Crapanzano, "A Reporter At Large," p. 96.

15. *Time*, March 9, 1987, p. 54.

16. Hurston, *I Love Myself*, p. 153.

17. Dora Hertzog, quoted in Vincent Crapanzano, "A Reporter at Large," II, *The New Yorker*, March 25, 1985, p. 93.

18. Hurston, *I Love Myself*, p. 83.

19. *Négritude et négrologues* (Paris: Union Générale d'Editions, 1972), p. 182 (my translation).

20. Hurston, *I Love Myself*, p. 161.

21. Breyten Breytenbach, "L'Aveuglement des Afrikaners," *Le Nouvel Observateur*, June 20–26, 1986, p. 48 (my translation).

22. *The African Image* (1962; rpt., New York: Praeger, 1966), p.73.

23. "Being Japanese-American Doesn't Mean 'Made In Japan,' " in

Dexter Fisher, ed., *The Third Woman* (Boston: Houghton Mifflin Cie, 1980), p. 446.

24. *The Woman Warrior* (New York: Vintage Books, 1977).

25. "Asian Pacific American Women and Feminism," in Cherríe Moraga and Gloria Anzaldúa, eds., *This Bridge Called My Back* (Watertown, MA: Persephone Press, 1981), p. 75.

5 All-Owning Spectatorship
pp. 81–105

1. In *Wit and Humor from Old Cathay*, trans. J. Kowallis (Beijing: Panda Books, 1986), p. 63.

2. A sentence borrowed from Paul Eluard's poem "La Terre est bleue" in *Capitale de la douleur* (1926; rpt; Paris: Gallimard, 1966), p. 153.

3. Irwin R. Blacker, *The Elements of Screen-writing: A Guide for Film and Television Writing* (New York: Collier Books, 1986), p. 48.

4. From Arthur Rimbaud's poem "Voyelles," in *Rimbaud: Complete Works*, trans. W. Fowlie (Chicago: Chicago University Press, 1966), p. 121.

5. In *China After Mao: A Collection of Eighty Topical Essays by the editors of Beijing Review* (Beijing: Beijing Review, 1983), p. 115.

6. *Antonio Gramsci: Selected Writings 1916–1935*, ed. D. Forgacs (New York: Schocken Books, 1988), p. 321.

7. Jean Baudrillard, *In the Shadow of the Silent Majority* (New York: Semiotext(e), 1981), p. 105.

8. Guy Debord, *Society of the Spectacle* (1967; rpt., Detroit: Black & Red, 1983), p. 82.

9. Raoul Vaneigem, *The Revolution of Everyday Life*, trans. D. Nicholson-Smith (London: Left Bank Books & Rebel Press, 1983), p. 23.

10. Johannes Itten, *The Elements of Color*, trans. E. Van Hagen (New York: Van Nostrand Reinhold, 1970), p. 86.

11. For more information, see Geneviève Calame-Griaule, *Ethnologie et langage: La Parole chez les Dogon* (Paris: Institut d'ethnologie, 1987), pp. 136, 246.

12. Discussion of the symbolics of red among the Dogon is based on the above book by G. Calame Griaule.

13. In *Foucault Live: Interviews 1966–84*, trans. J. Johnston, ed. S. Lotringer (New York: Semiotext(e), 1989), pp. 99–100.

14. Debord, *Society of the Spectacle*, p. 53.

15. Roland Barthes, *The Rustle of Language*, trans. R. Howard (New York: Hill & Wang, 1986), p. 63.

16. Michel Foucault, "The Subject and Power," in *Art After Modernism. Rethinking Representation*, ed. B. Wallis (New York: The New Museum of Contemporary Art and M.I.T. Press, 1984), pp. 429–30.

17. Baudrillard, *The Silent Majority*, p. 18.

18. See Julia Lesage, "Why Christian Television Is Good TV," *The Independent*, Vol. 10, No. 4 (May 1987): 18.

19. Michael Novak, "Television Shapes the Soul," in *Television: The Critical View*, ed. H. Newcomb (New York: Oxford University Press, 1982), pp. 343, 346.

20. Lesage, "Christian Television," p. 15.

21. Quoted in Stanley Karnow, *Vietnam: A History* (New York: Penguin, 1983), pp. 27–28.

22. See interviews with Thu Van and Anh in Mai Thu Van, *Vietnam, un peuple, des voix* (Paris: Editions Pierre Horay, 1982).

23. Quoted in *Marxism and Art*, ed. Maynard Solomon (Detroit: Wayne State University Press, 1979), p. 12.

24. Miranda Davies, ed., *Third World Second Sex: Women's Struggles and National Liberation* (London: Zed, 1983), p. iv.

25. Teresa de Lauretis, *Technologies of Gender* (Bloomington: Indiana University Press, 1987), p. 15.

6 A Minute Too Long
pp. 107–116

1. Fredric Jameson, "Cognitive Mapping," in Cary Nelson and Lawrence Grossberg, eds., *Marxism and the Interpretation of Culture* (Chicago: University of Illinois Press, 1988), p. 347.

2. Andrei Tarkovsky, *Sculpting in Time: Reflections on the Cinema* (New York: Alfred A. Knopf, 1987), p. 64.

3. *Ibid.*

4. *Ibid.*, p. 67.

5. Quoted in Françoise Pfaff, *Twenty-five Black African Filmmakers* New York: Greenwood Press, 1988), p. 209.

6. Roland Barthes, "Caro Antonioni," *Art & Text*, 17 (April 1985): 45.

7. Marguerite Duras, *Duras by Duras* (San Francisco: City Lights, 1987), p. 71.

8. Barthes, "Caro Antonioni," p. 46.

9. See Gilles Deleuze, *L'Image-temps* (Paris: Les Editions de Minuit, 1985).

10. See Laura Mulvey, "Visual Pleasure and Narrative Cinema," in *Art After Modernism*, ed. Brian Wallis (New York: The New Museum of Contemporary Art, 1984).

11. Duras, *Duras by Duras*, p. 90.

7 *L'Innécriture:* Un-writing/Inmost Writing
pp. 119–145

1. *Ecoute ma différence* (Paris: Grasset, 1978), pp. 32–33.

2. Stanislas S. Adotevi, *Négritude et négrologues* (Paris: UGE, 1972), p. 102.

3. Interview with Michèle Coquillat, *F magazine*, No. 20 (October 1979); 29.

4. In *Yale French Studies*, No. 27: 47.

5. Hélène Cixous, "Le Rire de la Méduse," *L'Arc*, No. 61 (n.d.): 42–46 ["The Laugh of the Medusa," trans. K. Cohen and P. Cohen, *Signs* 1.4 (Summer 1976)]. Cf. "Sorties," in *La Jeune Née* (Paris: UGE, 1975), pp. 155–64 [Hélène Cixous and Catherine Clément, *The Newly Born Woman*, trans. Betsy Wing (Minneapolis: University of Minnesota Press, 1986)].

6. A word which, reflecting the male chauvinist ideology in the writings of Freud and Lacan ("castration lack"), has become a double-edged weapon in Cixous's language. Man, accustomed to seeing a "lack" in woman, is himself lacking. Cf. "Le Rire," p. 47.

7. "Ecrire," *Socières*, No. 7 (n.d.): 13.

8. In *Etudes Littéraires* (December 1973): 327–28.

9. Marshall McLuhan, *D'oeil à oreille* (Paris: Denoël-Gonthier, 1977), p. 170. These citations represent neither a reference to a paternalistic authority, nor a takeover by a male context; they allow the detection of

an agreement on events and principles through the juxtaposition of discourses.

10. Anne D. Ketchum,"Vers une écriture féminine," *Revue Pacifique*, IV (1979): 24, 26.

11. "Lettre aux Ecoles de Bouddha," in *Oeuvres complètes* (Paris: Gallimard, 1956), I, p. 264.

12. A more detailed analysis has been made in Trinh T. Minh-ha, *Un art sans oeuvre* Lathrup Village, Mich.: International Book Publishers, Inc., 1981).

13. *Ecrits* (Paris: UGE, 1978), p. 155.

14. Cf. the writings of Jacques Derrida, especially *L'écriture et la différence* (Paris: Seuil, 1967).

15. (Paris: Des Femmes, 1974), p. 7.

16. *Essais critiques* (Paris: Stock 2, 1975), cited in *L'Itinéraire psychiatrique* (Paris: Des Femmes, 1977), p. 55.

18. *La Malcastrée* (Paris: Maspéro, 1973; Des Femmes, 1976), cited in *L'Itinéraire*, pp. 63, 72–73.

19. *L'Itinéraire*, pp. 81, 49, 127, 102, 132.

20. *Les Parleuses* (Paris: Minuit, 1974), p. 8.

21. "Quant à la pomme du texte," *Etudes littéraires* (December 1979): 411.

22. *La Passion selon G. H.* (Paris: Des Femmes, 1978), p. 24.

23. In *Etudes littéraires* (December 1979): 423.

24. *Vivre l'orange* (Paris: Des Femmes, 1979), p. 9 [p. 8, facing English translation].

25. Verena Andermatt, "Hélène Cixous and the Uncovery of a Feminine Language," *Women in Literature*, VII (1979–1980): 38–47.

26. *L'Arc*, No. 54 (n.d.): 47.

9 Bold Omissions and Minute Depictions
pp. 155–166

1. Wen Yi Hou, "Being in America," Master thesis (University of California San Diego, 1990), pp. 1, 14–15.

2. Ezekiel Mphahlele, *The African Image* (New York: Praeger, 1962, rpt., 1966), p. 15.

Notes

3. *Ibid.*, p. 54.

4. Wole Soyinka, *Myth, Literature and The African World* (New York: Cambridge University Press, 1976; rpt., 1978), p. 127.

5. Mai-mai Sze, *Echo of a Cry, A Story Which Began in China* (New York: Harcourt Brace, 1945), p. 202; quoted in Amy Ling, *Between Worlds: Women Writers of Chinese Ancestry* (Elmsford, NY: Pergamon Press, 1990), p. 108.

6. Stella Wong, "The Return," poem quoted in Russell Leong, "Poetry Within Earshot," *Amerasia Journal*, Vol. 15 No 1 (1989), 172.

7. Al Robles, "Tagatac on Ifugao Mountain," quoted in *Amerasia Journal*, ibid., p. 175.

8. "Being in America," p. 27.

9. Andrei Tarkovsky, *Sculpting in Time: Reflections on The Cinema*, trans. K. Hunter-Blair (New York: Alfred A. Knopf, 1987). The quote from Mann is on p. 104; the rest is on p. 109.

10. In Earle J. Coleman, *Philosophy of Painting by Shih T'ao: A Translation and Exposition of his Hua-P'u* (New York: Mouton Publishers, 1978).

11. Tarkovsky's italics, *Sculpting In Time*, pp. 104, 110.

12. *Philosophy of Painting*, p. 15.

13. Homi Bhabha, "The Other Question: Difference, Discrimination and The Discourse of Colonialism," in *Literature, Politics and Theory*, ed. F. Baker, et al. (London: Methuen, 1986), p. 163.

14. Bell hooks, *Talking Back: Thinking Feminist, Thinking Black* (Boston, Mass.: South End Press, 1989), p. 107.

15. Claire Johnston, "Women's Cinema As Counter-Cinema," in *Movies and Methods: An Anthology,*Vol. 1 ed. B. Nichols (Berkeley: University of California Press, 1976), pp. 211;214.

16. See James Cahill, *The Compelling Image* (Cambridge, Mass.: Harvard University Press, 1982), pp. 72, 74, 82, 96. The complexities of Cahill's discussion on the influences from Europe among Chinese artists cannot be conveyed in the few general lines I have drawn here.

17. Quoted in George Rowley, *Principles of Chinese Painting* (Princeton, NJ: Princeton University Press, 1947; rpt., 1959), p. 66.

18. *Philosophy of Painting*, pp. 142–43.

19. Huang Shang, *Tales from Peking Opera* (Beijing: New World Press, 1985), p. 7.

10 Aminata Sow Fall and the Beggars' Gift
pp. 169–183

1. Charles R. Larson, *The Emergence of African Fiction* (Bloomington: Indiana University Press, 1971), pp. 11–12.

2. Roland Bartes, *Le Degré zéro de l'écriture* (1953; rpt., Paris: Seuil, 1972), p. 32. [*Writing Degree Zero*, trans. Annette Lavers and Colin Smith (New York: Hill and Wang, 1967), p. 39.]

3. *Ibid.*, pp. 27, 29 [32, 35]. Italics mine.

4. For a more detailed analysis, cf. Barthes, *Essais critiques* (Paris: Seuil, 1964), pp. 162–63, and "L'Ecriture du Roman" in *Le Degré zéro* [*Critical Essays*, trans. Richard Howard (Evanston, IL: Northwestern University Press, 1972), pp. 158–59, and "Writing and the Novel" in *Writing Degree Zero*]; A. Robbe-Grillet, "Sur quelques notions périmées" in *Pour un nouveau roman* (Paris: Minuit, 1963) ["On Several Obsolete Notions; in *For a New Novel*, trans. Richard Howard (New York: Grove Press, 1965)]; Nathalie Sarraute, *L'Ere du soupçon* (Paris: Gallimard, 1956), pp. 69–94) [*The Age of Suspicion*, trans. Maria Jolas (New York: G. Braziller, 1963), pp. 53–74].

5. Nathalie Sarraute, *L'Ere du soupçon*, p. 85 [p. 66; trans. taken from the English edition cited in n.4].

6. See J. Herbert, *Ce que Gandhi a vraiment dit* (Verviers: Marabout, 1974).

11 The World as Foreign Land
pp. 185–199

1. Homi K. Bhabha, "The Other Question: Difference, Discrimination and the Discourse of Colonialism," in *Literature, Politics and Theory*, ed. F. Baker, et al. (London: Methuen, 1986), pp. 151, 171.

2. Gayatri Chakravorty Spivak, "Can the Subaltern Speak?," in *Marxism and the Interpretation of Culture*, ed. C. Nelson and L. Grossberg (Chicago: University of Illinois Press, 1988), p 275.

3. Maurice Blanchot, *Thomas the Obscure*, trans. R. Lamberton (New York: David Lewis, 1973), p. 90.

4. Idries Shah, *Thinkers of the East* (New York: Penguin Books, 1971; rpt., 1979), p. 137.

5. Moumen Smihi, "Moroccan Society as Mythology," in *Film and Politics in the Third World*, ed. J. D. H. Downing (New York: Autonomedia, 1987), p. 85.

6. Shah, *Thinkers*, p. 110.

7. Tchicaya U Tam'si, *Selected Poems*, trans. G. Moore (London: Heinemann, 1970; rpt., 1972), p. 137.

8. Smihi, "Moroccan Society," p. 80.

9. Jean Baudrillard, *The Evil Demon of Images* (Sydney: The Power Institute of Fine Arts, 1987; rpt., 1988), p. 22.

10. Shah, *Thinkers*, p. 82.

11. Blanchot, *Thomas*, p. 10.

12. *Ibid.*, p. 32.

13. Edward Said, "Reflections on Exile," *Granta*, No. 13 (1985): 171.

14. Jorge Sanjines and the Ukamau Group, *Theory and Practice of A Cinema With the People*, trans. R. Schaaf (Willimantic, Conn.: Curbstone Press, 1989), p. 60.

15. Toni Morrison, "Unspeakable Things Unspoken: The Afro-American Presence in American Literature," *Michigan Quarterly Review* (Winter 1988–89): 11.

16. Colin MacCabe, *Godard: Images, Sounds, Politics* (Bloomington: Indiana University Press, 1980), pp. 138, 154.

17. Sanjines, *A Cinema With the People*, p. 61.

18. *Ibid.*, pp. 63, 65.

19. Toni Morrison, "The Site of Memory," in *Out There. Marginalization and Contemporary Culture*, ed. R. Ferguson, et al. (New York: The New Museum of Contemporary Art and M.I.T. Press, 1990), p. 305.

20. U Tam'si, *Selected Poems*, p. 141.

13 The Plural Void: Barthes and Asia
pp. 209–222

1. All quotations have been translated by Stanley Gray unless otherwise indicated.

2. *Essais critiques* (Paris: Seuil, 1964); trans. R. Howard, *Critical Essays* (Evanston: Northwestern University Press, 1972), p. 156.

3. *Ibid.*, p. xii.

4. *Ibid.*, pp. xv, 160.

5. In R. Macksey and E. Donato, *The Structuralist Controversy* (Baltimore and London: The Johns Hopkins University Press, 1970), pp. 134–45.

6. *Le Plaisir du texte* (Paris: Seuil 1973); trans. R. Miller; *The Pleasure of the Text* (New York: Hill & Wang, 1975), p. 45.

7. *Critical Essays*, p. 160.

8. *Ibid.*, p. 147.

9. *Alors la Chine?* (Paris: C. Bourgois, 1975), pp. 13–14.

10. *The Pleasure*, p. 65.

11. "Au Séminaire," *L'Arc*, No. 56 (n.d.): 55.

12. Translated from the French translation by F. Houang and P. Leyris, *La Voie et sa vertu: Tao-te-king* (Paris: Seuil, 1979), pp. 141, 75. English translations of the *Tao-te-king* are numerous. I prefer however to keep Houang and Leyris's poetic version.

13. *Fragments d'un discours amoureux* (Paris: Seuil, 1977), pp. 272–73.

14. *La Chambre claire* (Paris: Gallimard-Seuil, 1980); trans. R. Howard, *Camera Lucida* (New York: Hill & Wang, 1981), p. 4.

15. *Fragments*, p. 26.

16. *Ibid.*, p. 116.

17. "Au Séminaire", pp. 48, 52–53.

18. *Ibid.*, p. 54.

19. *Ibid.*

20. Barthes quotes Angelus Silesius, *The Pleasure*, p. 16.

21. *Leçon* (Paris: Seuil, 1978), p. 20.

22. *Camera*, p. 8.

23. *Fragments*, p. 228.

24. "Au Séminaire," p. 54.

25. *Critical Essays*, p. 278.

26. *Camera*, p. 9.

27. *Ibid.*, p. 55.

14 The Other Censorship
pp. 225–235

1. Michel Foucault, *Politics, Philosophy, Culture: Interviews and Other Writings 1977–1984.* Ed. L. Kritzman, trans. A. Sheridan et al., (New York: Routledge, 1988), p. 14.

2. Antonio Gramsci, *Selections from the Prison Notebooks*, eds. and trans. Q. Hoare and G. Nowell Smith (New York: International Publishers, 1971; rpt., 1987), p. 9.

3. Isaac Julien, "The Afternoon Discussion," *Framework* (London), No. 36 (1989), a special Issue on "Third Scenario: Theory and the Politics of Location," p. 60.

4. Stuart Hall, *ibid.*, p. 59.

5. May Stevens, "Taking Art to the Revolution," in *Visibly Female: Feminism and Art Today*, ed. H. Robinson (New York: Universe Books, 1988), pp. 182–83.

6. Adrian Piper, in the abstract entitled "The Triple Negation of Women Artists of Color," circulated in Piper's absence at the College of Arts Association Annual Meeting, New York, February 1990. See also Howardina Pindell, "Covenant of Silence: Defacto Censorship in the Visual Arts," *Third Text*, No. 11 (Summer 1990), p. 71–90.

7. Juan Sanchez, in a speech given at the same CAA meeting as above.

8. Adrian Piper, "The Joy of Marginality," paper given at "The Ideology of the Margin: Gender, Race and Culture" Conference organized by the New Museum of Contemporary Art, New York, May 11, 1988.

9. Quoted in Andrei Tarkovsky, *Sculpting in Time: Reflections on the Cinema*, trans. K. Hunter-Blair (New York: Alfred A. Knopf, 1987), p. 10.

10. Tarkovsky, *ibid.*, p. 40.

11. Both song and statement are quoted in Robert Farris Thompson, "Yoruba Artistic Criticism," *The Traditional Artist in African Societies*, ed. W. L. D'Azevedo (Bloomington: Indiana University Press, 1973; rpt., 1974), pp. 29, 59.

NS